BOWIE'S BOOKSHELF

BOWIE'S BOOKSHELF

The Hundred Books That Changed David Bowie's Life

JOHN O'CONNELL

Illustrations by Luis Paadín

GALLERY BOOKS

New York London Toronto Sydney New Delhi

G

Gallery Books
An Imprint of Simon & Schuster, Inc.
1230 Avenue of the Americas
New York, NY 10020

Text copyright © 2019 by John O'Connell Illustrations copyright © 2019 by Luis Paadín Originally published in Spain in 2019 by Blackie Books, Barcelona as *El Club de Lectura de David Bowie* Permissions arranged by Blackie Books, S.L.U.

All rights reserved, including the right to reproduce this book or portions thereof in any form whatsoever. For information address Gallery Books Subsidiary Rights Department, 1230 Avenue of the Americas, New York, NY 10020

First Gallery Books hardcover edition November 2019

GALLERY BOOKS and colophon are registered trademarks of Simon & Schuster, Inc.

For information about special discounts for bulk purchases, please contact Simon & Schuster Special Sales at 1-866-506-1949 or business@simonandschuster.com

The Simon & Schuster Speakers Bureau can bring authors to your live event. For more information or to book an event contact the Simon & Schuster Speakers Bureau at 1-866-248-3049 or visit our website at www.simonspeakers.com.

Interior design by Alexis Minieri

Manufactured in the United States of America

7 9 10 8 6

Library of Congress Cataloging-in-Publication Data

Names: O'Connell, John (Music journalist) author. Title: Bowie's bookshelf : the hundred books that changed David Bowie's life / John O'Connell.

Description: New York : Gallery Books, 2019. Identifiers: LCCN 2019028517 (print) | LCCN 2019028518 (ebook) | ISBN 9781982112554 (ebook)

Subjects: LCSH: Bowie, David—Books and reading. Classification: LCC ML420.B754 O3 2019 (print) | LCC ML420.B754 (ebook) | DDC 782.42166092—dc23

> LC record available at https://lccn.loc.gov/2019028517 LC ebook record available at https://lccn.loc.gov/2019028518

> > ISBN 978-1-9821-1254-7 ISBN 978-1-9821-1255-4 (ebook)

CONTENTS

	Introduction	xiii
1.	Anthony Burgess, A Clockwork Orange (1962)	1
2.	Albert Camus, The Outsider (1942)	5
3.	Nik Cohn, Awopbopaloobop Alopbamboom (1969)	8
4.	Dante Alighieri, Inferno (c.1320)	11
5.	Junot Díaz, The Brief Wondrous Life of	
	Oscar Wao (2007)	14
6.	Yukio Mishima, The Sailor Who Fell from Grace	
	with the Sea (1963)	17
7.	Frank O'Hara, Selected Poems (2009)	21
8.	Christopher Hitchens, The Trial of Henry	
	Kissinger (2001)	23
9.	Vladimir Nabokov, Lolita (1955)	25
10.	Martin Amis, Money (1984)	27
11.	Colin Wilson, The Outsider (1956)	30
12.	Gustave Flaubert, Madame Bovary (1856)	32
13.	Homer, The Iliad (8th Century BC)	34

viii 4 CONTENTS

14.	James Hall, Hall's Dictionary of Subjects and	
	Symbols in Art (1974)	36
15.	Saul Bellow, Herzog (1964)	39
16.	T. S. Eliot, The Waste Land (1922)	41
17.	John Kennedy Toole, A Confederacy of Dunces (1980)	45
18.	Greil Marcus, Mystery Train (1975)	48
19.	The Beano (1938-present)	51
20.	Fran Lebowitz, Metropolitan Life (1978)	53
21.	Richard Cork, David Bomberg (1988)	56
22.	Alfred Döblin, Berlin Alexanderplatz (1929)	59
23.	George Steiner, In Bluebeard's Castle: Some Notes	
	Towards the Redefinition of Culture (1971)	62
24.	D. H. Lawrence, Lady Chatterley's Lover (1928)	65
25.	Petr Sadecký, Octobriana and the Russian	
	Underground (1971)	68
26.	Comte de Lautréamont, Les Chants de Maldoror (1868)	72
27.	John Cage, Silence: Lectures and Writing (1961)	74
28.	George Orwell, Nineteen Eighty-Four (1949)	77
29.	Peter Ackroyd, Hawksmoor (1985)	80
30.	James Baldwin, The Fire Next Time (1963)	82
31.	Angela Carter, Nights at the Circus (1984)	85
32.	Eliphas Levi, Transcendental Magic: Its Doctrine	
	and Ritual (1856)	88
33.	Sarah Waters, Fingersmith (2002)	91
34.	William Faulkner, As I Lay Dying (1930)	94
35.	Christopher Isherwood, Mr. Norris Changes	
	Trains (1935)	96
36.	Jack Kerouac, On the Road (1957)	99

CONTENTS 4 ix

37.	Edward Bulwer-Lytton, Zanoni (1842)	103
38.	George Orwell, Inside the Whale and Other Essays (1940)	107
39.	John Rechy, City of Night (1963)	110
40.	David Sylvester, The Brutality of Fact: Interviews	
	with Francis Bacon (1987)	113
41.	Julian Jaynes, The Origins of Consciousness in	
	the Breakdown of the Bicameral Mind (1976)	115
42.	F. Scott Fitzgerald, The Great Gatsby (1925)	117
43.	Julian Barnes, Flaubert's Parrot (1984)	120
44.	J. B. Priestley, English Journey (1934)	123
45.	Keith Waterhouse, Billy Liar (1959)	126
46.	Alberto Denti di Pirajno, A Grave for a Dolphin (1956)	128
47.	Raw (1986–91)	131
48.	Susan Jacoby, The Age of American Unreason (2008)	133
49.	Richard Wright, Black Boy (1945)	136
50.	Viz (1979-present)	139
51.	Ann Petry, The Street (1946)	141
52.	Giuseppe Tomasi di Lampedusa, The Leopard (1958)	143
53.	Don DeLillo, White Noise (1985)	146
54.	Douglas Harding, On Having No Head (1961)	148
55.	Anatole Broyard, Kafka Was the Rage (1993)	151
56.	Charles White, The Life and Times of	
	Little Richard (1984)	153
57.	Michael Chabon, Wonder Boys (1995)	156
58.	Arthur Koestler, Darkness at Noon (1940)	159
59.	Muriel Spark, The Prime of Miss Jean Brodie (1961)	161
60.	John Braine, Room at the Top (1957)	164
61.	Elaine Pagels, The Gnostic Gospels (1979)	166

x 4 CONTENTS

62.	Truman Capote, In Cold Blood (1966)	168
63.	Orlando Figes, A People's Tragedy: The Russian	
	Revolution 1891–1924 (1996)	170
64.	Rupert Thomson, The Insult (1996)	173
65.	Gerri Hirshey, Nowhere to Run: The Story of Soul Music	
	(1984)	176
66.	Arthur C. Danto, Beyond the Brillo Box: The Visual	
	Arts in Post-Historical Perspective (1992)	179
67.	Frank Norris, McTeague (1899)	181
68.	Mikhail Bulgakov, The Master and Margarita (1966)	183
69.	Nella Larsen, Passing (1929)	186
70.	Hubert Selby Jr., Last Exit to Brooklyn (1964)	188
71.	Frank Edwards, Strange People: Unusual Humans	
	Who Have Baffled the World (1961)	190
72.	Nathanael West, The Day of the Locust (1939)	193
73.	Tadanori Yokoo, Tadanori Yokoo (1997)	196
74.	Jon Savage, Teenage: The Creation of Youth	
	Culture (2007)	199
75.	Wallace Thurman, Infants of the Spring (1932)	202
76.	Hart Crane, The Bridge (1930)	205
77.	Eugenia Ginzburg, Journey Into the Whirlwind (1967)	208
78.	Ed Sanders, Tales of Beatnik Glory (1975)	211
79.	John Dos Passos, The 42nd Parallel (1930)	213
80.	Peter Guralnick, Sweet Soul Music: Rhythm and	
	Blues and the Southern Dream of Freedom (1986)	216
81.	Bruce Chatwin, The Songlines (1987)	219
82.	Camille Paglia, Sexual Personae: Art and Decadence	
	from Nefertiti to Emily Dickinson (1990)	222

CONTENTS 4 xi

83.	Jessica Mitford, The American Way of Death (1963)	225
84.	Otto Friedrich, Before the Deluge: A Portrait of	
	Berlin in the 1920s (1972)	227
85.	Private Eye (1961–)	230
86.	R. D. Laing, The Divided Self (1960)	232
87.	Vance Packard, The Hidden Persuaders (1957)	235
88.	Evelyn Waugh, Vile Bodies (1930)	239
89.	Howard Zinn, A People's History of the	
	United States (1980)	241
90.	Wyndham Lewis, ed., Blast (1914-15)	244
91.	Ian McEwan, In Between the Sheets (1978)	248
92.	David Kidd, All the Emperor's Horses (1961)	251
93.	Malcolm Cowley, ed., Writers at Work: The Paris Review	
	Interviews, vol. 1 (1958)	255
94.	Christa Wolf, The Quest for Christa T. (1968)	258
95.	Tom Stoppard, The Coast of Utopia (2002)	261
96.	Anthony Burgess, Earthly Powers (1980)	264
97.	Howard Norman, The Bird Artist (1994)	267
98.	Spike Milligan, Puckoon (1963)	269
99.	Charlie Gillett, The Sound of the City: The Rise of Rock	
	and Roll (1970)	271
100.	Lawrence Weschler, Mr. Wilson's Cabinet of	
	Wonder (1995)	274
Selec	cted Bibliography	277
Acki	Acknowledgments	

LONG THE STATE OF THE STATE OF

INTRODUCTION

n July 1975, stick-thin and in the grip of a severe cocaine addiction, David Bowie arrived in New Mexico to shoot *The Man Who Fell to Earth*. He was twenty-eight and had been cast in the lead role of alien emissary Thomas Jerome Newton after the film's director, Nicolas Roeg, saw him in a BBC documentary called *Cracked Actor* and was struck by his air of ethereal otherness.

On set Bowie surprised everyone by being diligent and engaged, happy to banter with the crew and work on his lines with costar Candy Clark. He had, rather ambitiously, promised not to use drugs for the duration of the shoot, so when he wasn't needed he would take himself off to his trailer and indulge in an altogether less harmful pastime: reading books. Luckily, he had plenty to choose from. As a *Sunday Times* location report explained, "Bowie hates aircraft so he mostly travels across the States by train, carrying his mobile bibliothèque in special trunks which open out with all his books neatly displayed on shelves. In New Mexico the volumes dealt mainly with the occult, his current enthusiasm." This portable library stored fifteen hundred titles—enough to make Clark's later observation to a journalist that Bowie "really read a lot" while making *The Man Who Fell to Earth* seem like a bit of an understatement.

Fast-forward to March 2013: The Victoria & Albert Museum's exhibition *David Bowie Is* has opened in London to rave reviews and record-breaking ticket sales. A career retrospective featuring some five hundred items from the singer's personal archive, including costumes, paintings, handwritten lyrics, and video storyboards, it will traverse the world before bowing out at New York's Brooklyn Museum just over five years later. To coincide with the opening in Ontario, the show's first port of call after London, the V&A issued the list, on which this book is based, of the hundred books Bowie considered the most important and influential—not, note, his "favorite books" as such—out of the thousands he had read during his life.

These books had actually been a feature of the original London show, where a selection of them was suspended from the ceiling. Still, the list quickly went viral amid a flurry of incredulous commentary, much of it reducible to: Wow, who knew David Bowie read so much? Which was odd because Bowie had advertised his bookishness for years, not just in interviews but, more obliquely, in his work and the range of masks he wore when he presented it to the public.

The mobile-library story shows how Bowie's reading had calcified into a compulsion by the time he achieved his goal of being world-famous. He went about it the way he went about everything, with a kind of manic fervor. As a casual habit, however, it would have started in his bedroom at 4 Plaistow Grove, the small terraced house in the London suburb of Bromley where he spent his formative years of childhood and adolescence.

Books were cool and sexy back then; even cooler and sexier than they are now. (Imagine!) Allen Lane didn't invent the paperback when, in 1935, he launched Penguin Books, but he used his marketing and entrepreneurial genius to democratize reading, making the world's best writing available for the price of a packet of cigarettes. Bowie's postwar generation was the first to take this phenomenon for granted so that by 1966, when the Beatles' "Paperback Writer" hit number one, the term stood somehow for the takeover of Britain's creative industries by people from provincial or working-class backgrounds.

Bowie underperformed at school and left in 1963 with just one qualification to his name—a basic O level in art. Given the wide range of interests he subsequently cultivated, this suggests not laziness or an inability to retain information so much as impatience with formal education. Like many autodidacts, Bowie realized early on that he enjoyed teaching himself much more than he enjoyed being taught. And he took huge pleasure in passing on what he had learned to others: when he loved a book, friends say, he would proselytize passionately on its behalf.

This may be why, in 1998, he started writing book reviews for the US bookstore chain Barnes & Noble. "They saw that I did a lot of book reviews on the site [his early website BowieNet], and they figured that it might not be a bad thing if they got me to do some for them as well," he told *Time Out*. "I gave them five categories I'd be interested in reviewing, from art to fiction to music. The first one I've done is *Glam!* by Barney Hoskyns. What's it like? Excellent."

Bowie's creative method was particular and, until his imitators caught up with him, unusual for a pop musician. It involved opening himself wide to every possible influence. Not just other music but—and this is what marked him out—anything in any medium that might serve his vision. The resulting song, look, video, or album cover inevitably pointed the way home to its sources, but via multiple, circuitous routes, those sources having been distilled in the alembic of Bowie's charisma until they were sometimes barely recognizable. Bowie liked reading, so there was a natural role for books in this process.

Bowie also liked playing games, and the V&A list is but one element of a game he enjoyed more than any other—that of curating his own mythology. It has a notable precedent, as Bowie surely knew. In 1985 a publisher asked the Argentinean writer Jorge Luis Borges, laureate of libraries and labyrinths, to choose his hundred favorite books and write an introduction to each. Borges only made it to number 74 before he died, but his list, like Bowie's, is wonderfully eclectic, suggestive, and surprising, not to mention stuffed with writers we either know or can be pretty certain that Bowie admired (Oscar Wilde, Franz Kafka, Thomas De Quincey), though oddly there isn't a single title in common.

I like to think Bowie intended his list as a homage to Borges—as a garden of forking paths (to borrow the title of one of Borges's most

famous stories) where, if you turn left at Edward Bulwer-Lytton's Rosicrucian romance Zanoni, you end up at Angela Carter's Nights at the Circus; and where, having been inspired to seek clues to the identity of the "real" David Bowie by Flaubert's Parrot, you're briskly funneled along to Mr. Wilson's Cabinet of Wonder, a book about the hairsplittingly fine line between artifice and authenticity.

None of which is to accuse Bowie's list of being insincere or unrevealing. On the contrary. Stare at it long enough and two main patterns emerge. The first is made up of the different cultural elements that cohered to form Bowie's artistic sensibility. The second, a little hazier, has to do with chronology: arranged in the right order, the books plot a course through Bowie's life from child to teenager and from drug-addled superstar to reflective, reclusive family man. "I never became who I should have been until maybe twelve or fifteen years ago," he told the talk-show host Michael Parkinson in 2002. "I spent an awful lot of my life . . . actually looking for myself, understanding what I existed for and what made me happy in life and who exactly I was and what were the parts of myself that I was trying to hide from."

The role that reading played in this quest can't be underestimated. Because reading is, among much else, an escape—into other people, other perspectives, other consciousnesses. It takes you out of yourself, only to put you back there infinitely enriched.

David Jones was born in Brixton, south London, on January 8, 1947. It's no surprise, then, if the books he found most significant are products of (or became fashionable in) the 1960 and '70s.

Like everything else about us, our adult cultural habits are shaped by our childhoods: not just how or where we were brought up, but the spirit of the times. Bowie said on numerous occasions that one of the most significant events of his life was his older half brother Terry Burns introducing him to Jack Kerouac's Beat classic *On the Road*. David was too young for Beat, but by the early '60s the movement had slipped on an Italian suit and mutated into mod while retaining its aesthetic—a romantic existentialism that combined, in the words of one mod, "amphetamine, Jean-Paul Sartre and John Lee Hooker."

Today, when we think of mods, we think of scooters, parkas, and the film *Quadrophenia*, based on the Who's album of the same name. But this was a much later, cruder iteration. By the time the Who's "My Generation" reached number two on the UK singles chart in November 1965, mod as its original adherents would have understood it had already peaked. As David May, a mod from Plymouth who went on to work for *Time Out* and ITN, put it in Jonathon Green's book *Days In The Life: Voices from the English Underground 1961–1971:* "Mods were always intellectual. There was always a large gay element in it. . . . We didn't fight rockers, we were far more interested in some guy's incredible shoes, or his leather coat. But underneath this, one did read Camus. *The Outsider*, there it was, it explained an awful lot. A sort of Jean Genet criminal lowlife was also important."

Like his friend and sometime rival Marc Bolan, Bowie became a mod in 1964. Unlike Bolan, who was disapproved of by "proper" mods because of his failure to grasp that there was more to the scene than clothes and drugs, Bowie made the connection between his

half brother's Beat tastes, which he shared, and the fact that mod was short for modernist.

Lots of the books on Bowie's list are, in this sense, mod books: not just On the Road and The Outsider, but also T. S. Eliot's The Waste Land and the various titles that touch on Dada and surrealism, both Beat fascinations. Alex and his droogs in A Clockwork Orange would have felt familiar to Bowie because he would have known about the antics of Peter Shertser and his mod street gang the Firm, reprobates from the Ilford area who would turn up at parties and smash the place up—but with an art-terrorist manifesto that compared their wrecking to the work of René Magritte, Man Ray, and Luis Buñuel. London's art colleges swarmed with intellectual mods. Pete Townshend enrolled at Ealing Technical College & School of Art in the summer of 1961. There, he encountered the artist Gustav Metzger's theories of "auto-destructive" art, which a few years later gave Townshend's band the Who a clever-sounding excuse to destroy their instruments on stage.

By 1967 David Jones was a veteran of several going-nowhere bands, including the Who-influenced Manish Boys, the King Bees, and the Lower Third. His first solo album having flopped, the next phase for David Bowie—as he renamed himself to avoid confusion with Davy Jones from the Monkees—was hippie, with its interest in happenings and festivals, esoteric religion and the occult; though, as ever, Bowie did it on his terms, stressing later that he was "never a flower child."

He explored Tibetan Buddhism, mingling its tenets—such as the concept of the "adept," an advanced yogi possessed of arcane knowledge passed down from teacher to pupil—with half-formed ideas scavenged from science-fiction novels (e.g., Olaf Stapledon's Odd John, source of the phrase homo superior, which turns up in "Oh! You Pretty Things"), Nietzsche, and theosophy about the existence of a gifted elite that has existed throughout history to oversee the fate of the planet and diffuse learning through the lower strata of society.

This kind of thinking was fashionable—indeed, everywhere—in late-'60s pop-intellectual circles. It's there in Colin Wilson; in hippie favorites Hermann Hesse and H. P. Lovecraft; and in the then bestselling novelist John Fowles's 1964 collection of philosophical maxims *The Aristos*, which draws on Heraclitus to posit an "elect" body of supermen who advance society in the face of a lumpen, ignoble mass content merely to exist. It's also there in Louis Pauwels and Jacques Bergier's treasury of conspiracist nonsense *The Morning of the Magicians*, translated into English in 1963 and a palpable influence on "Quicksand" from 1971's *Hunky Dory*.

For Bowie there may have been a personal dimension to this. The half brother he adored as a child developed schizophrenia in his twenties and spent much of his life in the hospital. In the *Daily Telegraph* the psychologist Oliver James wrote that Bowie "often wondered why he was chosen for greatness and Terry for madness." I don't think Bowie necessarily thought of himself at this stage as great or gifted. But he would have been aware that he was quick and bright; more charming, ambitious, and sexually charismatic than most of his peers.

Where these qualities would take him was anyone's guess. Bowie's natural egotism ran counter to the prevailing late-'60s mood of utopian leftism, notwithstanding his founding of an "arts lab"

in Beckenham to promote, as the blurb put it, "the ideals and creative processes of the underground." Another revealing moment in Green's book *Days in the Life* is when Sue Miles, wife of Barry Miles, cofounder of London's trendy Indica Bookshop and Gallery where John Lennon and Yoko Ono first met, remembers how obsessed she and her friends were with Alfred Jarry (the playwright and inventor of the mystical science pataphysics, studied by Joan in the Beatles' "Maxwell's Silver Hammer"), André Breton, and Marcel Duchamp—what she calls "that modern avant-garde stuff"—and how neatly it merged with what was going on politically at the time, for example campaigning against nuclear weapons.

What's interesting is how Bowie bought into "that modern avant-garde stuff" not to secure world peace or undermine capitalism but as a sort of mood board, a dressing-up box he could raid at will. As he put it a few years later in "All the Young Dudes," the glam anthem he wrote for Mott the Hoople, he never got it off on revolutionary politics. He just wanted to channel these mostly high-modernist influences, artists, and writers he admired for their daring and their extravagant sense of spectacle, into a new, knowing type of pop performance.

This isn't to say that Bowie wasn't genuinely on a quest, searching like Edward Casaubon in George Eliot's *Middlemarch* for a Key to All Mythologies. He found intellectual mentors in people like his early manager Kenneth Pitt, who remembered Bowie pulling from the shelves at his Marylebone flat three significant books: Antoine de Saint-Exupéry's *The Little Prince*, James Baldwin's *Nobody Knows My Name*, and Oscar Wilde's *The Picture of Dorian Gray*. Mime artist Lindsay Kemp kindled his interest in Japanese culture

and introduced him to figures such as Jean Cocteau and Jean Genet. In 1966 Bowie befriended the Tibetan guru Chime Rinpoche and even toyed with the idea of becoming a Buddhist monk himself. In terms of the list, his interest in Douglas Harding's Buddhist rumination On Having No Head (see p. 148) surely dates from this period.

Bowie's Buddhist phase has divided biographers. Was he a true believer or just posturing? If his Buddhism had its roots (as it probably did) in half brother Terry's passed-on love of Kerouac, then the appeal of Tibetan Buddhism, as opposed to the more Beatfriendly Zen variety, was that Tibet was a hot political cause in the mid-'60s. But Westerners had been romanticizing the country for years. James Hilton's bestselling novel Lost Horizon, published in 1933, gave the world the idea of the mythical Tibetan utopia of Shangri-la, one with which Bowie seemed smitten when in 1966 he told Melody Maker: "I want to go to Tibet. It's a fascinating place, y'know. I'd like to take a holiday and have a look inside the monasteries. The Tibetan monks, Lamas, bury themselves inside mountains for weeks, and only eat every three days. They're ridiculous—and it's said they live for centuries. . . ."

A book that isn't on Bowie's list but probably should be is the Austrian mountaineer Heinrich Harrer's memoir of his stint as tutor to the fourteenth Dalai Lama, Seven Years in Tibet, which Bowie named a song for on his 1997 album Earthling, telling a journalist around this time that it had been a very influential book for him when he was about nineteen and had left a lasting impression. In the years to come David Jones would enfold writers like Harrer and David Kidd (see p. 251) into the "Orientalist pioneer" side of his David Bowie persona.

As the fog of drugs descended during 1974's Diamond Dogs/Philly Dogs tour, this business of persona construction became increasingly fraught. The Thin White Duke character from the 1976 album Station to Station compounds all manner of unsavory types, from the nineteenth-century magus Eliphas Levi (who makes the list) to the openly fascist Norwegian modernist writer Knut Hamsun (who doesn't, though I'm convinced Bowie read him around this time) and the occultist's occultist Aleister Crowley (who doesn't feature either—surprisingly, given how obsessed Bowie was with him). Funnily enough, none of the occult- or Nazi-themed books it's often claimed Bowie read while he was cracking up in Los Angeles in the mid-'70s is there. There's no sign of The Morning of the Magicians, Israel Regardie's The Golden Dawn, Trevor Ravenscroft's The Spear of Destiny, or Dion Fortune's Psychic Self-Defense.

How to explain their absence? One possible explanation is that Bowie simply didn't want to revisit what he later came to regard as an awful, depressing period in his life by including a load of mostly dumb books that reminded him of it, however much they'd meant to him when he was out of his gourd.

What else did Bowie like to read? Stephen King, for starters. "I love Stephen King," he told Q in 1999. "He scares the shite out of me." He also liked true-crime books such as Vincent Bugliosi and Curt Gentry's bestselling Helter Skelter: The True Story of the Manson Murders, which Tina Brown saw in his hotel room with a half-eaten piece of cheese balanced on the cover when she went to Los Angeles to interview him for the Sunday Times in July 1975. (Brown calls

the book *Manson Murder Trials* and doesn't name the author, but she probably means *Helter Skelter*, as it won the Edgar Award for Best Fact Crime book that year.)

In 1978 Bowie told *Crawdaddy* magazine about the extraordinary effect Kafka's *Metamorphosis* had had on him, making him feel as if he was losing his mind: "I had vivid nightmares about that—literal translations of what he was writing about: of enormous bugs flying and lying on their backs and other creepy-crawly dreams. I saw myself become something unrecognizable, a monster."

Then there's the stuff Bowie read for laughs, for example the book he and his childhood friend Geoff MacCormack amused themselves by reciting chunks from on an Amtrak train from Philadelphia to Los Angeles in September 1974—a pornographic novel called Yodel in the Canyon. "The main characters in this classic piece of literature were Big Rod Randelli and his girlfriend Mona," recalls MacCormack. "I won't go into details but suffice to say, neither Rod nor Mona were shy folk."

A genre Bowie seems particularly to have loved is the exotic travelogue, represented on the list by David Kidd and Alberto Denti di Pirajno. Artist George Underwood, Bowie's friend since childhood, remembers that in 1989 when he visited Bowie at his house on Mustique, the singer was reading a book about the Victorian explorer and naturalist Alfred Russel Wallace's journey around Indonesia—almost certainly Wallace's own *The Malay Archipelago*. (Adds Underwood: "It wasn't until a couple of weeks ago, when I went on Amazon to look it up and maybe buy it, that I noticed Wallace had written another book about whether or not there was life on

Mars [this would be *Is Mars Habitable?*].... I wish I'd asked David whether he'd read that one as well!")

Bowie also recommended to Underwood *Skulduggery*, Mark Shand's account of his and photojournalist Don McCullin's journey through Irian Jaya, now West Papua. "David had met Mark Shand and was fascinated with Irian Jaya," says Underwood. "He phoned me after this meeting and wanted me to go with him to this uncharted territory. It would have meant going along the Sepik River in a dugout canoe and meeting up with natives who had never seen white men before. David said this would make men of us and it was something we should do before we died. He was totally serious about this and wanted me to go with him. Of course, it never happened, but for a moment I was considering it. A very short moment!"

Bowie had lots of writer friends and enjoyed literary gossip. His friendship with Hanif Kureishi began when the novelist requested permission to use his songs in the BBC's adaptation of his novel *The Buddha of Suburbia*. "I thought you'd never ask," Bowie replied—then provided an entire bespoke soundtrack.

Bowie seems to have had few serious literary ambitions for himself. In 1987 he told *Rolling Stone*'s Kurt Loder he'd been approached to write an autobiography "a *million* times. For *amazing* amounts of money." Was he tempted? "Not in the least." Perhaps this reluctance to compete on their turf gave his friendships with writers an ease and simplicity missing from his friendships with, say, rival rock stars. William Boyd, a fellow contributor to the magazine *Modern Painters* in the mid-1990s, says he and Bowie mostly discussed art, which led to their working together on the Nat Tate hoax of 1998 (see p. 22), as Boyd remembers:

I did talk to Bowie about books quite a lot. But it was on the gossipy level of "Have you read this? Do you know X? What's he/she like?" He always said he'd read all my books (and I used to send him the new ones) and yet I'm absent from his list. Go figure. Maybe he thought our collaboration on Nat Tate was enough—and time has proved him right. Frank O'Hara [see p. 21] appears in the book *Nat Tate: An American Artist 1928–1960*, of course, as does Hart Crane [see p. 205]. My recollection is that we spoke mainly about my contemporaries—[Martin] Amis, [Salman] Rushdie, [Ian] McEwan etc. I've checked my journals from the time I used to see him regularly and all the names bandied about are artists.

One novelist Bowie actively championed, though, like Boyd, didn't include on the list, is Jake Arnott, author of the atmospheric thriller *The Long Firm*. The novel is set in a 1950s Soho that would have been familiar to Bowie both from his half brother's stories of jazz clubs and espresso bars, and from what he called the "family mythology": As a young man, Bowie's father, Haywood Jones, frittered away several thousand pounds he'd inherited by opening a piano bar in Charlotte Street called Boop-a-Doop, which failed within a year.

"Bowie read an awful lot of books so it's no surprise if people like me and Hanif didn't make the top one hundred," says Arnott of Bowie's list. "I first heard he'd read *The Long Firm* from [film director] Stephen Frears. I met Frears at a book launch in 2000 and he said he'd seen Bowie reading it on [the] Concorde and Bowie had

said to him, 'It's very good!' I thought at the time that this was just the old film director's trick of blowing smoke up one's arse, but it turned out to be true."

Bowie and Arnott finally met backstage at Hammersmith Apollo and a generous blurb from the star—"Whenever he's got a new book out, I drop everything"—duly appeared on the cover of Arnott's 2003 novel *Truecrime*.

Happily, I also once got to meet David Bowie. It was in 2002, shortly before the release of his album *Heathen*. The magazine I was working for used to sponsor a music festival on London's South Bank called Meltdown. That year Bowie had agreed to curate it, so I flew to New York to talk to him in a hotel around the corner from his Manhattan apartment.

I was terrified. He'd been my hero since I was twelve. Now I was thirty. I didn't know what to wear, so from some trendy store I bought drainpipe jeans and a T-shirt with cuddly toys on it playing guitar, bass, and drums. I hoped this marked me out as a fan of the Strokes, which I recall I was, briefly. It was all a bit desperate.

Bowie was kind enough not to appear to notice any of this. I lost the tape years ago in a house move, so no evidence of our encounter survives beyond the printed interview, which mostly focused on his choice of artists for Meltdown. I remember him being friendly and polite—faultlessly so—but also a big character who filled the room. He was restless, jittery, and slightly manic, as if he'd just drunk several strong espressos, which he probably had.

More than anything, I remember thinking how funny he was:

properly stand-up-comedian funny. "I'd put Shirley Bassey in the Meltdown lineup if I thought it would drag in a few punters," he told me. (The festival had a reputation for sober worthiness.) "Shirley Bassey, with some Yugoslavian acrobats!"

Journalists who've interviewed Bowie often remark on the way he weighed you up and gave you the version of himself he thought you wanted—a trick he learned early on from Kenneth Pitt. I suppose I should be flattered that I got "Bromley Dave": matey banter interspersed with incongruous intellectual flourishes ("Of course, the tripartite view within Christian theology . . ."), all delivered in the broadest South London accent.

He looked really good for fifty-five. His hair was dyed ash blond and there were dabs of concealer on the bags under his eyes. But his body was as trim and wiry as ever. He'd finally given up smoking after numerous failed attempts. I was almost surprised when, two years later, he had his heart attack. This momentous, terrifying event precipitated the great hiatus in Bowie's career—a decade-long stretch during which, give or take the odd guest appearance, he concentrated his energy on being a husband and a father.

He also used the time to do what his long-standing producer Tony Visconti described to *The Times* as "a phenomenal amount of reading: old English history, Russian history, the monarchs of Great Britain—what made them bad and good." The books on the list published during this period—so he very likely read them then—are Junot Díaz's *The Brief Wondrous Life of Oscar Wao*, Tom Stoppard's *The Coast of Utopia*, Susan Jacoby's *The Age of American Unreason*, and Jon Savage's *Teenage*. Of these, only the

Stoppard fits any of Visconti's categories. But it's likely Bowie used his hiatus to read deeply around particular subjects, for example Russian history: this is probably when he tackled Orlando Figes's ginormous *A People's Tragedy*. You need time on your hands for that one.

Aging changes your relationship to history. As the bittersweet milestone of his seventieth birthday approached, perhaps it dawned on Bowie that a) a century isn't very long and b) far from being the main character in the film of his life—which illusion most of us have when we're young, regardless of how we make our living—he was really an infinitesimal part of a much bigger, older story, a revenge tragedy where everyone dies and keeps on dying, day after day, until the last syllable of recorded time.

One of his final songs, "Blackstar," squares up to this cosmic irony with the savage glee of a man who has nothing left to lose. The devilish trickster who takes over the narration halfway through—telling us he was born upside down and the wrong way round—is cancer: cells that have gone bad.

This isn't the story of David Bowie's life. You can find that in plenty of other places. But it is a look at the tools he used to *navigate* his life, not to mention a shot in the arm for the unfashionable theory, one I've always liked, that reading books makes you a better person. All biography junkies know how unusual it is for successful artists also to be successful human beings. After Bowie's death, grieving fans drew comfort from the fact that hardly anyone seemed to have a bad word to say about him. On the contrary, we heard again and again how loyal and loving he was, how kind, compas-

xxx 4 INTRODUCTION

sionate, wise, and funny. (And attractive. Let's not forget attractive. He'd hate that.)

How did David Jones turn out this way, despite the venality of the music industry, the derailing potential of his addictions, and his grand, even ruthless ambition to become the biggest star possible? It could be you're holding the answer in your hands.

Anthony Burgess, A Clockwork Orange (1962)

he debt owed by David Bowie's first hit song, "Space Oddity," to Stanley Kubrick's 2001: A Space Odyssey couldn't be more obvious. But Kubrick's next film, a chilly adaptation of Anthony Burgess's novel A Clockwork Orange, is where the story really gets interesting.

Set in a totalitarian, future-present Britain, A Clockwork Orange is the story of delinquent, Beethoven-loving schoolboy Alex, the leader of a gang that spends its nights raping and pillaging while wired on amphetamine-laced "milk-plus." Kubrick had set aside his planned biopic of Napoléon Bonaparte to make a movie version after being given a copy of the book by screenwriter Terry Southern, with whom he'd worked on *Dr. Strangelove*, and falling in love with

it. In 1972 Bowie repurposed its swagger and shock value for his career-making turn as "leper messiah" Ziggy Stardust, a bisexual alien rock star with fluffy red hair and a weakness for asymmetric knitted bodysuits who ends up being killed by his fans.

Ziggy was a collision of unstable elements—some obscure (drugaddled rocker Vince Taylor; American psychobilly pioneer the Legendary Stardust Cowboy), others less so. It's easy to see what Bowie took from Kubrick's movie because, like his hijacking of the melody from "Over the Rainbow" for the chorus of "Starman," the borrowing is so blatant. Bowie-as-Ziggy walked onstage to Beethoven's Symphony no. 9, as played by Moog synthesizer maestro Wendy Carlos, while his band the Spiders' costumes were modeled on those of Alex and his droogs—"friends" in Burgess's invented language Nadsat.

The early '70s was a grim, embattled era in England. John Lennon sang in 1970 that the (hippie) dream was over. But 1971 was the year things turned brutish as the alternative society splintered into a mass of competing factions such as the radical-left urban terrorists the Angry Brigade—Britain's answer to Germany's Baader-Meinhof gang—who launched a string of bomb attacks against Establishment targets. Kubrick's A Clockwork Orange came out in the UK in January 1972, five months before The Rise and Fall of Ziggy Stardust and the Spiders from Mars. The following year the director withdrew it from cinemas after receiving death threats; the gesture amplified the film's air of leering menace while saying a good deal about the febrile social climate.

Both the movie and its source novel celebrate the exquisite sense of belonging that being in a gang affords. But they're also interested in the aftermath: what happens when the gang dissolves and the power that held it together leaks away. You can, if you want, see Alex as Ziggy and his droogs as the Spiders—the fictional band, not Bowie's actual musicians Mick Ronson, Woody Woodmansey, and Trevor Bolder. In Bowie's opaque Ziggy narrative they're cast as bitter sidemen who bitch about their leader's fans and wonder if they should give him a taste of the old ultraviolence by crushing his sweet hands. . . .

The novel itself had a tragic genesis. The story goes that in 1959 Burgess was diagnosed incorrectly with terminal brain cancer. Spurred into action, he wrote five novels very quickly to support his soon-to-be widow. A Clockwork Orange took him three weeks and was inspired by a horrific incident in April 1944 where his first wife, Lynne, pregnant at the time—she subsequently miscarried—was assaulted in a blackout by a group of American soldiers. She'd been on her way home from the London offices of the Ministry of War Transport where she was involved in planning the D-Day landings. A Clockwork Orange is interested not just in what might drive someone to carry out this kind of attack, but also in the ethics of rehabilitation. Can you force someone to be good by torturing them, as per the Ludovico Technique aversion therapy Alex undergoes?

If Burgess and Kubrick were equally important to Bowie, it's worth noting the differences in their visions, differences Burgess considered so stark he ended up renouncing the novel because he felt the film made it easy for readers to misunderstand the book. He meant that his handling of sex and violence was more nuanced than Kubrick's, which might be true, though in some ways the novel is nastier—for example, the scene where Alex rapes two underage girls after getting them drunk. In the movie they are clearly adult

women, the sex is clearly consensual, and Kubrick uses a fast-motion technique to blur the action and create a slapstick tone.

The biggest difference, though, has to do with the ending. The British edition of the novel ends on an optimistic note, with Alex turning his back on violence and contemplating fatherhood. But the original US edition on which Kubrick based his screenplay omits this epilogue. It ends with Alex saying sarcastically, "I was cured all right," having just shared with us his dream of "carving the whole litso [face] of the creeching [screaming] world with my cut-throat britva [razor]."

Burgess had been intrigued by the razor-packing teddy boys of the late 1950s. Kubrick picked up on the androgyny of the mod culture Bowie flirted with in the mid-1960s. For example, Kubrick turned Alex's false eyelashes-bought in bulk from hip London boutique Biba, bombed by the Angry Brigade shortly after the shoot concluded-into a key visual motif. Nadsat, the Anglo-Russian slang spoken by Alex, crops up in "Suffragette City." But the way Bowie used it decades later in one of his final songs, "Girl Loves Me," suggests a deeper appreciation that leads back to the rich linguistic textures of the novel. For in "Girl Loves Me," Bowie mixes it knowingly with the secret gay language Polari, reinforcing the cultural historian Michael Bracewell's point that A Clockwork Orange was an audit on modern masculinity. Finding men to be in crisis, the movie hastened the birth of a new kind of loner—the young soul rebel, who offset corruption with an intense emotional idealism. That sounds like Bowie to me.

Read it while listening to: "Girl Loves Me," "Suffragette City" If you like this, try: Graham Greene, *Brighton Rock*

Albert Camus, The Outsider (1942)

Bowie probably came to Camus's slender classic via the 1950s bestseller whose title it shares, Colin Wilson's *The Outsider* (see p. 30). Wilson admired Camus but used the French writer's philosophy, often called existentialist, though Camus disliked the term, to feed his own romantic concept of "outsiderdom" as the aloof superiority of a select few. Camus's *The Outsider* (*The Stranger* in the US) is subtler than this. In fact, its small but crucial ambiguities of language and tone make it one of those rare novels that feel different every time you read them.

Existentialism stressed the importance of free will and personal responsibility and was therefore impossibly exciting to teenagers trapped in suburbs they hated—Bromley, in Bowie's case—with parents who were likely to be clapped-out conformists drunk on war nostalgia. It legitimized clever, driven teenagers' sense of uniqueness; of being able to understand, as others could not, the absurdity at the heart of everything. Once, these teenagers had identified themselves as Beats. (In Germany they were actually called Exis—Astrid Kirchherr, the photographer who, in Hamburg, gave

the Beatles their mop-top haircuts, was an Exi.) By the time Bowie was old enough to join in the fun they had morphed into mods. He embraced the subculture enthusiastically, especially its uniform of drainpipe jeans, tailored jackets, and half-inch-wide ties.

The Outsider is the story of Meursault, a Frenchman living in colonial Algiers. He's a curious character—blank, inert, slightly cold. His fatal flaw is his inability to dissemble. When his mother dies, he doesn't much care so doesn't bother to pretend otherwise. When his girlfriend Marie asks him if he loves her he says no, because he doesn't. He drifts into a friendship with a violent neighbor, Raymond, and as a result ends up one boilingly hot day on a beach where he shoots dead an Arab man-not because he feels threatened or afraid, but because killing him is as easy as not killing him, and anyway the dazzling reflection of the sun on the man's blade was annoying. In court, Meursault refuses to express regret either for the shooting or for his mother's death and so is found guilty and sent to the guillotine. He has disrespected convention and, as Camus archly put it in an afterword, a man who doesn't cry at his mother's funeral is pretty much asking to be executed.

But *The Outsider* raises too many questions for this to be the end of the matter. Is Meursault a psychopath? What was the nature of his relationship with his mother? Why, having killed the Arab man with his first shot, did he fire four more bullets into his body? Why is the Arab man simply called "the Arab" throughout? Is it a deliberate distancing effect or racism? If the latter, *whose* racism, Meursault's or Camus's? There's endless food for thought here about motive, conscience, and the arbitrariness of rules.

BOWIE'S BOOKSHELF 4 7

"I've always felt comfortable with writers like Camus," Bowie told *Soma* in 2003. "But people would read that as being so negative. And it wasn't! It just made absolute sense, what he had to say."

Read it while listening to: "Valentine's Day"

If you like this, try: Jean-Paul Sartre, Nausea

Nik Cohn, Awopbopaloobop Alopbamboom (1969)

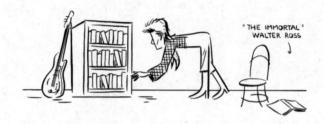

ournalist Nik Cohn had just turned twenty-two when he holed up in a rented house in Connemara on Ireland's west coast and bashed out *Awopbopaloobop Alopbamboom*, arguably the first piece of serious, long-form writing about pop music. Looking back now on the period Cohn has in his sights—1968, the year of the Beatles' *White Album* and the Rolling Stones' *Beggars Banquet*; Marvin Gaye's "I Heard It Through the Grapevine" and Sly and the Family Stone's "Dance to the Music"—it's clear pop had hardly gotten going. David Bowie, for one, had yet to grace the UK Top 40. But to Cohn it felt as if the fun had gone out of the scene.

The book reads accordingly. It's downbeat, resigned—even about the Beatles, whom Cohn loves but whose later work he feels has been contaminated by acid-fried arrogance and pomposity. Nothing will ever be as good again as Elvis's "great ducktail plume and lopsided grin," Phil Spector's "beautiful noise," and of course Little Richard, who was for Cohn what he was for Bowie: the most exciting live performer he ever saw in his life. Heartbreaking stuff, yet much of it is, to borrow Evelyn Waugh's phrase, a panegyric preached over an empty coffin. The solemn prog rock Cohn hated so much-Pink Floyd he finds "boring almost beyond belief"—never became the dominant strain. Not long afterward, glam and then punk would supply threeminute thrills aplenty. Disco, with its cult of the extended remix, stretched out the ecstasy even longer, and here Cohn was an accidental prime mover: Saturday Night Fever, soundtracked so miraculously by the Bee Gees, was based on "Tribal Rites of the New Saturday Night," an article about the New York disco scene Cohn wrote for New York magazine in 1976, although he later admitted to making most of it up and basing Vincent, the main character, on a mod he'd known in Shepherd's Bush over a decade before.

A refugee from sectarian Derry, in Northern Ireland, Cohn arrived back in London where he'd been born aged seventeen. In no time he'd become an ace face who wrote about youth for *The Observer* and rock music for *Queen*, the society magazine behind pirate radio station Radio Caroline. *Awophopaloobop* is full of sharp, merciless judgments: poet Allen Ginsberg is "a bit of a joke but a good one," the Doors "sexy but unclever." Cohn is funny about one of Bowie's favorite bands, Deptford-hailing R&B stalwarts turned psychedelic rock visionaries the Pretty Things: "Man, they were ugly. I mean, really ugly—Phil May, the singer, had a fat face, entirely hidden by hair, and he'd bang about the stage like some maimed gorilla." None of

this stopped people falling over themselves to secure his endorsement. Cohn's obsession with pinball prompted Pete Townshend to write "Pinball Wizard" for last-minute inclusion on the Who's *Tommy* after the writer criticized a rough mix of the album as stuffy and pompous.

In all likelihood Bowie not only read Awopbopaloobop the second it came out but also studied it as a manual. Another alleged source for Ziggy is the hero of Cohn's 1967 novel about a self-destructive rock star, I Am Still the Greatest Says Johnny Angelo. The book describes Johnny, based on the mid-'60s star P. J. Proby, as "all things at once, masculine and feminine and neuter, active and passive, animal and vegetable, and he was satanic, messianic, kitsch and camp, and psychotic, and martyred, and just plain dirty."

Cohn's and Bowie's paths crossed vaguely in 1974, though it wasn't Cohn who benefited. Cohn had just collaborated with the Belgian artist Guy Peellaert on the bestselling book *Rock Dreams*—a series of tableaux of rock stars in situations inspired by their lyrics or reputations. Bowie loved it so much, he commissioned Peellaert to design the sleeve for *Diamond Dogs*, beating Mick Jagger, who had wanted him to do the Rolling Stones' *It's Only Rock 'n Roll* cover first.

To my knowledge, Cohn never wrote about Bowie—he'd lost interest in pop music by the time Bowie became successful—but he was complimentary about the singer after his death, telling the *Irish Times* that Bowie "always seemed to have one foot strongly in the street, and to have a very strong sense of what was going on down there."

Read it while listening to: "Let Me Sleep Beside You"

If you like this, try: Lester Bangs, Psychotic Reactions and
Carburetor Dung

Dante Alighieri, Inferno (c.1308-20)

bandon hope, all ye who enter here. . . ." This inscription, seen by Dante on a ledge above the gate of hell, is the line everyone knows from *Inferno*, the first part of Florentine writer Dante Alighieri's allegorical poem *Divine Comedy*, a thrilling, surprisingly accessible summary of late-medieval European thinking about religion, art, science, politics, and love.

Dante is thirty-five, "midway along the journey of our life," when he wakes to find himself lost in a dark wood on the rim of the underworld. He's rescued by the ghost of the Roman poet Virgil, who's been sent by Dante's ideal woman, Beatrice—in real life Beatrice Portinari, a banker's daughter with whom Dante was infatuated but who died aged twenty-four in 1290. Together they descend into the darkness of the Inferno, the prelude to subsequent trips to the mountainous in-between zone of Purgatory and, finally, Paradise.

Dante's cosmology is precise and symmetrical, the kind we know from the books on Bowie's list about esoteric religion and the occult that the musician preferred in his younger days. For Dante, hell isn't other people; it's an actual physical place formed of nine concentric circles of increasing horribleness, starting with the premium-economy heaven of Limbo and ending with the cattle class of Treachery, home to Brutus, Cassius, Judas Iscariot, and, frozen in icy mud at the center of it all, Lucifer, with his three faces and bat-like wings: "He wept with all six eyes, and the tears fell over his three chins mingled with bloody foam."

Some of the *Inferno* is genteel. Some of it pokes scabrous fun at corrupt popes and political figures. Most appealing to modern sensibilities is the body-shock horror of, for example, Canto XXXIV, in which Dante and Virgil escape from the lowest circle of hell, "the deepest isolation," by sliding down Lucifer's furry body "tuft by tuft."

This kind of graphic, tactile imagery made *Inferno* a gift for future illustrators such as William Blake, Gustave Doré, and Salvador Dalí. Their literal interpretations of Dante's symbolic landscapes fed into the "hollow earth" science-fiction stories of Jules Verne, Edgar Rice Burroughs, Edward Bulwer-Lytton, et al., that Bowie loved. But he also loved surrealism and would have been aware that in the 1924 *Manifesto of Surrealism* the movement's principal theorist, André Breton, placed Dante at number one on his list of proto-surrealists ahead of the Comte de Lautréamont, whose Bowie-approved *Les Chants de Maldoror* (see p. 72) is like a clever child's dashed-off approximation of Dante's masterpiece.

At heart, the *Divine Comedy* is a poem about love, for God and for Beatrice—the prettiest star, a "fair, saintly Lady" with the voice of an angel who intercedes to save Dante at the point when he seems

BOWIE'S BOOKSHELF # 13

most lost. Was Dante one of the reasons Bowie and Iman chose to have their marriage solemnized in Florence in June 1992?

Read it while listening to: "Scary Monsters (and Super Creeps)"

If you like this, try: William Langland, Piers Plowman

Junot Díaz, The Brief Wondrous Life of Oscar Wao (2007)

Bowie fashioned his most memorable personae out of the science fiction he consumed in his youth—for example, the groundbreaking BBC drama *The Quatermass Experiment*, about a manned space flight that goes horribly wrong, which he recalled watching from behind the sofa aged six when his parents thought he'd gone to bed. An obsession with space, estrangement, and alternative worlds runs through his work from "Space Oddity" at one end to "Blackstar" at the other. So he would have empathized deeply with the plight of nerdy, overweight misfit Oscar de León, the Dominican-American hero of Junot Díaz's Pulitzer Prizewinning novel.

Young Oscar loves science fiction and fantasy—all of it, even obscure British stuff like the BBC TV drama *Blake's 7*, which ran from 1978 to 1981. When other children are playing wallball and pitching quarters, Oscar is steaming through the canon (H. P. Lovecraft, H. G. Wells, William S. Burroughs, Robert E. Howard, Frank Herbert, Isaac Asimov, Ben Bova, Robert Heinlein), fortunate that

the local libraries are so underfunded they can't afford to throw anything out. As a schoolboy growing up in New Jersey during the 1980s he is tormented for this, which only drives him deeper into himself, deeper into movies about doomsday devices and mutants and magic.

There's more to it than that, though. Sci-fi and fantasy are the only genres capable of reflecting the vicious, parallel-universe quality of life in the country Oscar's family comes from, the Dominican Republic, under dictator Rafael Trujillo, compared in the novel to Sauron from The Lord of the Rings. Like Anthony Burgess's Earthly Powers (see p. 264), The Brief Wondrous Life of Oscar Wao suggests that human affairs are ultimately governed by supernatural, indeed diabolical forces, in this case a curse called fukú, which was placed on the New World by colonizing Europeans.

Bowie's nerdery was every bit as epic as Oscar's, although considering how much of his life the singer spent pretending to be an alien there's surprisingly little sci-fi on the V&A list. Nothing by fellow Bromley-hater H. G. Wells or Bowie's occasional Los Angeles dining companion Ray Bradbury. No sign of Heinlein's Starman Jones—which he must have read!—or Stranger in a Strange Land, whose messiah-from-Mars plot has more than a whiff of Ziggy Stardust about it. Bowie's Ziggy-era manager Tony Defries even had plans for a movie version in which the singer would make his Hollywood debut as its hero, Mars-born-and-raised humanoid Valentine Michael Smith.

For Oscar, the tragedy of his obsession is that it makes him invisible to girls—not a problem the teenage Bowie ever had (and *his* idea of a date was going UFO-spotting on Hampstead Heath). So

depressed does Oscar feel after one of his sort-of-but-not-really girl-friends, Jenni, dumps him for a tall punk boy who looks like Lou Reed that he jumps in front of a train, ignoring the entreaties of a mystical golden mongoose that has appeared beside him and which stands for zafa, the counterspell that stops $fuk\acute{u}$.

Yunior, Oscar's university roommate, visits him at home afterward. (Our hero has survived the accident but broken both legs.) Yunior notes the X-wings and TIE fighters still hanging from the ceiling; also that of the sundry names scrawled on Oscar's cast, only two are real—the others are the forged signatures of Oscar's sci-fi writer heroes (who also happen to be Bowie's). It's a poignant, revealing moment in a dazzling multigenerational saga of immigrant life, love, and loss.

Read it while listening to: "The Supermen"

If you like this, try: Jeffrey Eugenides, Middlesex

Yukio Mishima, The Sailor Who Fell from Grace with the Sea (1963)

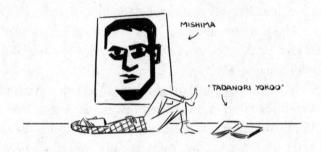

n the Berlin flat where he lived while he was recording "Heroes", Bowie slept beneath his own painting of Yukio Mishima, the handsome Japanese multihyphenate (author, actor, playwright, singer, terrorist) who committed suicide by hara-kiri in November 1970 after he and four members of his Tatenokai private militia failed in their attempt to incite a coup intended to restore the power of Japan's emperor.

What did Bowie find so admirable in Mishima's warrior machismo? Perhaps the fact that it was so obviously a performance. Film historian Donald Richie, who knew Mishima, thought him a dandy whose talent was bound up with his understanding that if

you behave the way you want to be, you will become it: you become who you are by practicing.

As a child, Kimitake Hiraoka—Yukio Mishima was a pseudonym—was raised in isolation by his deranged, bullying grandmother Natsu, who refused to let him play with other boys or be exposed to sunlight. Encouraged by her, he read everything he could lay his hands on and emerged a model of poised, precocious elegance. To exorcise his shame at having been rejected by the army on health grounds, an event recounted in his semiautobiographical first novel *Confessions of a Mask*, he transformed his weedy body into a solid knot of muscle. He learned the ways of the samurai, becoming skilled at kendo (swordsmanship).

Despite having a wife and two children, Mishima was openly gay rather than bisexual; he rationalized this paradox in a later autobiographical work, *Sun and Steel*, as a means of embracing contradiction and collision. (Another key scene in *Confessions of a Mask* is his first, explosively successful attempt at masturbation, electrified by a painting of St. Sebastian pierced all over by arrows.) To please his ailing mother, his marriage was an arranged one, in traditional Japanese fashion. Among Mishima's requirements were that his bride should be no taller than he; pretty, with a round face; and careful not to disturb him while he worked. Eventually he settled on Yoko Sugiyama, the twenty-one-year-old daughter of a popular Japanese painter.

Having himself come out as bisexual in 1972, albeit in what was felt to be a publicity stunt, Bowie was still talking up his fluidity four years later. His gay side was mostly dormant, Bowie explained to nineteen-year-old Cameron Crowe in a deliberately outrageous

interview in the September 1976 issue of *Playboy*, but visiting Japan always roused it reliably: "There are such beautiful-looking boys over there. Little boys? Not that little. About 18 or 19. They have a wonderful sort of mentality. They're all queens until they reach 25, then suddenly they become samurai, get married and have thousands of children. I love it."

An allegory of Japan's postwar humiliation not usually ranked among Mishima's best works, *The Sailor Who Fell from Grace with the Sea* has the brutal symmetry of one of the Grimms' fairy tales Mishima devoured as a child. It unfolds in a suburb of Yokohama in the aftermath of the war. Fusako, a widow who runs a store selling European luxury goods, takes a sailor, Ryuji, as a lover. Her son Noboru watches them have sex through a peephole in his room. At first Noboru idolizes Ryuji as a hero who has traveled the world, but the next day, on the way back from killing and vivisecting a stray kitten with his sociopathic school friends, he meets Ryuji again and decides he is weak and ineffectual because he has sprayed water on himself to keep cool.

Ryuji swaps his seafaring life for domestic security with Noboru's mother. But Noboru is unimpressed, even more so when Fusako catches him looking through the peephole a second time, and Ryuji refuses to punish Noboru despite Fusako's urging. Noboru and his gang decide to restore Ryuji's lost honor by giving him the full kitten treatment.

Anyone who managed to miss the Mishima-ish themes (affronted honor, repressed homosexuality) of Nagisa Oshima's Second World War drama *Merry Christmas Mr. Lawrence*, in which Bowie played imprisoned British officer Major Jack Celliers, could find elucida-

20 4 John O'Connell

tion in the title of David Sylvian and Ryuichi Sakamoto's haunting theme song—"Forbidden Colors," after Mishima's novel of the same name. Bowie himself returned to Mishima on 2013's *The Next Day*, borrowing *Spring Snow*'s ominous image of a dead dog obstructing a waterfall for the lyrics of the sparse, Scott Walker–style "Heat."

Read it while listening to: "Blackout"

If you like this, try: Yukio Mishima, Confessions of a Mask

Frank O'Hara, Selected Poems (2009)

as a New Yorker, Bowie was drawn to the languid comic perfection of Frank O'Hara, unofficial laureate of everyday life in the city. O'Hara transfigures the humdrum so that a lunch break spent walking along a sidewalk where "laborers feed their dirty / glistening torsos sandwiches / and Coca-Cola, with yellow helmets / on" glows in the memory. It's hard to believe O'Hara lived in New York for only fifteen years, from 1951 until his premature death in 1966, after being hit by a jeep on a beach.

In a speech she gave marking Lou Reed's induction into the Rock & Roll Hall of Fame in 2015, Patti Smith mentioned that Reed had been a fan of O'Hara and could quote him by heart, which makes sense and sheds new light on the urban, ironic strain in Reed's writing, as seen, for example, in "New York Telephone Conversation" from his Bowie-produced album *Transformer*. O'Hara and other New York School poets such as Kenneth Koch and John Ashbery were part of the avant-garde world that gave birth to the Factory (Warhol associate and key Factory player Gerard Malanga was taught by Koch) and the Velvet Underground.

Additionally, O'Hara has an entertaining cameo in *Nat Tate: An American Artist* 1928–1960, William Boyd's spoof biography. Boyd's coconspirator in this 1998 plot to trick the New York art world into applauding an artist who had never actually existed was David Bowie, who wrote the preface and published the book through his company 21. After describing O'Hara, entirely accurately, as "a key link in the chain that bound the world of literature to that of contemporary painting," Boyd notes with the straightest of faces that it was O'Hara's enthusiasm for Tate that encouraged the (fictional) gallerist Janet Felzer to show Tate's work at her (fictional) Aperto Gallery on Hudson Street. . . .

O'Hara produced poems with supernatural facility, if not consistent quality control. After leaving the navy, he studied at Harvard courtesy of the G.I. Bill, then moved to New York, where he invented himself as an arch, combative face on the scene, part of a milieu that included Jackson Pollock and Willem de Kooning. He combined his writing with a job as assistant curator at the Museum of Modern Art.

Just as most people know Philip Larkin from his poem "This Be the Verse," they know O'Hara from "Having a Coke with You," its fluid, conversational quality enhanced by the lack of formal poetic scaffolding. It's a poem about reveling in the sensual moment, the *aesthetic* moment, hoping it will endure as surely as art endures, but knowing deep down that it won't. As Bowie knew, you can't rely on moments to endure. Only by keeping moving can you guarantee that you are truly alive.

Read it while listening to: "It's Hard to Be a Saint in the City" (cover of Bruce Springsteen song)

If you like this, try: Ted Berrigan, The Sonnets

Christopher Hitchens, The Trial of Henry Kissinger (2001)

Sometimes you just want the lights to go down and the show to begin. In *The Trial of Henry Kissinger* the late British journalist, best known for his *Vanity Fair* columns, deliberately provocative opinion that women aren't funny, and penchant for booze and cigarettes, steamrolls the former US national security advisor and secretary of state for presidents Richard Nixon and Gerald Ford with a polemical brilliance so assured it cancels out the occasional flashes of arrogance and pomposity.

Hitchens's charge sheet is long, if deliberately incomplete: he's only interested in offenses that could form the basis of a prosecution. He accuses Kissinger of helping to sabotage the 1968 Vietnam peace talks and so allowing the war to run on for another seven slaughter-filled years; of ordering the bombing of Cambodia and Vietnam for no good reason; and of involvement in the attempted assassination of Cyprus's Archbishop Makarios and the actual killings of the Chilean economist Orlando Letelier and the commander-in-chief of the Chilean army René Schneider. And that's just for starters.

Little of this was new or unknown when the book was published in 2001. But that is Hitchens's point. Those who could have done something about it averted their gaze, believing that the sanctity of the American empire was more important. The 1998 arrest of the Chilean dictator Augusto Pinochet—in London, at the request of Spain—set a new precedent, overturning the traditional defense of "sovereign immunity" for state crimes. On a global stage, America has more than once operated on the assumption that it is morally superior to other countries. How, Hitchens argues, can it sustain this pretense when a war criminal of the caliber of Adolf Eichmann (as Hitchens sees Kissinger) is permitted to walk free?

Like Howard Zinn (see p. 241) and James Baldwin (see p. 82), Hitchens is made furious by the sort of unthinking patriotism that drowns out honest accounts of how America has sometimes behaved toward its enemies. As someone who loved America, a country that for all its faults "filled a vast expanse of my imagination" (as he once told Alan Yentob), it's likely Bowie felt this fury too.

Read it while listening to: "This Is Not America"

If you like this, try: Christopher Hitchens, Hitch-22

Vladimir Nabokov, Lolita (1955)

welve-year-old Dolores "Lolita" Haze was Vladimir Nabokov's passport to acclaim and notoriety. She's the hapless prey of Lolita's hero-narrator Humbert Humbert, an academic and minor poet living off a legacy who winds up in Ramsdale, New England, lodging with a wealthy widow, Charlotte Haze. He marries Charlotte, but it's her daughter he really wants. For Humbert is a pedophile obsessed with girls aged between nine and fourteen whom he designates "nymphets." After Charlotte's death—she is killed rushing across the road to post letters denouncing Humbert, whose true nature she has just discovered—Humbert takes Lolita on an American motel odyssey, only for her to abandon him for a playwright, Clare Quilty. . . .

Queasily for the reader, Humbert is terrific company—ironic, smug, contemptuous, snobbish, narcissistic. His old-world disdain for American consumerism is hilarious. Nabokov's masterful language, ripe with clever wordplay and allusion, dazzles us and draws us into complicity with this monster, this serial rapist of children.

In 1959, flush from the success of Lolita, Nabokov moved from

the US back to Europe and a sixth-floor suite at the Montreux Palace Hotel in Switzerland, not far from Bowie's house in Lausanne; although by the time Bowie moved there, Nabokov was dead. For years the Penguin edition of *Lolita* featured on its cover the painting *Girl with Cat* (1937) by another of Bowie's Swiss neighbors, the reclusive artist Balthus, whom Bowie interviewed at length for *Modern Painters* magazine in 1994.

Nabokov cut a grand, regal figure. "I don't think an artist should bother about his audience," he told the BBC's *Listener* magazine. "His best audience is the person he sees in his shaving mirror every morning." After the debacle of the 1980s and dud albums like *Tonight* and *Never Let Me Down*, Bowie came to share this viewpoint: "All my big mistakes are when I try to second-guess or please an audience," he admitted in 2003 to *The Word* magazine. "My work is always stronger when I get very selfish about it."

Read it while listening to: "Little Bombardier" If you like this, try: Vladimir Nabokov, Pale Fire

10

Martin Amis, Money (1984)

he corrosive effect of money and the things it can buy you—sex, drugs, and drink—is the subject of *Money*, Martin Amis's best-loved novel. The transatlantic tale of commercial director John Self and his efforts to cast and finance his first proper feature film is told by Self himself in an exotic, lyrical slang (a haircut is a "rug rethink"; New York police cars are "pigs' cocked traps ready for the first incautious paw") that owes a lot to Tom Wolfe. And Nabokov. But mostly Tom Wolfe.

Self is consumed by consumerism, so distracted by money and stupefied by porn and bad TV that he forgets to notice *anything*. "What is this state," he asks himself in a rare moment of self-awareness, "seeing the difference between good and bad and choosing bad—okaying bad?" He ends up the dupe of almost everybody, especially movie producer Fielding Goodney, who orchestrates his downfall with magisterial relish.

Bowie understood money's dubious lure. In October 1982, unbound finally from an onerous contract to a former manager, he signed a new deal with EMI worth a reputed \$17 million; made

his most commercial record, *Let's Dance*; and launched the Serious Moonlight tour, his biggest to date. Sixteen countries, ninety-six performances, every ticket sold. By the end of 1983 he was a bigger star than ever. But success, which he never expected on this scale, rattled him. He found himself rich but anxious and, for the first time in his career, bored.

With his friend Iggy Pop in tow he headed for Canada, where, in between bouts of skiing, clubbing, and chasing women, he cut the bland, phoned-in *Tonight*, which received some of the poorest reviews of his career and sold only a fraction of the seven million copies shifted by *Let's Dance*. It ushered in a creative slump that lasted well into the next decade.

Several years before *Money* came out, Bowie had an awful experience playing a Prussian soldier opposite Marlene Dietrich in David Hemmings's film *Just a Gigolo*. The pair never actually met: Dietrich, who was paid \$250,000 for two days' work, insisted all her scenes be shot in Paris, where she lived, rather than in Berlin, where the rest of the cast and crew were based. As a result, she and Bowie never appear on-screen at the same time, even when they're in the same scene. Critics were merciless and the movie bombed. Which wasn't a surprise to Bowie. "Everybody who was involved in that film—when they meet each other now, they look away," Bowie admitted later to *NME*. "It was my 32 Elvis Presley movies rolled into one."

This personal knowledge of filmmaking's more wretched aspects would have intensified Bowie's enjoyment of *Money*. Amis based much of it on his experience of working as a screenwriter on *Saturn 3*, a low-budget British space movie blighted by rows between

BOWIE'S BOOKSHELF 4 29

its director and its aging but virile star Kirk Douglas—the inspiration for Lorne Guyland in *Money*, who needs constant reassurance and insists Self include a scene where he fights his twenty-year-old costar Spunk Davis in the nude.

Read it while listening to: "Tonight"

If you like this, try: Tom Wolfe, The Bonfire of the Vanities

11

Colin Wilson, The Outsider (1956)

n 1981, at a party at Bowie's loft in Manhattan, former Blondie bassist Gary Lachman got into an argument with the singer about Colin Wilson. "He goes around at night and traces pentagrams on people's doorsteps," Bowie told Lachman. "He draws down the ectoplasm of dead Nazis and fashions homunculi." Lachman replied that he didn't think Wilson was into that sort of thing. "Oh yes he is," said Bowie. "I know for a fact that he heads a coven in Cornwall." When Lachman disagreed again, he was asked to leave by two assistants.

Who is Colin Wilson? You might well ask. For about six weeks in 1956 he was the most famous intellectual in Britain. His big success was *The Outsider*, an ambitious study of nihilistic loners in art, literature, and philosophy from Albert Camus (see p. 5) to Nietzsche, Heidegger, and Dostoevsky. A firm believer in his own genius, Wilson was an autodidact who left school at sixteen and avoided national service by pretending to be gay. He wrote *The Outsider* in the Reading Room of the British Museum while living in a sleeping bag on Hampstead Heath. Glowing reviews sent it to the top of the bestseller lists.

Closer inspection revealed it to be a bit rubbish—"second-rate, off-the-peg philosophy from start to finish," as the critic Terry Eagleton recently put it in *The Guardian*—and Wilson's second book, *Religion and the Rebel*, flopped resoundingly. But for generations of students *The Outsider* has functioned more or less effectively as a primer on existentialism in its most romantic-heroic mode. And the outsider as defined by Wilson does sound distractingly like Bowie, or at least how Bowie chose to project himself at various points in his career: "The Outsider is not sure who he is. He has found an 'I' but it is not his true 'I'. His main business is to find his way back to himself." Over time, Wilson's repertoire expanded to include serial killers, UFOs, Nazis, and the occult—all big Bowie obsessions.

Disappointingly for Bowie, when the film director Nicolas "The Man Who Fell to Earth" Roeg ran into Wilson and mentioned that Bowie was a fan, Wilson replied that he was unable to return the compliment as he had no interest in rock music and no idea who David Bowie was.

Read it while listening to: "Space Oddity"

If you like this, try: Colin Wilson, The Occult: A History

12

Gustave Flaubert, Madame Bovary (1856)

Suburban Bromley isn't so different from the flatlands of nineteenth-century Normandy. The daydreaming heroine of Flaubert's satire on provincial life—which is to say, life outside Paris—isn't so different from the daydreaming heroine of Bowie's song "Life on Mars?" Henry James's complaint about *Madame Bovary* was that, in spite of everything, its low-key story of a flighty girl's unhappy marriage to a second-rate doctor was "really too small an affair." Emma Rouault—soon to become Emma Bovary—has black hair, of course; not mousy. But both women crave sensation and escape, oscillating between ennui and an intense romantic longing that in Emma's case ends in the tragedy of her suicide.

The girl with the mousy hair struggles through a film too boring

to hold her attention: it doesn't take her anywhere new, just reflects her lived experience. Emma devours books, but the wrong sort—trite, silly, romantic ones. They fill her head with false ideas, unrealistic expectations, not the least of which is that adultery will be more interesting than marriage to Charles. Her romance has taken away her individuality and made her the third Madame Bovary in the book after her mother-in-law and Charles's dead first wife, whose ancient wedding bouquet she finds in a drawer—an agreeably gothic touch. Although Emma comes to realize she's trapped in a kind of hell, married to a dullard she despises, she lacks the intellectual wherewithal to plot a breakout more sophisticated than consorting with idiots such as Léon and Rodolphe.

Madame Bovary is a novel about thwarted escape and the dangers of indiscriminate reading. Mostly, though, it's about the lure of illicit sex, the reason Flaubert was prosecuted for obscenity in January 1857. It's a description borne out by its most famous scene, in which Emma and Léon shudder around Rouen for hours in a horse-drawn cab, blinds firmly down, shouting at the coachman whenever he threatens to stop.

"Madame Bovary, *c'est moi*," Flaubert famously declared—and Bowie would have understood her frustration, her desperate longing for sensation. For Flaubert, however, the identification was so close that while he was writing Emma's death scenes—describing the inky taste of the arsenic, scooped in haste from the pharmacist's jar; her faltering heart "like the final echoing note of a distant symphony"—he was reported to have vomited repeatedly.

Read it while listening to: "Life on Mars?"

If you like this, try: Gustave Flaubert, Sentimental Education

Homer, The Iliad (8th Century BC)

The European canon starts here. Did Bowie come to *The Iliad* by way of Julian Jaynes's theories about the bicameral mind (see p. 115) or Camille Paglia (see p. 222), who discusses it in *Sexual Personae* and praises Homer's cinematic pictorialism? Maybe he just had a weakness for Greek epic poetry?

Attributed to the poet Homer, *The Iliad* tells of events at the close of the Trojan War and the Greek siege of the city of Troy. It's a bloody, bellicose roll call of mythic heroes. Of particular interest to Bowie would have been the relationship, sometimes glossed as gay, between the warrior Achilles and his best friend Patroclus. Achilles is set apart from other soldiers because of his enchanted armor—bronze, speckled with stars—which symbolizes his power. When Achilles refuses to fight one day after an argument with King Agamemnon, Patroclus borrows Achilles's armor and is therefore mistaken for Achilles by both sides. What's more, Patroclus actually derives power from the armor to the point where he starts to assume Achilles's fighting skills and mannerisms. Unfortunately, the god Apollo intervenes to assist the Trojans. He stuns Patroclus,

removing his helmet to expose him to the Trojan hero Hector, who kills him and steals the armor for himself.

There's a lesson here about the power of clothes, so crucial to the projection of personality, and how it not only waxes and wanes, but can be lost or transferred. The story also sheds light on Bowie's complicated relationships with Iggy Pop and Lou Reed—artists who influenced him, were eclipsed by him, then had their lost power restored through his intercession, becoming cooler in the 1980s and '90s as Bowie struggled to connect with the mainstream audience Let's Dance had won him.

The Iliad and its Homeric sibling The Odyssey were recited at feasts, festivals, and ceremonies by professional singers called *rhapsodes*, who accompanied themselves on lyres. These illiterate rhapsodes worked by conflating and elaborating existing songs, "composing" new versions in the act of performance in a manner that would have struck Bowie as quintessentially Beat.

Read it while listening to: "Wishful Beginnings"

If you like this, try: Madeline Miller, The Song of Achilles

14

James Hall, Hall's Dictionary of Subjects and Symbols in Art (1974)

As a young man, Bowie was ravenous for greater knowledge about art, a subject that fascinated him almost as much as music. Modern art, from impressionism onward, he found relatively easy to decode. But older art, the sort of art his parents' generation considered "real art," was different. Understanding its form was one thing. But what about its content?

One of critic George Steiner's worries (see p. 62) was that the art of the past had become incomprehensible to younger generations because of a decline in educational standards. At school, Steiner believed, children no longer studied the Bible or Greek and Roman literature as closely as they once had. Consequently, their ability

to "read" art grounded in biblical or mythological imagery was limited.

Teasing out this meaning requires *Hall's Dictionary*, a friendly, at-a-glance guide not to individual paintings as such, though it cites plenty of examples, but to symbols and themes in Western art. Thanks to Hall, nonspecialist art lovers can understand why a pig with a bell around its neck standing beside an old monk identifies that monk as St. Antony the Great—it's something to do with grazing rights—and work out what all those skulls, jugs, and bunches of grapes in Dutch paintings stand for. Equally, a character may sometimes mean *less* than we think: Venus turns up everywhere but, as Hall explains, often has no symbolic resonance whatsoever. She's just, well, a naked woman.

For all his air of patrician authority, Hall was not a trained art historian but a production manager at the publishing firm J. M. Dent & Sons who had left school at seventeen and taught himself everything he knew by wandering around London's museums and galleries—Dent's office was in Covent Garden—during his lunch break. The book took Hall several long years to write. He would work on it early in the mornings before catching the train into town from his home in Harpenden. After it was published, art experts couldn't believe that it hadn't been written by one of their own kind.

Bowie loved the potency of traditional art symbols, perhaps because of the freight they carried from having been around so long. They crop up in stage shows, album artwork, and videos throughout his career. But he used them in a more careful, concentrated way in the extraordinary videos for "Lazarus" and "Blackstar." With Hall's help we can deduce that Button Eyes, the blindfolded beg-

38 4 John O'Connell

gar character Bowie plays in both videos, is either a saint about to be executed or a symbol of spiritual or moral blindness. Although in the "Lazarus" video it's all too clear what the skull on the desk means as Bowie sits scribbling frenziedly, desperate to commit his final ideas to paper. . . .

Read it while listening to (and watching the video for): "Lazarus" If you like this, try: E. H. Gombrich, *The Story of Art*

15

Saul Bellow, Herzog (1964)

Saul Bellow's sixth book, *Herzog*, appeared the same year as Andy Warhol's Brillo Boxes and Bob Dylan's first entirely self-penned album *The Times They Are a-Changin*'. On the face of it, this expansive but interiorized novel of Jewish-American intellectual life has little in common either with them or with the Beatnik mirage Bowie's brother Terry would have been selling him around this time.

But *Herzog* has the same speedy jazz energy as Kerouac's *On the Road*; the same sense of a whole fizzing, multitudinous world being drawn into a single person's field of vision; the same awareness of that world's ability to drive you insane.

Herzog is exhausting and inexhaustible, as dense and learned as it is sensual and hilarious. Its antihero is an anxious middle-aged Jewish academic tormented to an obsessive degree by his ex-wife Madeleine's affair. She is involved with Herzog's former friend Valentine Gersbach, a one-legged, red-haired radio presenter. There's no plot as such. Rather, the novel locks us inside Herzog's racing brain, the sort of brain Bowie would have recognized, as it makes vast associational leaps between his poverty-stricken Montreal

childhood—his father was a bootlegger during Prohibition—his failing career, his previous marriages, his current chaotic love life, and his distant relationship with his children. At irregular intervals it has what amount to seizures in the form of letters Herzog writes (though never sends) to friends and acquaintances, family members, public figures, and philosophers.

So intimately do we share Herzog's paranoia that we risk missing Bellow's hints that this failed mensch is misreading signals. Was Madeleine's behavior so unreasonable? Is Valentine such a devious bastard? Herzog barely pauses to consider. He's restless, constantly in motion, sometimes reaching a destination only to panic and turn back. Only sex with his exotic, male-fantasy-figure lover Ramona seems to turn his brain off.

An injection of drama comes when Herzog receives a letter from the babysitter of his and Madeleine's daughter, Junie. He learns that Valentine locked Junie in the car during a row with Madeleine. Roused to action, Herzog takes his father's old pistol and goes to their house, intending to kill Valentine and Madeleine. But then he looks through the window and sees Valentine washing June with love and tenderness. It's the beginning of Herzog's own fall into properly proportioned self-awareness, a state he attains at the end of the novel as he picks a bouquet of flowers for Ramona and cooks her dinner. Simple, domestic things. Small, human connections of the kind Bowie was so good at making. The urge to write letters leaves him like a banished migraine.

Read it while listening to: "Without You"

If you like this, try: Saul Bellow, The Adventures of Augie March

T. S. Eliot, The Waste Land (1922)

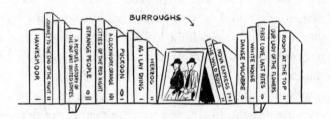

Way back in 1974, William S. Burroughs made the link between Bowie's lyrics and the poetry of T. S. Eliot. Interviewing the singer for *Rolling Stone*, Burroughs asked if *Hunky Dory*'s "Eight Line Poem" had been influenced by Eliot's 1925 poem "The Hollow Men." Bowie denied all knowledge: "Never read him," he said.

This is odd, because Bowie was definitely exposed to Eliot's influence. "Goodnight Ladies" on *Transformer*, the album Bowie produced for Lou Reed in 1972, is a riff on the end of the second section of Eliot's groundbreaking 1922 poem *The Waste Land*, "A Game of Chess." (Eliot, for his part, is quoting Ophelia's "Good night, sweet ladies" speech from Shakespeare's *Hamlet*.) And of course, Eliot was one of the writers co-opted by Colin Wilson (see p. 30) into his pantheon of romantic literary misfits.

Assuming Bowie was telling Burroughs the truth, when did he get around to reading The Waste Land? Had he read it by the time he recorded Lodger in 1978? In which case, do the "red sails" sailing on Thunder Ocean (and remember, part five of The Waste Land is titled "What the Thunder Said") have anything to do with the "red sails" of the barges drifting down the Thames in part three, "The Fire Sermon"?

A riot of pastiche, parody, and allusion, The Waste Land did for poetry what cubism did for the visual arts: it is wilfully obscure in a manner some find compelling, others exasperating. Eliot added seven pages of notes to the book version (it was originally published in his magazine The Criterion), which he admitted later were to pad it out and send readers off on a wild goose chase rather than supply genuine insight. Bowie was sometimes guilty of this himself. "Don't listen to the words, they don't mean anything," he advised engineer Ken Scott while they were recording Hunky Dory's "The Bewlay Brothers." "I've just written them for the American market, they like this kind of thing." Bowie's death on January 10, 2016, two days after the release of Blackstar, sent grieving fans into an interpretive frenzy. What, in the song "Blackstar," was the "villa of Ormen" where the "solitary candle" burns? Was the title a reference to the Elvis Presley song of that name, a cancer lesion, or a hypothetical concept in quantum physics?

Eliot's approach in *The Waste Land* was that of bricolage: he took fragments—of overheard speech, jazz rhythms, popular songs, and quotations from other writers—and welded them together. By doing so, he created a poetry that was breathtakingly modern yet also reflected the spiritual bankruptcy of Europe after the First

World War. For Eliot, the modern city was filthy and noisy. A truly modern poetry needed to reflect this by attempting what Eliot called a fusion between the sordid and the magical—a good description of Bowie's ambition for *Diamond Dogs* and its accompanying stage spectacular. For Eliot, the best poets weren't grand, seer-like romantic figures but anxious, sensitive individuals ravaged by self-doubt who wore poetry like a protective mask.

Eliot's method established a new protocol for artistic theft. The modern poet is in constant dialogue with his or her predecessors, who exist not in some dusty past but in a kind of timeless simultaneity, constantly shuffling around and readjusting their relationship to one another to accommodate newcomers. These newcomers are free to reconfigure older poets' work. In fact, doing this well should be their main ambition: "Immature poets imitate; mature poets steal; bad poets deface what they take, and good poets make it into something better, or at least something different," Eliot wrote. (Bowie was frequently candid about how much he took from other artists. "You can't steal from a thief," he reassured LCD Soundsystem's James Murphy when Murphy admitted to stealing from Bowie's songs.)

Thomas Stearns Eliot grew up in Saint Louis on the banks of the Mississippi and arrived in London in 1914. As a young man he had, like Bowie in the mid-1970s, dabbled in the occult and grown suspicious of democratic politics. In London he married a British woman, Vivienne Haigh-Wood—as Bowie would later marry an American, Angie Barnett—and financed his writing and editing with a job as a bank clerk. In 1921, however, overwork combined with money worries and the stress of coping with Vivienne, who suffered from

depression, to trigger a nervous breakdown. To recuperate, Eliot went first to Margate, then to a sanatorium in Lausanne, Switzerland, where he finished writing *The Waste Land*. (Bowie, too, lived in Lausanne, spending much of the 1980s and '90s at Château du Signal, a fourteen-room mansion built in 1900 for a Russian prince. *Lodger* and several subsequent Bowie albums were recorded at Mountain Studios, forty minutes' drive away in Montreux.)

So yes, Burroughs got it right. The ties binding Bowie and Eliot are compellingly strong. And we haven't even mentioned the connection between "The Hollow Men" and the blind Button Eyes character from the videos for "Blackstar" and "Lazarus":

The eyes are not here
There are no eyes here
In this valley of dying stars....

Button Eyes is "dying star" Bowie laying down a trail of Reese's Pieces—not just for "the American market," but for everyone who loved him.

Read it while listening to: "Eight Line Poem"

If you like this, try: T. S. Eliot, "The Hollow Men"

17

John Kennedy Toole, A Confederacy of Dunces (1980)

"When a true genius appears in the world, you may know him by this sign, that the dunces are all in confederacy against him."

-Jonathan Swift

ike Spike Milligan's *Puckoon* (see p. 269), John Kennedy Toole's *A Confederacy of Dunces* underscores the link between creative pyrotechnics and mental instability. As someone who spent many years trying unsuccessfully to break into his chosen industry, Bowie would also have loved the story's curious genesis and discovery. We tend to forget that there was ever a time before David Jones became "David Bowie," international superstar. But *he* never forgot.

Without anyone knowing, Toole wrote the novel in the early 1960s while doing his national service in Puerto Rico. He submitted it to celebrated editor Robert Gottlieb at Simon & Schuster, who initially encouraged Toole before rejecting the manuscript on the grounds that "it isn't really about anything." Depressed, Toole drifted into academia, teaching English at a college in New Orleans,

but began to behave in an increasingly eccentric, paranoid way. One day he disappeared on a three-month road trip to California. Then, outside Biloxi, Mississippi, on March 26, 1969, he gassed himself by connecting a length of hose to his car exhaust.

Among her late son's possessions, Toole's mother, Thelma, found the manuscript of A Confederacy of Dunces and his correspondence with Simon & Schuster. Furious that the novel had been rejected, she devoted the rest of her life to proving her son's genius. Against the odds, she succeeded. A Confederacy of Dunces was published by a small university press and became a surprise bestseller, winning the Pulitzer Prize in 1981.

Toole's comic antihero, obese slob Ignatius J. Reilly, leaps off the page from the start; he is instantly distinguishable in a squished-down hunting cap that barely contains his uncut hair and large, bristly ears. This is Don Quixote relocated to 1960s New Orleans, and Reilly is an internet troll *avant la lettre*. Who needs Reddit when you have Big Chief tablets in which to scrawl your fusty racist diatribes and pedantically erudite musings on medieval philosophy? Thirty years old but still living with his mother, worrying constantly about Fortuna's wheel and the state of his "pyloric valve," Reilly masturbates while dreaming of Rex, his pet collie from his high school days.

Bowie was fascinated by misfits; he characterized among these anyone who chose to remain living with their parents into midadulthood. The whimsical "Uncle Arthur" on his first solo album, released in 1967, profiles just such a character—a shopkeeper in his early thirties who still reads comics, follows Batman, and cycles home to his mother at the end of the working day. Bowie expert

BOWIE'S BOOKSHELF 4 47

Nicholas Pegg thinks Bowie got the idea for the song from a bleak short story by Alan Sillitoe called "The Disgrace of Jim Scarfedale." (You can find it in Sillitoe's bestselling first story collection, *The Loneliness of the Long-Distance Runner.*) Like Uncle Arthur, Jim moves away from home to live with a woman only to move back in again when the relationship founders. Reading *A Confederacy of Dunces* decades later, it's easy to imagine that Bowie would have been thrilled to see these themes reiterated so stylishly.

Read it while listening to: "Uncle Arthur"

If you like this, try: Alan Sillitoe, The Loneliness of the LongDistance Runner

Greil Marcus, Mystery Train (1975)

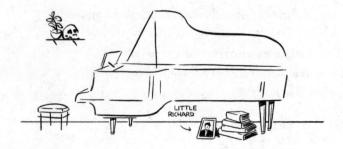

Greil Marcus was one of the first rock critics and remains one of the best. A veteran of late-'60s counterculture magazines like *Creem*, he understood before anyone else—and years before the leveling effect of postmodernism on the debate—that the best pop music was the equal of any form of "high" art. However trite and ephemeral pop seemed on the surface, its roots burrowed deep into American and British cultural history. So it deserved to be written about with respect and academic discernment. If you wanted to compare the Band with Herman Melville, or the Sex Pistols with the Anabaptist commune at Münster, well—you should just go ahead and do it. Don't apologize first.

The thing is, though, that Marcus didn't much care for David

Bowie. He rated the melodic inventiveness of *Hunky Dory* but not the endless shape-shifting that followed. He damned *Lodger* in a notorious review for *Rolling Stone*: "Time and again, ideas are run up the flagpole," he wrote, "but try and find the flagpole." It says a lot about Bowie's generosity that he felt able after this slight to recommend Marcus's best-known book so unhesitatingly. But it also says a lot about how fantastic *Mystery Train* is.

Wherever Bowie recorded in the world, he took with him a framed photo of Little Richard, the man who (arguably) invented rock 'n' roll, to hang on the studio wall before he started work. Nile Rodgers, who produced *Let's Dance*, remembers Bowie showing him a picture of Little Richard wearing a red suit getting into a red Cadillac and telling him *that* was how he wanted the album to sound.

Mystery Train also begins with Little Richard (see p. 153) as Marcus talks us through the piano-pounding, sexually ambiguous "Tutti Frutti" singer's appearance on a US talk show. Forced into silence by the pompous loquacity of the other guests, Little Richard simmers furiously until he can contain himself no more; triggered by the novelist Erich Segal lecturing everyone present on the history of art, he stands up and denounces the white custodians of culture like a pastor preaching fire and brimstone. In this way he proves himself to be the only true artist present—the only true rule-breaker.

Marcus started writing Mystery Train in the autumn of 1972, as Ziggy-mania was building, and finished it in the summer of 1974, when Bowie was dragging his Diamond Dogs tour across America, transforming it along the way into a soul revue. Marcus focuses on four acts who were all alive and (more or less) functional at the

time: Elvis Presley, Randy Newman, the Band, and Sly Stone. But in writing about Stone—a showman-disruptor in the Little Richard tradition who had jettisoned what Marcus calls his "big freaky black superstar" image with the album *There's a Riot Goin' On*—he might as well be writing about Bowie:

If the audience demands only more of what it has already accepted, the artist has a choice. He can move on, and perhaps cut himself off from his audience; if he does, his work will lose all the vitality and strength it had when he knew it mattered to other people. Or the artist can accept the audience's image of himself, pretend that his audience is his shadowy ideal, and lose himself in his audience. Then he will only be able to confirm; he will never be able to create.

This tension—between confirming and creating, needing a mass audience and disdaining it—animated Bowie throughout his life.

Read it while listening to: "Fame"

If you like this, try: Greil Marcus, Lipstick Traces

19

The Beano (1938-present)

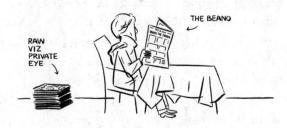

n the world of British postwar children's comics, two titles stood apart from the crowd—The Beano and The Dandy. Though they were both published by the same company, Dundee, Scotland—based D. C. Thomson, The Beano had the edge. It was goofier and zanier. More anarchic. And it had had a good war, mocking the Nazis so viciously that its editor was on Hitler's "murder list" of figures the führer wanted arrested after his planned invasion of Britain in 1940.

The Beano's illustrators, like Leo Baxendale and David Law, were almost as famous as their creations—Biffo the Bear, Lord Snooty, the Bash Street Kids. The early 1950s, when David Jones first got his hands on *The Beano*, coincided with the comic's commercial apogee (weekly sales of two million) and the introduction of its best-loved

characters Minnie the Minx, Roger the Dodger, and of course Dennis the Menace, with his electric-shock hair and distinctive black-and-red jumper. For baby boomers more than anyone, *The Beano* stood for defiance in the face of adult authority. This is why Eric Clapton is holding a copy on the cover of John Mayall & the Bluesbreakers' 1966 album *Blues Breakers with Eric Clapton*. Clapton hated photo shoots and decided to annoy everybody by buying *The Beano* and reading it while his bandmates posed obligingly.

Bowie's lifelong love of comics and graphic novels started with *The Beano*. So it was fitting and somehow beautiful that on the day of the singer's death the comic honored him by sharing an image of Dennis with an Aladdin Sane stripe on his face.

Read it while listening to: "The Laughing Gnome" **If you like this, try:** 2000 AD

20

Fran Lebowitz, Metropolitan Life (1978)

Apparently Bowie once borrowed a book from Fran Lebowitz's vast library and never returned it. But if you're concerned this might have been a source of rancor between them, relax. The New York humorist and style icon was an old friend. She remains a friend of Iman, for whose 2001 autobiography-cum-manifesto I Am Iman Bowie interviewed her. The pair chat over the course of several pages and typefaces, touching on the lack of black models in Vogue, why fashion shows have become like sporting events, why Andy Warhol is the reason there's a Starbucks in Rome, and what happens when a sensibility that's meant to be covert—camp, for example—goes mainstream. It's a blast.

Metropolitan Life collects columns and essays Lebowitz wrote in the 1970s for Mademoiselle and, before that, Warhol's Interview. Sly, sardonic observations of New York life, they delight in their insularity. Interview was known for the same quality; Lebowitz once observed that everyone who read the magazine knew one another. It just so happened that many of them were people who, as Edmund White noted in the New York Times, went on to have

"a lasting influence on American taste and music and painting and poetry and amusements."

Lebowitz's columns probably fall into the category of "amusements," though that's not to diminish them in any way. For one thing, they're hilarious. For another, they're time capsules of Old New York—pre-gentrification, pre-AIDS. The arty, sexy, intellectual New York of Studio 54 and Max's Kansas City, Robert Mapplethorpe and Susan Sontag. Not that Lebowitz is vulgar enough to name-check any of these people or places. Her real subject is the urban mind-set and how, to survive in a city, you must sharpen it to a point.

The best tools for that job turn out to be sarcasm and irony. For example, she instructed that if you want to be a landlord, the minimum acceptable roach-to-tenant ratio is four thousand to one. Infuriated by the practice of using syllabic abbreviations to describe specific areas of the city—e.g., SoHo and TriBeCa—she comes up with NoTifSoSher: North of Tiffany's, South of the Sherry-Netherland. Then there are the sparkling, Dorothy Parker—esque one-liners: "Sleep is death without the responsibility." "To me, the outdoors is what you must pass through to get from your apartment into a taxicab."

Running beneath it all like an underground stream is a ferocious love of New York—one Bowie shared. In fact, he acquired it the moment he first visited the city in January 1971 as a guest of Mercury Records, who were about to release *The Man Who Sold the World* in the US. He swanned around Manhattan in his Mr. Fish "man dress," Veronica Lake hair cascading down his shoulders. He bought lunch for Moondog, the blind, homeless street poet and

musician who used to hang out, dressed as a Viking, at the corner of West Fifty-Fourth Street and Sixth Avenue. And he saw his favorite band the Velvet Underground play live at the Electric Circus in the East Village. Blown away by the show, Bowie went backstage afterward to congratulate Lou Reed and tell him how great he thought his songs were. The pair chatted amiably for some time. Only later did Bowie realize that Lou Reed had left the band the previous summer and the recipient of his glowing praise had been their swiftly promoted former bass player Doug Yule.

A valuable lesson in the precariousness of rock celebrity—or as Lebowitz once put it: "You're only as good as your last haircut."

Read it while listening to: "New York's in Love"

If you like this, try: Fran Lebowitz, Social Studies

21

Richard Cork, David Bomberg (1988)

Bowie owned several paintings by the questing, formally radical British artist David Bomberg. "I've always been a huge David Bomberg fan," he revealed to the *New York Times* in 1998. "I love that particular school. There's something very parochial English about it. But I don't care." Among the Bomberg works in Bowie's collection sold at Sotheby's after his death were *Sunrise in the Mountains*, *Picos de Asturias* and *Moorish Ronda*, *Andalucia*—landscapes painted in Spain in the mid-1930s that represent Bomberg's search for what he called the "spirit in the mass," a means of uniting form and feeling.

Bomberg, the fifth of eleven children, was born in Birmingham, England, in 1890 to a Polish-Jewish immigrant leatherworker and his wife. When he was five the family moved to Whitechapel in East London. As a child, Bomberg showed huge artistic promise but there was no money for him to go to art school. Between 1908 and 1910, however, he attended evening classes given by Walter Sickert at Westminster School of Art. Thanks to a loan from the Jewish Education Aid Society he went on to the Slade School of Fine Art

in 1911, where he studied under the famous drawing teacher Henry Tonks alongside Paul Nash, Stanley Spencer, Dora Carrington, and Mark Gertler—a starry bunch hailed by Tonks as the school's last "crisis of brilliance."

Of them all it was Bomberg who rebelled most fiercely against the Victorian stiffness of Tonks's teaching, experimenting wildly and absorbing influences from postimpressionism, futurism, vorticism (see p. 244) and cubism. The intricate geometric scaffolding and use of color in paintings such as *In the Hold* (1913–14) baffled most contemporary critics.

After the Second World War Bomberg taught at the Borough Polytechnic Institute in London where his students included other Bowie favorites Leon Kossoff and Frank Auerbach. But his painting career floundered. Richard Cork notes with barely suppressed fury that most of his life's work was locked away in a storeroom. In 1951 the influential critic Herbert Read omitted him from his survey Contemporary British Art. Two years later, when the polymathic arts patron Edward Marsh left his collection to the nation, the Contemporary Arts Society rejected his two Bomberg paintings. By the time Bomberg died in August 1957 he was destitute and forgotten. Says Cork: "Nobody, outside his immediate family and a few friends, had any notion of the size or complexity of Bomberg's achievement."

But then a funny thing happened. Almost immediately, the critical establishment went into paroxysms of guilt. Superstar art critic David Sylvester (see p. 113) berated himself and everyone else for having waited until Bomberg died before they acknowledged his importance. The retrospective exhibition Bomberg had needed so

58 4 John O'Connell

badly was staged by the Arts Council in 1958. In 1987 Cork published this major monograph and by the following year, when he curated the Tate's first solo exhibition of Bomberg's work, the rehabilitation was complete. If there's a moral to be drawn from Bomberg's career, it's that what one generation considers heretical, the next will hail as genius. Let the Tin Machine reappraisal commence!

Read it while listening to: "Up the Hill Backwards"

If you like this, try: David Boyd Haycock, A Crisis of Brilliance
1908–1922: Nash, Nevinson, Spencer, Gertler, Carrington,
Bomberg

Alfred Döblin, Berlin Alexanderplatz (1929)

he machine sounds of Bowie's Berlin albums and Iggy Pop's *The Idiot* pulsate with the influence of Alfred Döblin's masterpiece, the German equivalent of *Ulysses*. It's the story of Franz Biberkopf, a pimp and murderer who upon his release from prison vows to live as a respectable, responsible Berliner but has no sense of how to do it. He can't seem to contain his anger and frustration, and besides, the criminal life is all he knows. He's doomed to fall back repeatedly into a world of petty larceny, loveless sex, and casual but breathtakingly brutal violence. Döblin doesn't spare us the details. At one point, Biberkopf is thrown from a moving car by a gangland boss. And when his friend Reinhold kills his prostitute lover Mitzi, Döblin intercuts her murder with abattoir instructions for slaughtering a veal calf.

Berlin Alexanderplatz was a bestseller in Germany, shifting fifty thousand copies in two years, until the Nazis banned it for being a debauched product of Weimar decadence. (After Hitler became chancellor in January 1933, Döblin fled first to Switzerland, then to Paris, then to Los Angeles, where he worked briefly for the movie studio

MGM.) Written in a dense street argot in a stream-of-consciousness style, the novel has a reputation for being untranslatable into any other language. Bowie would have read James Joyce's friend Eugene Jolas's broadly disliked 1931 English translation, which converts Döblin's *Berlinisch* into pulpy American slang. An epically long, emotionally brutalizing TV adaptation by Rainer Werner Fassbinder in 1980 brought *Berlin Alexanderplatz* to a wider audience.

When Döblin was writing in the 1920s, Alexanderplatz, the novel's psychic heart, was a night-life hub crisscrossed with street-car lines, famous for its ugly red police station and Tietz department store. By the late 1970s, when Bowie and Pop were doing their Christopher Isherwood routine (see p. 35), it was the center of East Berlin. Bowie and Pop would have read *Berlin Alexanderplatz* to travel back in time, but without the consolation of nostalgia

or indeed anything else: Döblin's novel is a consolation-free zone.

After losing an arm, being framed for another murder, and then force-fed in a mental hospital, Biberkopf gets a job as an assistant porter in a factory. He accepts, Döblin tells us, then says he has nothing further to report about Biberkopf's life. Nothing to *report*, but plenty to speculate about, such as what will become of Biberkopf, who reads Nazi newspapers and is suspicious of Jews, after

BOWIE'S BOOKSHELF 4 61

he joins the parade of soldiers marching past his window to the war Döblin knows is inevitable.

Because of the disjointed, absurd nature of urban life, there is, says Döblin, no clear line dividing criminals from non-criminals. He tells Biberkopf's story from multiple points of view and via a mixture of styles including advertising slogans, biblical allusions, songs, and recipes. Biberkopf is Shakespeare's unaccommodated man, out on an existential limb—the kind of man Bowie flirted with becoming on the heaviest of his heavy nights out. But he could never quite get there. There was always someone around to step in and pull him out of the mire.

Read it while listening to: "V-2 Schneider"

If you like this, try: Alfred Döblin, Tales of a Long Night

George Steiner, In Bluebeard's Castle: Some Notes Towards the Redefinition of Culture (1971)

Bowie first talked about the idea of "reality" being an abstraction in the mid-1990s. Possibly he'd been brainstorming with U2, who in turn had been brainstorming with Bowie's professorial friend Brian Eno, the producer of their album Achtung Baby.

U2's multimedia Zoo TV tour of 1992–93 doffed its cap to French theorist Jean Baudrillard's controversial set of essays *The Gulf War Did Not Take Place*, published the year before, which argued that the Western media's coverage of the war was so stylized it felt to viewers as if no real battle was occurring, merely a simulacrum. Eno picked up on this idea, a favorite with Don DeLillo (see p. 146) too, in a lecture he gave at London's Sadler's Wells Theatre in 1992 titled "Perfume, Defense and David Bowie's Wedding."

These issues—and the broader but connected one of cultural relativity: the erosion of barriers between "low" and "high" culture—seemed to preoccupy Bowie more as he aged. "Things that people regarded as truths seem to have just melted away, and it's almost as if we're thinking post-philosophically now," he told Sound on

Sound magazine in 2003. To Ingrid Sischy in *Interview* he went further, explaining that this view had been "reinforced by the first thing I read on postmodernism, a book by George Steiner called *In Bluebeard's Castle*."

Steiner's book confirmed for him, he said, that "there was actually some kind of theory behind what I was doing with my work—realizing that I could like artists as disparate as Anthony Newley and Little Richard, and that it was not wrong to like both at the same time. Or that I can like Igor Stravinsky and the Incredible String Band, or the Velvet Underground and Gustav Mahler."

To be clear, Steiner isn't endorsing the postmodernist cliché that all cultural artefacts have equal value. The polymathic literary critic would much rather you liked Mahler than the Velvet Underground. His argument in *Bluebeard's Castle*, which collects four lectures given at the University of Kent at Canterbury in March 1971, is that Western high culture is in crisis because the tradition of classical humanism that underpinned it for hundreds of years has, in the twentieth century, been exposed as a sham. Civilization is the flip side of barbarism. After the Holocaust—and it's worth bearing in mind that as a child the Jewish Steiner fled first Austria, then occupied France—the idea that the humanities humanize is laughable. Steiner wrote, "Nothing in the next-door world of Dachau impinged on the great winter cycle of Beethoven chamber music played in Munich."

The hangover from this is a state Steiner calls "post-culture": the devaluing of high art and the elevation of easily decoded mass art forms like rock music. "The line between education and ignorance is no longer self-evidently hierarchic," concludes Steiner. "Much of

64 4 John O'Connell

the mental performance of society now transpires in a middle zone of personal eclecticism." This zone, in which a largely untrained autodidact has the freedom to pull anything from anywhere (the avant-garde, Broadway musicals, books about UFOs) and turn it into art, is clearly the one Bowie inhabited.

Read it while listening to: "Reality"

If you like this, try: Umberto Eco, Travels in Hyperreality

D. H. Lawrence, Lady Chatterley's Lover (1928)

On November 2, 1960, after only three hours' deliberation, the jury at the "Lady Chatterley trial" in London's Old Bailey acquitted Penguin Books, which had been charged under the terms of the Obscene Publications Act 1959 for publishing D. H. Lawrence's Lady Chatterley's Lover—his final novel, written thirty years earlier.

Addressing the jury as they left to ponder their verdict, chief prosecutor Mervyn Griffith-Jones asked them to consider whether Lawrence's account of a neglected upper-class woman's sexual relationship with a gamekeeper was the kind of book "you would wish your wife or servants to read." Their answer, a resounding yes, overturned the censorious old order and set the stage for the 1960s as we know them. In his poem "Annus Mirabilis," Philip Larkin dated the point when sexual intercourse began to somewhere between the lifting of the Chatterley ban and the UK release of the Beatles' first LP, *Please Please Me*, on March 22, 1963. He added, mournfully, that it was rather late for him.

Possibly it was. But it wasn't for David Jones, who was thirteen in 1960.

The first Penguin paperback edition boasted an introduction by eminent sociologist Richard Hoggart assuring readers that Lawrence's language was not calculated to arouse. It's true that the animalistic side of sex was as important to Lawrence as the spiritual side and lends itself less easily to eroticization. ("Tha's got the nicest arse of anybody," gamekeeper Mellors tells Connie Chatterley. "An if tha shits an' tha pisses, I'm glad.") To thirteen-year-old boys in 1960, however, this distinction would have been academic. Bowie's old classmate George Underwood remembers a copy being passed around at their school "with all the well-worn dirty pages."

David Herbert Lawrence was born in Eastwood, Nottinghamshire, on September 11, 1885, the son of a miner and a former schoolmistress. A sickly, studious child, he benefited hugely from both his mother's ambitions for him and the educational opportunities then available to regional working-class communities. He knew Lady Chatterley's Lover would be controversial and called it "the most improper novel ever written."

Improper, but not pornographic. Rather, he wrote, it was an attempt "to make the sex relation valid and precious instead of shameful," to bring about a revolution in phallic consciousness that would renew Britain after the devastation of the First World War. The conflict had wiped out a generation of men and paralyzed Connie's twenty-nine-year-old husband below the waist. "Ours is essentially a tragic age," the novel begins, "so we refuse to take it tragically. The cataclysm has happened, we are among the ruins. . . . "

The four-letter words that so upset Mr. Griffith-Jones were used deliberately to purge them of what Lawrence called "unclean mental

BOWIE'S BOOKSHELF 4 67

associations": "The kangaroo is a harmless animal, the word shit is a harmless word. Make either into a taboo, and it becomes most dangerous. The result of taboo is insanity. And insanity, especially mob-insanity, mass-insanity, is the fearful danger that threatens our civilization."

Read it while listening to: "Let's Spend the Night Together" (cover of Rolling Stones song)

If you like this, try: D. H. Lawrence, The Rainbow

Petr Sadecký, Octobriana and the Russian Underground (1971)

n 1967 a Czech artist called Petr Sadecký defected to West Germany with some comic-book artwork he'd stolen from a group of Czech illustrators depicting a vast-breasted, peroxide-haired, vicious-looking superheroine called Amazona. He doctored this artwork to create fake propaganda, slapping a red star on Amazona's forehead and transforming her into Octobriana, the spirit of the October Revolution—a Communist version of Barbarella born thousands of years ago in a radioactive volcano, who traverses time and space in her Wonder Machine.

Four years later, Sadecký introduced Octobriana to the world in a book, Octobriana and the Russian Underground. In the course of a lengthy lecture on samizdat literature, it explained that Octobriana had been created by a group of radical Soviet dissidents called Progressive Political Pornography (PPP), who had initiated Sadecký into their extreme sexual practices in the early 1960s when he traveled to Kiev to give a lecture. Sadecký claimed to have smuggled the

material out of Ukraine together with photos of PPP members and other examples of their work.

Octobriana and the Russian Underground caught the imagination of the Western media, making the cover of the UK's Daily Telegraph magazine before it had even been published. But doubts about the veracity of Sadecký's stories, especially the provenance of Octobriana, surfaced soon afterward when one of the original illustrators, Bohuslav Konecný, contacted Germany's Stern magazine to complain that he'd been ripped off. None of this stopped Octobriana from becoming a sensation in hip circles.

In Mick Rock's book *Moonage Daydream*, Bowie says his interest in Sadecký was an offshoot of his fascination with Anthony Burgess's quasi-Russian invented language Nadsat (see p. 2). In 1974 Bowie got designer Freddie Burretti to appliqué the image of Octobriana onto a bottle-green bolero jacket he intended to wear to receive an award on a Dutch TV show. But disaster struck. At a press conference just before the ceremony, he took the jacket off and hung it on the back of his chair. Inevitably, it was swiped by a passing journalist.

Soon afterward, Bowie announced plans to produce a major film about Octobriana starring his then girlfriend, singer and model Amanda Lear, who had appeared as the character the previous October in *The 1980 Floor Show*, a Ziggy Stardust special filmed for American television at London's Marquee Club. Bowie—or rather his publicist Cherry Vanilla pretending to be him—told *Mirabelle* magazine all about it:

I was given the collection of *Oktobriana* [sic] comic strips as a present—and while reading them it suddenly came to mind what a fabulous thing it would be to make Oktobriana (OK for short) a real person and film all her escapades. We'd even update the Oktobriana adventures and while she'd still be an exotic Russian, her adventures would be all over the world and she'd perhaps even wind up in space, occasionally. . . .

When I told Amanda about it she was very excited and we began working on scripts immediately. You know, of course, that I just can't resist writing in at least a tiny part for myself. We'll have to come up with a segment, "Oktobriana Meets Starman" or something like that. Anything to get starstruck Bowie into the show!

Anyway, Amanda is having such a great time with this character that she doesn't want to be known as anything else. As she says, "Amanda is the past, Oktobriana is today." She says this with a flawless Russian accent so one tends to respect her wishes.

We're also having a wonderful time designing costumes for Oktobriana. Our plans so far have Oktobriana wearing clothes made out of animal skins, high boots on her legs and she'll also carry a shining sabre. This girl really means business. Sounds exciting, doesn't it?

It really does—but sadly nothing ever came of it.

Octobriana is a public-domain character, however—she belongs to everybody, a legacy of her Communist origins—so

BOWIE'S BOOKSHELF # 71

could theoretically turn up anywhere, doing anything. Watch that woman.

Read it while listening to: "Rebel Rebel"

If you like this, try: José Alaniz, Komiks: Comic Art in Russia

26

Comte de Lautréamont, Les Chants de Maldoror (1868)

Surrealism starts here, in the slender output of the French poet Comte de Lautréamont, as one Isidore-Lucien Ducasse called himself. Nearly fifty years after his mysterious death in 1870 at the age of twenty-four—"no further information," states the death certificate—the celebration of Ducasse's work began. André Breton, Salvador Dalí, and Antonin Artaud thought it pointed the way to the future, never mind that it owed a lot to the past, especially Dante (see p. 11).

Here, as with William S. Burroughs and Brion Gysin's cut-up method, collisions of unlikely images create a friction of unexpected meanings. Ducasse's most frequently quoted line—"As beautiful as the chance encounter of a sewing machine and an umbrella on an operating table"—anticipates the imagist opening of T. S. Eliot's "The Love Song of J. Alfred Prufrock" as well as the lyrics to Bowie songs such as "Watch That Man," where bleeding bodies on a screen are juxtaposed with a lemon in a bag playing the Tiger Rag.

A sequence of prose poems organized into six cantos, *Les Chants de Maldoror* is not for the fainthearted. In fact, its antihero embod-

ies everything that would have terrified (and enthralled) Bowie in his days of cocaine psychosis. For Maldoror is part devil, part alien—and wholly evil. A cave-dwelling shape-shifter with a single eye in his furrowed green forehead, he presides with a leer over the entirety of human suffering. Oh, and he loves torturing young boys:

One should let one's nails grow for a fortnight. O, how sweet it is to drag brutally from his bed a child with no hair on his upper lip and with wide open eyes, make as if to touch his forehead gently with one's hand and run one's fingers through his beautiful hair. Then suddenly, when he is least expecting it, to dig one's long nails into his soft breast, making sure, though, that one does not kill him; for if he died, one would not later be able to contemplate his agonies. Then one drinks his blood as one licks his wounds; and during this time, which ought to last for eternity, the child weeps.

The concentration of emetic, Bosch-like images is overwhelming. The poem is strongly reminiscent of the sequence in *The Man Who Sold the World*'s "The Width of a Circle," in which the protagonist is raped by a devilish, swollen-tongued monster. It may also have fed into 1.Outside's vague narrative about the art-ritual murder of Baby Grace Blue.

Read it while listening to: "The Width of a Circle"

If you like this, try: Charles Baudelaire, The Flowers of Evil

John Cage, Silence: Lectures and Writing (1961)

One of the biggest influences on Bowie's music-making from the mid-1970s onward was Brian Eno. And one of the biggest influences on Eno was the American composer and pioneer of postwar experimental music John Cage, born in Los Angeles in 1912.

That Cage's father invented an early type of submarine is one of the factoids scattered through *Silence: Lectures and Writing*, a loose collection-*cum*-manifesto-*cum*-memoir whose playful layout (multiple columns, tiny text, lots of white space) mirrors Cage's scorn for conventional concepts of harmony and notation. Mushrooms, an obsession of the composer, crop up repeatedly. Ditto vorticist-style sloganeering ("I HAVE NOTHING TO SAY AND I AM SAYING IT"), lists of questions ("What is more musical, a truck passing by

a factory or a truck passing by a music school?") and abstruse theorizing about the nature of sound which anticipates Eno's mid-1970s invention of ambient music: "Wherever we are, what we hear is mostly noise. When we ignore it, it disturbs us. When we listen to it, we find it fascinating. The sound of a truck at fifty miles per hour. Static between the stations. Rain. We want to capture and control these sounds, to use them not as sound effects but as musical instruments."

As for what most people assume to be the opposite of sound, silence, Cage believed there was no such thing. His most famous piece, 4'33", is not as sometimes supposed four minutes thirty-three seconds of silence but four minutes thirty-three seconds of whatever sound happens to fill that temporal space, whether it's a plane flying overhead, someone in the audience coughing, or the beating of your own heart. In the critic Alex Ross's words, it is a "Zen-like ritual of contemplation" whose arch theatricality—in performance it involved the virtuoso pianist David Tudor sitting at the piano, opening the sheet music, then just waiting there until the time was up—perfectly encapsulates Cage's air of earnest playfulness.

"He's a man with peculiar notions, some of which I can come to terms with very easily and are most accessible, and some of it is way above my head, mate, in terms of his analytical studies of cybernetics and his application of those things to music and his general sort of fine arts approach," Bowie said of Eno in a 1977 interview with NME. But he could just as easily have been talking about Cage.

Eno had been a founding member of the art-school glam troupe Roxy Music, headed by Bryan Ferry. But his real interest was in what he called generative music—music created by a system, for instance Steve Reich's *It's Gonna Rain*, where the system is two tape recorders playing identical tape loops. In England in the early 1960s, generative music was the province of composer Cornelius Cardew, in whose experimental ensemble the Scratch Orchestra Eno played after he left school.

Cardew had caught the generative bug in 1958 in Cologne, where, while studying with Karlheinz Stockhausen, he witnessed a performance of Cage's groundbreaking Concert for Piano and Orchestra, which Cage explained he had composed using the ancient Chinese divination text the *I Ching Book of Changes* to decide tempo, volume, and note duration.

Eno's famous "Oblique Strategies" cards, devised with the artist Peter Schmidt, follow on naturally from this. A means of unblocking creativity, the cards encourage lateral thinking through instructions such as "Honor thy error as a hidden intention." In the studio Bowie and Eno interspersed their use of them on songs like "Boys Keep Swinging" (on which the band swap roles as per the card saying "Abandon normal instruments") with highbrow clowning—what Bowie later recalled to *Uncut* magazine as long dialogues in Peter Cook and Dudley Moore voices "about John Cage performing on a 'prepared layer' at the Bricklayers Arms on the Old Kent Road and such like. Quite silly."

Read it while listening to: "Boys Keep Swinging"

If you like this, try: Alex Ross, The Rest Is Noise: Listening to the
Twentieth Century

George Orwell, Nineteen Eighty-Four (1949)

Ninety Eighty-Four has one of the most famous opening sentences in literature: "It was a bright cold day in April, and the clocks were striking thirteen." It's uncanny, then, that at midnight on the day of David Jones's birth—January 8, 1947—the intense cold is said to have caused the clock on Lambeth Town Hall in Brixton to strike thirteen instead of twelve. The mistake would have been audible at 40 Stansfield Road, five minutes' walk away, where his mother, Peggy, was in labor. . . .

Eric Blair, better known as George Orwell, did most of his work on *Nineteen Eighty-Four* in 1947. He'd had a so-so war, hacking out a pittance reviewing books before getting a job at the Indian section of the BBC World Service, then a better one at the left-wing (though anti-Stalin) magazine *Tribune*, where he wrote most of his best essays. But then the success of *Animal Farm*, published in 1945, made him wealthy enough to junk journalism and focus on writing the novel that had been coalescing in his mind for several years, precipitated by a reading of Yevgeny Zamyatin's dystopian fantasy *We* (1924) in which the nameless but numbered citizens of

One State live in glass buildings, the better to assist the secret police who watch over them.

Isolated on the remote Hebridean island of Jura, terminally ill with tuberculosis, Orwell recast the gray, bomb-ravaged London that would form the backdrop of Bowie's childhood as the capital of Airstrip One, a province within the greater superpower of Oceania—ruled over by the Stalin-like Big Brother and locked in permanent war with rival superpower Eurasia. The novel's working title was *The Last Man in Europe*. That man is thirty-nine-year-old Winston Smith, who works for the Ministry of Truth removing traitorous, vaporized "unpeople" from historical records.

It's a miracle the book was ever finished, for Orwell had an extraordinary talent for self-sabotage. During an ill-fated boat trip in August 1946, he misread the tide tables and nearly drowned himself, his son, and his nieces and nephew. He avoided doctors for years and smoked constantly despite the terrible state of his lungs. Experimental treatment with the antibiotic streptomycin bought him extra time. Aneurin Bevan—Orwell's former editor at *Tribune*, then secretary of state for health in Clement Attlee's government, obtained the medication specially from America. It enabled Orwell to live long enough to see *Nineteen Eighty-Four* published, if not to luxuriate in the acclaim heaped upon it.

Nineteen Eighty-Four left a vast psychic imprint on Bowie. It's possible, given that he remembered watching The Quatermass Experiment as a small child, that Bowie also watched its author Nigel Kneale's BBC adaptation of Nineteen Eighty-Four in December 1954, starring Peter Cushing as Winston Smith. However he discovered the book, though, he showed his love for it the way he

knew best—extravagantly. In 1973 he hatched a grand plan to develop *Nineteen Eighty-Four* as a stage musical, then as a television show. But Orwell's widow, Sonia, who controlled the rights, wasn't having any of it. This was a major inconvenience for Bowie, who was left with a load of half-recorded material he wasn't sure how or where to use.

The result was the album *Diamond Dogs*, into which he decanted songs like "Big Brother," "1984," and "We Are the Dead" while subtly changing the emphasis until the project felt more like *Oliver Twist* as rewritten by William S. Burroughs. Airstrip One became Hunger City and *Diamond Dogs* a portrait of disaffected youth running wild in gangs and living on rooftops—an echo, perhaps, of the kind of stories Bowie's father, Haywood Jones, used to tell him about the displaced, war-damaged children he met in the course of his work as a publicist for the children's charity Dr. Barnardo's.

If the soul of *Nineteen Eighty-Four* exists anywhere on *Diamond Dogs* it's in "We Are the Dead," Winston's hymn of doomed love for Julia. It is the album's most sensuous and heartfelt moment, its title a direct quote: it's what Winston says as he is lying with Julia, just before their hideout is raided by troops and they are separated forever.

Read it while listening to: "Big Brother"

If you like this, try: Margaret Atwood, The Handmaid's Tale

29

Peter Ackroyd, Hawksmoor (1985)

icholas Hawksmoor was an English architect at the turn of the eighteenth century—the point when scientific rationalism began to usurp magic and religion. In 1680, aged just eighteen, he was taken on by Sir Christopher Wren as a clerk and worked with Wren on landmark London projects such as Hampton Court Palace and Wren's masterpiece, St. Paul's Cathedral. Capable and hardworking, Hawksmoor was soon acclaimed in his own right. He designed parts of All Souls College, Oxford, and collaborated with John Vanbrugh on Castle Howard and Blenheim Palace. But he's best known for his series of London churches, commissioned as part of a scheme to rebuild London after the Great Fire.

Around these churches dark rumors swirl. Inspired by his membership in the mystical Freemason cult—linked to one of Bowie's pet obsessions, Rosicrucianism (see p. 104)—Hawksmoor used pagan symbols and motifs in their construction. A bizarre pyramidal tower adorns the church of St. George's, Bloomsbury, while St. Luke's, Old Street, has an obelisk spire. In his 1975 prose poem *Lud Heat*, the writer and psychogeographer Iain Sinclair proposed that

these churches were part of a system of occult signification, built along ley-like power lines to form a pentagram shape.

Ackroyd had just published his biography of T. S. Eliot (see p. 41) when, inspired by Sinclair, he had the idea for a thriller that would use the figure of Hawksmoor to link two sets of murders from the eighteenth and twentieth centuries. In the "historical" sections, written in a striking pastiche of eighteenth-century prose, architect Nicholas Dyer (modeled on Hawksmoor) consecrates his churches with blood from ritual sacrifices. In the present day, a detective called Nicholas Hawksmoor investigates strangulations that have taken place at the sites of these churches. The two accounts shimmer with eerie echoes. Throughout, the two Nicholases shadow each other until at the end they fuse in a terrifying, hallucinogenic act of physical and mental communion.

Song titles like "Thru' These Architects' Eyes" and "A Small Plot of Land" suggest Bowie read *Hawksmoor* in the early to mid'90s while he was working on his album about "art-ritual murder" 1.Outside. If so, it stayed with him as he mentioned the novel in a short film he made to promote *Reality* in 2003: "There's a writer in England called Peter Ackroyd who wrote a book called *Hawksmoor*... about churches designed by an architect who was a pupil of Christopher Wren's. But he was also a pagan and had built them on grave sites throughout London so they... these five [churches] formed the shape of a pentangle. It was a very powerful book and quite scary."

Read it while listening to: "Thru' These Architects' Eyes"

If you like this, try: lain Sinclair, Lights Out for the Territory

James Baldwin, The Fire Next Time (1963)

he song "Black Tie, White Noise" from the 1993 album of that name is one of Bowie's least elliptical lyrics and represents perhaps his most personal statement on the subject of race. Hiding from the 1992 LA riots in a hotel room, the recently married Bowie and Iman are having sex. But in the thick of this intimate moment Bowie looks into his Somali wife's eyes and wonders if, despite being a wellmeaning white liberal, he really understands her blackness, or if he's living in a Benetton-advert multicultural fantasy world. He hints that he is scared himself, as a famous white man, by the rioting black crowds below. Assuming there's a part of Iman that shares their anger, is any of it directed at him? In an astonishing line which he repeats three times, Bowie reassures himself that Iman-and by extension Al B. Sure!, with whom he is duetting and who functions as a sort of proxy for Iman in the song-will not kill him. Then he admits he sometimes wonders why she won't, given white people's appalling racism and mistreatment of black people through the centuries.

Of course, the reason Iman won't kill him is because she loves him. And as James Baldwin assures us in *The Fire Next Time*, one of the wisest polemics ever written, "Love takes off the masks that we fear we cannot live without and know we cannot live within."

The book, which is in two parts, had its roots in a letter to Baldwin's nephew on the centenary of black America's "emancipation." The elegance of Baldwin's sentences, with their teeming subclauses and rich biblical cadences, is a function of anger, the same anger that energized the LA rioters. It is also a desperate need to cancel out the real white noise—the spurious national mythology white people invoke to convince themselves that their ancestors were wise, fair-minded heroes who always treated their neighbors and ethnic minority populations honorably.

Baldwin has news for his nephew: it's not for white people to decide it's within their gift to accept him. Nor should he try to impersonate them in any way or be tempted to believe that he is what the white world thinks he is—inferior. Why should black people have respect for the standards by which white people claim to live when it's clear those standards are illusory?

He sounds implacable. Yet Baldwin, like Bowie, believes that the future has to be postracial. Hybrid. Tolerant. There can be no frisson of shock, no disapproval on either side, when it comes to interracial marriage and mixed-race children. When, in the book, Baldwin meets with Elijah Muhammad of the separatist Nation of Islam, he understands the doctrine of black self-sufficiency and self-respect Muhammad preaches but is suspicious of the groupthink he inspires in his followers. Baldwin has white friends he would trust with his life. Can he set this fact against the historic evilness of white people? Muhammad would say no. But for Baldwin there is no other way forward.

84 4 John O'Connell

There is an invented aspect to racial difference, Baldwin felt. Which is how it becomes a tool of oppression: "Color is not a human or a personal reality. It is a political reality." Views like this set him apart from the radical black movements of the late '60s and early '70s, some of whose followers and leaders—Eldridge Cleaver, for example—saw Baldwin's homosexuality as deeply suspect, even treasonous. Baldwin had no wish to be typecast, or to be a spokesman—hence his move to France at the age of twenty-four.

Plenty of the books on Bowie's list are thrilling, fun, or informative. Many of them are important. *The Fire Next Time* is essential.

Read it while listening to: "Black Tie, White Noise"

If you like this, try: James Baldwin, Another Country

Angela Carter, Nights at the Circus (1984)

t might be laboring the point to say Bowie knew all about traveling circuses and freak shows, from the vaudeville troupers of his Brixton childhood to the louche court over which he presided as a touring rock star. But his knowledge may well have fed into his admiration for *Nights at the Circus*, one of the most underrated British novels of the 1980s. It turned out to be Carter's penultimate work: she died of lung cancer in 1992, at the age of fifty-one.

Drawing on folklore and fairy tales, Carter created spellbinding dream-realities that defy all conventional laws of time and space—a bit like glam rock, which she recognized as dandyism, "the ambivalent triumph of the oppressed." Her stories and novels often take the form of feminist fables set in exotic landscapes where resource-

ful heroines battle cruel, autocratic villains. Nights at the Circus draws on the picaresque tradition: think of Miguel de Cervantes's Don Quixote or Charles Dickens's The Pickwick Papers.

Nights at the Circus whisks us to Saint Petersburg and Siberia before it's through. But it opens in London in 1899, in the dressing room of acclaimed aerialiste Sophie Fevvers, who was (she says) hatched from an egg. This freakish giantess is telling her story to an American journalist, Jack Walser. And what a story it is—of how, as a foundling, Fevvers was raised by prostitutes and styled as their mascot, a powder-white Cockney Venus. When puberty hit, the feathery buds on her back blossomed into wings. But (she says) she remained a virgin, the only fully feathered virgo intacta in history.

When her luck changes, Fevvers is forced to work in a different, more sordid brothel, playing a tombstone angel at the head of a naked woman on a marble slab—"Sleeping Beauty." Then she narrowly avoids being sacrificed by a religious maniac calling himself Christian Rosencreuz, after one of the founders of Rosicrucianism (see p. 104). But she lives to tell the (tall) tale. So entranced is Walser that, even though he thinks of himself as a hard-bitten skeptic, he joins Fevvers on her Grand Imperial Tour, working as a clown alongside downtrodden Mignon, who waltzes with tigers; Monsieur Lamarck, Mignon's abusive monkey-trainer husband; and a clairvoyant pig called Sybil, whom the tour's manager, Colonel Kearney, consults before making any business decisions.

Is Fevvers a fraud? Does it matter? (There are obvious shades here of Lawrence Weschler's Mr. Wilson's Cabinet of Wonder, about the Museum of Jurassic Technology—surely Fevvers's natural home. See p. 274.) Nights at the Circus keeps us guessing even when

BOWIE'S BOOKSHELF 4 87

Fevvers seems to give the game away, her beguiling, bullshitting, clever-Cockney voice swooping high and low, and sounding, at times, disarmingly like Bowie's.

Read it while listening to: "Look Back in Anger"

If you like this, try: Angela Carter, The Bloody Chamber

Eliphas Levi, Transcendental Magic: Its Doctrine and Ritual (1856)

This is an obscure tome from Bowie's portable library circa 1975, the height of his cocaine crackup. Eliphas Levi was the Hebrew pseudonym of Alphonse Louis Constant, the son of an impoverished Parisian shoemaker. Devoutly religious, he trained as a Catholic priest but was never ordained, which omission left him free to marry. His wife walked out, however, after which he developed an obsessive interest in mesmerism, the tarot and, especially, the esoteric strand of Judaism known as kabbalah.

Levi's influence in occult circles grew after the publication of *Transcendental Magic*. The preface to the English edition tells us the great magus was "commonly to be found *chez lui* in a species

of magical vestment"—a dressing gown with buttons, if the sole surviving photograph of him is anything to go by. Leading lights within England's magic scene such as Frederick Hockley, employee of a famous occult bookseller in London's Covent Garden called John Denley, made pilgrimages to his house. Levi visited Britain twice, in 1854 and 1861, on both occasions enjoying the hospitality of politician-cum-novelist Edward Bulwer-Lytton at his Knebworth estate. Lytton gave Denley a cameo in Bowie favorite Zanoni (see p. 103) as the bookseller D, who "lavished a fortune in the purchase of unsalable treasures."

Kabbalah underpins Bowie's transcendent spiritual epic "Station to Station," the magical movement from Kether to Malkuth: in other words, from the godhead-like top of the Sephiroth, or Tree of Life, to the quotidian bottom. The Sephiroth is represented by a map on which each stage, or "station," numbered from one to ten, is supported by pillars representing mercy (on the right-hand side), severity (on the left), and balance (the central channel, down which divinity flows into the lower regions). Bowie's wonky drawing of it is visible in the famous photo Steve Schapiro took of him wearing a stripy jumpsuit that was later used in the artwork for the 1991 reissue of *Station to Station*.

According to the laws of kabbalah, man is able to manipulate events in the earthly sphere by connecting to the higher, divine sphere through the medium of his astral body. When Bowie warns us in "Breaking Glass" not to look at the carpet because he drew something awful on it, he's referring to the practice—cautioned against by Levi, who called black magic "an epidemic of unreason"—of drawing particular combinations of lines and symbols on the floor

90 4 John O'Connell

in order to summon visions and/or assert diabolical control over a person. "What are you drawing?" the US TV host Dick Cavett asked Bowie in a notorious 1975 edition of his talk show when he noticed his emaciated, nasally congested guest scrawling something on the floor with a cane. "Your attention," Bowie replied, quick as a flash.

Read it while listening to: "Station to Station"

If you like this, try: Eliphas Levi, The Mysteries of the Qabalah

Sarah Waters, Fingersmith (2002)

One night in the late 1960s, David Jones was walking home with his older half brother, Terry. It had been a momentous night—a Cream show in Beckenham, Terry's first rock concert. (Jazz had always been more Terry's thing.) But suddenly Terry's behavior grew strange. Claiming he could see cracks in the road with flames coming out of them, he got down on all fours and gripped the tarmac, terrified he was about to be sucked into space. . . .

"When he came back from doing service in the RAF he was in his early twenties and I was about ten years old," Bowie told *Crawdaddy* magazine. "And he would seem miserable. We'd been told he was ultra-intelligent in school. Then he got to where he almost vegetated, wouldn't talk, read, wouldn't do anything." Terry was diagnosed with schizophrenia and incarcerated in Cane Hill Hospital in Coulsdon near Croydon (see p. 232). On January 16, 1985, he walked down to the local train station and lay down on the rails: he'd attempted this method of suicide once before. That time he'd been thwarted. This time he was successful.

Mental illness ran in David Bowie's family. The curse, as he

thought of it, was concentrated on his mother's side: his aunts Vivienne, Una, and Nora were all afflicted to some degree, Vivienne with schizophrenia, like Terry. Bowie's fear that he might have inherited the gene gnawed at him all his life and explains the obsession with mental instability that haunts his work, from the mournful punning of *Aladdin Sane* to the blanked-out catatonia evoked by *Low*'s droning soundscapes. It's no surprise that so many of his favorite books touch on the subject.

Sarah Waters's 2002 novel Fingersmith is one of them. The last of the trio of "lesbo Victorian romps" (as the author self-mockingly described them) that made Waters's name, it's a loving pastiche of English "sensation novels" of the 1860s and '70s, such as Mary Elizabeth Braddon's Lady Audley's Secret, Sheridan Le Fanu's The Rose and the Key, and Wilkie Collins's The Woman in White. Here, madness is part of a cocktail that also includes identity theft and long-buried family secrets. The aim of sensation novels was to supply a delicious, transgressive, almost erotic thrill. Fingersmith's plot is obligingly dense with secrets and deceptions. Richard "Gentleman" Rivers enlists orphan Sue, raised in the rookeries of London's Borough district, as a petty thief, or "fingersmith," to help him trick an innocent heiress called Maud into marrying him so that he can make off with her fortune. Sue will become Maud's maid and chaperone, receiving a cut of the profits for her efforts. But she falls deeply in love with Maud-so deeply, she fails to notice that she too is being duped.

The novel's midpoint twist, borrowed from *The Woman in White*, pulls the rug from under our feet, shuttling us headlong into the mansions cold and gray of Bowie's song "All the Madmen." But

BOWIE'S BOOKSHELF 4 93

Fingersmith is much more than pastiche. What's brilliant about it is the way it transcends its sources to become something startlingly, vibrantly new. By teasing out fresh associations and moving what was latent in the Victorian originals to the foreground, Waters mirrors Bowie's own magpie method as an artist. As his glam peers Roxy Music put it: remake, remodel.

Bowie loved slang and occult arcana. Waters has said that Christopher Lilly, Maud's uncle who obsessively collects (and forces Maud to read aloud from) pornography, is based on Henry Spencer Ashbee, who between 1877 and 1885 published three annotated bibliographies of erotica under the pseudonym Pisanus Fraxi. Ashbee is rumored to be the true identity of "Walter," author of the Victorian sexual memoir *My Secret Life* that was one of Aleister Crowley's favorite books. As a Crowley fan, Bowie would have relished this tissue of connections.

Read it while listening to: "All the Madmen"

If you like this, try: Sarah Waters, Tipping the Velvet

34

William Faulkner, As I Lay Dying (1930)

Sometime in the late 1990s, Bowie had his crooked, nicotine-stained "British teeth" fixed. He would, then, have appreciated the important role played by teeth in As I Lay Dying, Faulkner's compact epic of rural life in 1920s Mississippi. Teeth and sex. They're the main reason Anse Bundren is so happy to respect his dead wife Addie's wishes and drag her corpse forty miles from their isolated village to the town of Jackson so that she can be buried among her own people. He wants new teeth and a new wife. Never mind that it's baking hot and Addie's corpse is starting to smell. Never mind that the bridge he and his family—sensitive Darl, carpenter Cash, violent Jewel, pregnant Dewey Dell, and traumatized youngest child Vardaman—need to cross has completely washed away.

This being a modernist masterpiece, Faulkner refracts his account of the journey through multiple viewpoints—mostly the family's, though also their neighbors' and that of the doctor who tends Addie. Nineteen of the fifty-five interior monologues are Darl's. Which ought to be a problem, given the way Darl's mental state deteriorates as the novel progresses. He seems to feel the awful urgency of

the family's situation more keenly than anyone else. One night he sets fire to a barn where the family have stored Addie's stinking coffin; the act results in his arrest and transportation to a state mental institution. Literary critics have queued up to diagnose schizophrenia. It's this, they say, that lends his monologues their uncanny clarity and intelligence. Mental illness makes Darl a privileged observer, a poet, a seer. It's all very R. D. Laing (see p. 232).

Where did Bowie first encounter Faulkner, who famously wrote As I Lay Dying in six weeks, at night, while working at a power plant? Maybe through the Zombies' song "A Rose for Emily," which compresses Faulkner's story of that name into two minutes and nineteen seconds. Bowie mostly steered clear of Southern Gothic influence in his own work, though it seeps into 1.Outside. And toward the end, of course, there was the frenzied murder ballad "Sue (Or in a Season of Crime)" with its talk of endless faith in hopeless deeds. Which is a good way of summing up As I Lay Dying.

Read it while listening to: "Please Mr. Gravedigger"

If you like this, try: William Faulkner, The Sound and the Fury

35

Christopher Isherwood, Mr. Norris Changes Trains (1935)

Berlin in the 1970s: a bleak, divided city still haunted by its Nazi past. Disreputable and forbidding, it was a magnet for artists and activists as well as the source of the best new music—Neu!, Kraftwerk, Tangerine Dream. Bowie and Iggy Pop moved there in August 1976, renting an unassuming flat at 155 Hauptstrasse in the mostly Turkish Schöneberg district.

Bowie was twenty-nine and almost broke; addicted to fame, yet bored with its trappings. Berlin would be a sanctuary for him, a place where he could recharge his creative batteries. Conveniently, he already had a spiritual guide to the city's dark mysteries: Christopher Isherwood.

Isherwood's two semiautobiographical "Berlin novels," of which Mr. Norris Changes Trains is the first and 1939's Goodbye to Berlin the second, would probably have come to Bowie's attention in their various adapted forms, most famously John Kander and Fred Ebb's 1966 Broadway musical Cabaret. Judi Dench played Sally Bowles in Cabaret's 1968 London run, and the 1972 film version had a powerful influence on the Ziggy Stardust stage shows. Although some credit Bowie's first manager, Kenneth Pitt, who accompanied the singer on his first trip to Berlin in October 1969, with introducing him to Isherwood's work. Pitt would have encouraged Bowie to watch the BBC's Omnibus documentary on Isherwood, "A Born Foreigner," broadcast upon their return in early November. But Bowie rediscovered Isherwood during his mid-1970s LA phase and met him when the author popped backstage with artist David Hockney to say hello after watching the singer perform in the city in March 1976. (The two remained friendly: four years later Isherwood was in the audience on the opening night of The Elephant Man.)

Emaciated and cocaine-addicted, Bowie developed a romantic fixation with Weimar Berlin—a place where, as Isherwood put it, hate had a habit of erupting suddenly out of nowhere. Divining the source of this hate, Bowie created the occult-obsessed Nietzschean overlord the Thin White Duke for his album *Station to Station*. Not long after, he plotted an escape route from excess, for himself and Pop, that was a knowing reversal of the journey Isherwood and his lover/mentor W. H. Auden had made in 1939 when the pair fled Berlin for America.

Prickly, aloof Isherwood had moved to Berlin in 1928, quitting his medical studies in Britain to become a long-term sex tourist in a city renowned for its sparkling degeneracy and obliging rent boys. *Mr*.

Norris Changes Trains chronicles rather coyly his adventures there as the Nazis' grip tightens, focusing on the relationship between passive, camera-like narrator William Bradshaw (Isherwood, essentially) and Arthur Norris, a fraudulent, beguilingly camp opportunist of indeterminate profession.

Their first, memorable encounter is on a train. Norris, sweatily terrified, is traveling with a false passport. Isherwood/Bradshaw takes callous pleasure in Norris's grotesque appearance—his ludicrous, ill-fitting wig; his enormous, misshapen nose; his terrible teeth like broken rocks. But despite his looks, and beneath the charming surface, Norris is inscrutable. Isherwood based him on fellow expat Gerald Hamilton, a shadowy, self-invented figure who was at various points a spy, a Communist agitator and, supposedly, a roommate of Aleister Crowley.

Isherwood loved Berlin for the boys, but also because he believed forcible dislocation made him a better novelist, the sort of novelist Auden was always telling him he could be. As it transpired, his Berlin novels were an artistic high it would take him until 1964 and A Single Man (filmed in 2010 by Tom Ford) to reach again.

Embracing what Isherwood called the mystery-magic of foreignness, Bowie and Pop reinvented themselves in Berlin. They also partied hard, as Isherwood had, with the help of scenesters such as Bowie's transgender lover and muse Romy Haag. Somewhere along the line Bowie found time to finish off *Low* and record the whole of "*Heroes*" with Brian Eno and Tony Visconti at the dilapidated Hansa studios in the shadow of the Berlin Wall.

Read it while listening to: "Art Decade"

If you like this, try: Stephen Spender, The Temple

Jack Kerouac, On the Road (1957)

Bowie's older half brother Terry introduced him to all things hip—John Coltrane, Eric Dolphy, Tony Bennett, "bluebeat" R&B from Jamaica. On the Road was part of the package, but arguably the biggest part. By giving him Kerouac's Beat classic to read when he was twelve, Terry transformed young David's sense of the world and intensified his frustration with his hometown of Bromley where, he felt, nothing belonged to him culturally. After finishing it, Bowie started painting and asked his father if he could learn the saxophone.

On the Road is about freedom, escape, spontaneity, and creativity (and drugs and sex); the possibility of America, or at least an ideal of America that matched the teeming, multifarious America of Bowie's childhood imagination. The tension between this magical country and Cold War-era America as its critics saw it—closed-off, paranoid, warmongering—never stopped fascinating him. Hence the presence on the list of so many American writers, particularly Lost Generation novelists and poets who came of age during the First World War (e.g., F. Scott Fitzgerald, John Dos Passos, Wil-

liam Faulkner, and Hart Crane) and were as important in creating a sympathetic climate for Beat writing as more obviously proto-Beat figures such as John Fante and Dashiell Hammett.

Jack Kerouac was a former football star and university dropout from a French-Canadian Catholic family. Between 1946 and 1948 he crisscrossed America, stopping in Los Angeles, San Francisco, Mexico City, and Denver, among other places, sometimes accompanied by his friend and muse Neal Cassady. These trips formed the basis of *On the Road*, written in April 1951, although it didn't find a publisher until 1957, by which time its path had been smoothed by the success of another key Beat text, Allen Ginsberg's visionary poem *Howl*.

The core of *On the Road* is the relationship between Sal Paradise, a stand-in for Kerouac himself, and Dean Moriarty, based on Beat linchpin Cassady—a former slum-child petty criminal turned hyperbright autodidact. With whom did Bowie identify more strongly: writer Sal, who thinks of Dean as a long-lost brother? Or Dean, the Beat aesthetic incarnate; one of those special, madness-tinged people who never say a boring, ordinary thing and burn like roman candles? Certainly, the adolescent Bowie could never have imagined (or could he?) that within ten years he would be mixing with real-life Beat royalty, including Ginsberg and William Burroughs, on whom some of the characters in *On the Road* were based.

On the Road's massive impact on Bowie had three aspects. First, as he told Q in 1999, it made him feel "I wanna do that [i.e., drive across America], I do not wanna go down to Bromley South station and take the fucking train to Victoria station and work in a bloody advertising office again."

Second, it transformed his sense of how art could be made. Kerouac's "spontaneous prose"—he typed *On the Road* on a continuous scroll of tracing paper in a Benzedrine-fueled three-week burst—was the literary equivalent of bebop's improvisational élan, as exhibited by musicians such as Charlie Parker and Thelonious Monk. It showed Bowie how different art forms could spring from the same source and complement one another. And it alerted him to other rule-based compositional methods, for example Burroughs and artist Brion Gysin's randomizing cut-up technique and the aleatory devices of John Cage (see p. 74).

Third, On the Road framed art-making as a spiritual quest. Beat and Zen Buddhism were natural bedfellows, each focused on the purity of the transcendent moment. Poet Gary Snyder, a leading member of the West Coast wing of the Beats, introduced Kerouac to Zen in the mid-1950s. Before moving to Japan to live in a monastery, Snyder took Kerouac climbing on the Matterhorn mountain in Yosemite; the jaunt triggered in the latter a psychic epiphany—you can't fall off a mountain; when you get to the summit, keep going—similar to Douglas Harding's mind-blowing awareness of having no head (p. 148).

At the heart of Kerouac's method was the Zen-derived Beat dictum "first thought, best thought." Revision and elaboration kill feeling, kill the *moment*. Did you ever, Kerouac asked his *Paris Review* interviewer Ted Berrigan, hear a man telling a long wild story in a bar that the audience was enjoying, only for him to stop suddenly, go back to a previous sentence, and try to improve it? Of course you didn't.

Bowie's love of immediacy comes straight from Kerouac and

102 4 John O'Connell

explains why he mistrusted virtuosity in musicians (despite using virtuoso players when it suited him); why he preferred to write lyrics quickly and at the last minute, often using cut-ups; and why, when he was recording a song, he never did more than two vocal takes if he could help it.

Read it while listening to: 1.Outside

If you like this, try: |ack Kerouac, The Dharma Bums

37

Edward Bulwer-Lytton, Zanoni (1842)

"In dreams commences all human knowledge; in dreams hovers over measureless space the first faint bridge between spirit and spirit—this world and the worlds beyond..."

-Edward Bulwer-Lytton

dward Bulwer-Lytton was a rock star before rock stars existed: an aristocratic, bisexual, opium-addicted, paranormal-obsessed Orientalist dandy rumored to have had affairs with both Byron's oddball mistress Lady Caroline Lamb and prime minister Benjamin Disraeli. Tragically for a man so vain, Lytton is better known now for inspiring the plot of Wilkie Collins's *The Woman in White* (see p. 92)—he had his wife, Rosina, confined to a lunatic asylum—and for originating the phrases "It was a dark and stormy night" and "The pen is mightier than the sword" than for any of his literary achievements. He also maintained a successful parallel career as a politician: he entered Parliament in 1831, rising to the post of colonial secretary in 1858.

Bulwer-Lytton found success early with so-called silver-fork romances such as *Pelham*. After that he had a crack at almost every genre, attracting a larger readership than either Charles Dickens or Sir Walter Scott, but in later life he seemed most comfortable churning out ghost stories and occult-tinged science fiction like *The Coming Race*, about superintelligent aliens called Vril-ya who live underground and intend to invade our surface world when they run out of room. Bowie had clearly read this—or at least *The Morning of the Magicians* (see p. xx), which links the novel to a secret interwar community of German proto-Nazis called the Vril Society—by the time he recorded *Hunky Dory*. He name-checks it in "Oh! You Pretty Things," a deceptively jaunty warning to parents that they are about to be supplanted by their superintelligent alien children.

Judged on purely literary merit, Zanoni is awful, overwrought even by Bulwer-Lytton's standards. William Makepeace Thackeray dismissed it as "premeditated fine writing" and mocked its author's affectations: "If he would but leave off scents for his handkerchief, and oil for his hair: if he would but confine himself to three clean shirts a week, a couple of coats a year, a beef-steak and onions for dinner . . . how much might be made of him even yet." You can't imagine anyone reading Zanoni for pleasure, though Bulwer-Lytton considered it his best book, calling it "this well-loved work of my matured manhood." Which is one way of putting it.

Zanoni is about Rosicrucianism, a spiritual movement that holds that the world is run by a clandestine network of alchemists and sages possessing special knowledge passed down from ancient civilizations. (In fact, Rosicrucianism and its alleged originator, a knight called Christian Rosenkreuz, were the jokey invention of a seventeenth-century German theologian.) This notion fed into

Bowie's cocaine-fueled mid-1970s obsession with UFOs, hermetic magic, and the occult roots of Nazism.

As well as being friends with Eliphas Levi (see p. 88), Bulwer-Lytton was a devotee of theosophy, the Eastern-tinged philosophical tradition partly based on Rosicrucianism and founded by another of Bulwer-Lytton's chums, Helena Blavatsky. A Russian mystic, Blavatsky claimed to have traveled alone in Tibet, where she acquired esoteric powers from an "adept" called Master Morya, the reincarnated form of King Arthur, Sir Thomas More, and Akbar the Great, founder of the Mogul empire.

The novel's eponymous hero is a rich, exotic stranger ("mysterious, haunting, yet beautiful and stately") who confounds the Neapolitan high society he moves in by seeming never to age. It turns out he is one of the Rosicrucian elect, a genius whose job is to diffuse knowledge downward through society ("the few in every age improve the many"); immortal, as long as he resists every human tie. But he falls in love with an opera singer, Viola Pisani, which act would be complicated enough without the appearance on the scene of a rival for Viola's affections—Glyndon, an Englishman whose life Zanoni saved a little earlier on.

When Viola discovers Zanoni's secret—she disturbs him in the private chamber where he recharges his Rosicrucian powers—she is horrified ("Why did I never recoil before from thy mysterious lore?") and moves with Glyndon to revolutionary Paris, where, for reasons that need not detain us here, she's sentenced to death by guillotine. Having followed the pair to the city, Zanoni gallantly steps in and saves her by offering *his* neck instead.

It isn't absurd to see Zanoni as a forerunner of comic-book

superheroes such as Batman and Spider-Man. And it's uncanny, or perhaps not, how much Zanoni resembles both Thomas Jerome Newton—Bowie's character in *The Man Who Fell to Earth*, whose power fades as he acquires all-too-human addictions to alcohol and television—and John Blaylock, the vampire cellist Bowie plays in Tony Scott's film *The Hunger*. Blaylock could even be Zanoni reborn, for he is supposed to have married his equally sharp-toothed wife in eighteenth-century France. . . .

Like most dandies, Bulwer-Lytton never came to terms with aging. Portrait artists were encouraged to paint him as a young man, but Victorian cameras could not lie so easily. Confronted by a photograph taken of himself in 1871 he was appalled, comparing his appearance to "the ghost of a retired butler who has perished in a snow storm."

Read it while listening to: "Oh! You Pretty Things"

If you like this, try: Edward Bulwer-Lytton, The Coming Race

38

George Orwell, Inside the Whale and Other Essays (1940)

n 1940 George Orwell (see *Nineteen Eighty-Four*, p. 77) reviewed more than one hundred books, so where he found the time to write essays of the caliber of the three collected in *Inside the Whale and Other Essays*—"Charles Dickens," "Boys' Weeklies," and the title essay—is anyone's guess. The first two are each in their own way meditations on Englishness, which would have been the attraction for Bowie, always a keen student of the subject. But the one that got him excited would have been "Inside the Whale," a shrewd analysis of Henry Miller's 1934 novel *Tropic of Cancer*, about low-living bohemian expats in interwar Paris.

Orwell is intrigued by a particular paradox. The obscene, debauched subject matter of Miller's then banned novel ought to alienate morally upstanding readers. But somehow it doesn't because Miller's talent is to put you right down there among characters who are utterly familiar, to the point where you feel that what has happened to them could happen to you—when you have never in your

life been slumped on a Montparnasse pavement in a pool of your own vomit after being kicked out of a brothel.

Politically, the author of *Nineteen Eighty-Four* had little time for Miller. When the pair met briefly in Paris in 1936—Orwell was on his way to fight in the Spanish Civil War—Miller gave Orwell his corduroy jacket as a token of goodwill but told him he was an idiot for thinking anything he did could halt Fascism. Even so, Orwell thinks *Tropic of Cancer* is a book everyone should read because its honorable squalidness reflects Miller's belief that if civilization collapses, as Orwell thinks it will during the coming Second World War, it doesn't really matter. In doing this it points the way forward for literature in the second half of the twentieth century, especially (though Orwell obviously could not have foreseen this) the rawness and immediacy of the Beats.

Miller resembles the biblical Jonah in the sense that he has insulated himself in a dark, comfy space, where he remains passively indifferent to the grand historical sweep of whatever is happening beyond its blubbery walls. But this attitude actually brings him closer to ordinary people, because they are themselves mostly passive. Orwell loves *Tropic of Cancer* for its relentless focus on ordinary, everyday experiences and physical activities—vomiting, shitting, fucking. Its honesty makes for a strong empathetic bond between author and reader. Read Miller for five or ten pages, says Orwell, and you experience a kind of relief, one that comes "not so much from understanding as from *being understood*." You feel as if Miller knows all about you and is writing for you and you alone.

What Orwell gets, and expects us to get, from Miller's nonjudgmental acceptance of life in all its shades of sorrow and degradation

BOWIE'S BOOKSHELF 4 109

is what middle-class college graduate Lou Reed got from reading Hubert Selby Jr. (see p. 188) and what, further down the line, Bowie got from listening to Reed songs like "I'm Waiting for the Man," written under Selby's influence. Miller might offend some people, but in the end (to borrow Orwell's formulation), what people do feel is as important as what they *ought* to feel.

Read it while listening to: "The London Boys"

If you like this, try: George Orwell, Down and Out in Paris and
London

39

John Rechy, City of Night (1963)

"I was looking to create a profligate world that could have been inhabited by characters from Kurt Weill or John Rechy. . . . A bridge between Enid Blyton's Beckenham and the Velvet Underground's New York. Without Noddy, though."

-David Bowie, talking about Diamond Dogs

Bowie probably read City of Night around the time he was reading Hubert Selby Jr. (see p. 188) and discovering the Velvet Underground. In which case he would have been amazed by the debt Lou Reed's songs owed to both.

Such was the buzz around City of Night that it entered the New York Times bestseller charts before it was published. Never had the gay underworld of the late '50s and early '60s been so graphically mapped. Rechy's unnamed hustling Latino "youngman" ricochets between New York, San Francisco, LA, Chicago, and New Orleans, searching for meaning and a sense of identity as well as sex, which he has convinced himself he is having for money rather than because he enjoys it—denial is the default mode here. This is the "shadow love" of "John, I'm Only Dancing"; what small Jean Genie gets up to

after he's slunk off to the city. Talking of "The Jean Genie," among much else a tribute to the French novelist and activist Jean Genet, note that the English translation of Genet's similar, semiautobiographical *The Thief's Journal* was published around the same time.

In 1975 Bowie would sing that fascination was a part of him. In City of Night, as he knew, "F*A*S*C*I*N*A*T*I*O*N" is spelled out on a huge sign in front of a gay nightclub in Times Square. Bowie mined this world for visual iconography, too. As Camille Paglia (see p. 222) notes, the back cover of The Rise and Fall of Ziggy Stardust and the Spiders from Mars shows Bowie posing as a rent boy in a lighted telephone box, his elegant fingers and slinky hips suggesting a woman but his exposed chest and swollen crotch suggesting a male prostitute.

In City of Night, there's a sense of the windows being thrown open in a stuffy room, but the tone is anything but celebratory. For what is there to celebrate? The "city of night" is a state of mind. Rechy's hustler is desperate to forge connections with the men he encounters, but the covert nature of the scene, not to mention the complexity of the individuals who people it, makes this impossible. Everyone is wearing a mask. Everyone is afraid. It doesn't help that in this world, as Rechy puts it (anticipating a certain song on Alad-

112 4 John O'Connell

din Sane), the end of youth is a kind of death. Time is always the enemy.

Rechy refracts the resulting melancholia through a bleak urban poetry whose broken grammar and phonetic spelling resemble Selby's, and, in more subtle ways, Kerouac's. Like the *On the Road* author, Rechy worked hard to create the impression of spontaneity in his writing while leaving room for a tender lyricism that cuts through the secrecy and pretense and haunting sense of old faces being unsuccessfully erased by new ones.

Read it while listening to: "John, I'm Only Dancing"

If you like this, try: John Rechy, The Sexual Outlaw: A

Documentary

David Sylvester, The Brutality of Fact: Interviews with Francis Bacon (1987)

David Bowie wasn't a big fan of Francis Bacon and his raw, often grotesque paintings. "Two or three pieces I find extraordinary," he told the *New York Times* in 1998. "But he weakened fast. His demise was swift."

Still, Bacon remained important to Bowie. Though the two worked in different media (Bowie also painted, and took it seriously enough to exhibit his work), their compositional methods had much in common, as David Sylvester's vivid, arresting interviews with Bacon, conducted over a twenty-five-year period, make clear. Both Bowie and Bacon wanted to provoke an emotional response—Bacon used abstraction to amplify figurative aspects in his work and create a violent yet poignant effect in the viewer. Both used drink and drugs to free themselves up creatively—Bacon says he hardly knew what he was doing while painting his *Three Studies for Figures at the Base of a Crucifixion* triptych because he was so out of it; Bowie often claimed to have no memory of making one of his greatest albums, *Station to Station*. Both believed passionately in the need to embrace

the accidental without allowing it to dominate—as Bacon puts it, to keep the vitality of the accident without being disrupted by it.

In the late 1970s and again in the mid 1990s, the job of ensuring Bowie stuck to this brief fell to Brian Eno, his collaborator on the albums *Low*, "*Heroes*", *Lodger*, and *1.Outside*. Eno kept the singer and his backing musicians in a state of flux and uncertainty with his Oblique Strategies cards (see John Cage, p. 74). Bacon expresses regret that he never had this kind of midwife figure, someone to play Ezra Pound to his T. S. Eliot—someone to tell him what to do and not do and give cogent reasons.

One of the twentieth century's foremost art critics, Sylvester probes with the gentle empathy of a psychotherapist and is rewarded with detailed, sometimes surprising answers. Did Bowie study Sylvester's technique before interviewing Tracey Emin, Damien Hirst, and Balthus for *Modern Painters*, the magazine whose editorial board he joined in the mid-'90s? Balthus wouldn't have appreciated it if he had—he agreed to talk to Bowie specifically because he didn't want to have an "intellectual" conversation.

One day toward the end of Sylvester's life, his daughter Xanthe visited him in the hospital where he was recuperating after an operation. She arrived to find him talking animatedly on the phone. When the conversation had finished, Sylvester announced with delight: "You'll never guess who that was—David Bowie, asking me what I thought of his paintings!"

Read it while listening to: "The Voyeur of Utter Destruction (as Beauty)"

If you like this, try: David Sylvester, *Interviews with American Artists*

Julian Jaynes, The Origins of Consciousness in the Breakdown of the Bicameral Mind (1976)

ulian Jaynes was an eccentric Princeton psychologist with a tantalizing, if wholly speculative, theory about brain function. Using examples from early literature such as Homer's *Iliad* (see p. 34), Jaynes argued that until three thousand years ago humans didn't experience consciousness as we do. Instead, they performed ordinary human activities (eating, speaking, fighting, building) like automata, without any higher-order subjective awareness or facility for introspection.

Why? Because their brains were arranged in a bicameral, or "two-part," fashion: the decision-making right hemisphere transmitted auditory hallucinations—voices telling it what to do—to the left, which interpreted these voices as "gods" and obeyed them accordingly. For millennia this arrangement persisted, bolstered by rigidly hierarchical societies where everyone had a clear sense of purpose. But as famine, war, and overpopulation took their toll, sometimes forcing mass migrations, the bicameral mind began to break down. Once humans realized they could speak to themselves,

and as language itself grew more sophisticated, the gods' voices faded away.

Believe it or not, *The Origins of Consciousness* was a great success. Lay readers loved it for Jaynes's enthusiasm and gleeful portentousness. "O, what a world of unseen visions and heard silences," it begins, "this insubstantial country of the mind!" His fellow scientists were more skeptical, pointing out that his ideas had little basis in neurological fact. Richard Dawkins declared it either complete rubbish or a work of genius, nothing in between.

It isn't hard to find the romance in what Philip K. Dick called a "stunning theory," nor to understand what Bowie saw in it—a whole new approach to mental illness. As noted elsewhere, the plight of his half brother Terry gave Bowie a deep appreciation for writers who found in schizophrenia special rather than shameful qualities. Jaynes saw schizophrenia as a partial relapse to the bicameral mind because of the way sufferers hear voices compelling them to carry out certain actions; the way the narrator of Bowie's song "Look Back in Anger" experiences an angelic visitation falls into this category as well. In this sense, Jaynes thought, it was similar not only to demonic possession but to artistic creation, particularly the kind that operates under the radar of consciousness—like that in two of Bowie's favorite art movements, Dada and surrealism, for example.

Read it while listening to: "Look Back in Anger"

If you like this, try: Oliver Sacks, Musicophilia: Tales of Music
and the Brain

F. Scott Fitzgerald, The Great Gatsby (1925)

"Bowie was never meant to be. He's like a Lego kit. I'm convinced I wouldn't like him, because he's too vacuous and undisciplined. There is no definitive David Bowie."

—David Bowie in People magazine, 1976

Scott Fitzgerald times Jay Gatsby's entrance with a showman's stopwatch. We're a quarter of the way through this taut, perfectly formed novella before narrator Nick Carraway meets him at one of Gatsby's famous weekend parties—and has no idea whom he's talking to, because the Trimalchio of West Egg has momen-

tarily dialed down his charisma. But then he dials it up again, flashing a warm, empathetic smile that "understood you just so far as you wanted to be understood, believed in you as you would like to believe in yourself, and assured you that it had precisely the impression of you that, at your best, you hoped to convey." Remind you of anyone?

Until then Gatsby has been a haze of rumors—that he killed a man once, that he was a German spy in the war. Like Gatsby's affected habit of calling people "old sport," it all hints at something louche and self-invented, so much so that by the time we find out Jay Gatsby is really James Gatz, son of poor farming folk from North Dakota, and a gangster to boot, it isn't much of a surprise.

The gaudy display is all to win back Daisy, his onetime love, now married to brutish Tom Buchanan. Nick says at the start that Gatsby "turned out all right at the end" and blames his hangers-on for his undoing. But Gatsby, like so many of the celebrities who would emulate him, is shallow, vain, and petulant: the original dandy in the underworld, with his pink suit and mass of beautiful shirts which he pulls from the wardrobe to throw at Nick and Daisy.

At the end, before Gatsby's funeral, his weeping father says James/Jay made a success of himself because he used his brain. But he didn't, not really. He used his looks and charm and determination. He allowed himself to be dressed as a sailor by an elderly mentor, copper magnate Dan Cody, who employed him in what Nick winkingly calls "a vague personal capacity." Bowie, who as a young man had versions of that relationship with the mime artist Lindsay Kemp and the composer Lionel Bart, might have chuckled at this.

The salient line in The Great Gatsby is the one about personality

BOWIE'S BOOKSHELF 4 119

being an unbroken series of successful gestures. The salient image is of Gatsby standing at the end of the dock, arms outstretched toward the small green light on the opposite shore—asking Daisy (I like to think) to give him her hands because she's wonderful.

Read it while listening to: "Can You Hear Me"

If you like this, try: F. Scott Fitzgerald, Tender Is the Night

Julian Barnes, Flaubert's Parrot (1984)

ow do you get into the head and heart of an artist you admire? Maybe you can't, however much you want to. Julian Barnes's head-spinning third book squats at the junction of biography, literary criticism, and postmodern fiction, thumbing its nose at all three. Its fussy narrator, a retired doctor called Geoffrey Braithwaite, is a Gustave Flaubert superfan who, grief-stricken after his wife's death, wants to find out *everything* about the author of *A Sentimental Education* and *Madame Bovary* (see p. 32) to plug the gaping hole in his soul.

Braithwaite can't stop himself obsessing about the minutiae of Flaubert's life, even though he knows deep down that doing so won't help him. A "definitive" account of any life is as fantastical as a uni-

corn. Why, he wonders, does the writing make us chase the writer? What makes us "randy for relics"? On a pilgrimage to the Musée Flaubert in Rouen, Braithwaite is tickled by the sight of Loulou, the stuffed parrot the writer supposedly kept on his desk while he was working on his story "A Simple Heart." A few days later, however, visiting the Croisset pavilion where Flaubert lived and worked from 1843 until his death in 1880, he finds *another* parrot claiming to be Loulou. Which is the "real" one? Braithwaite wonders if somebody knows the answer—and if it matters to anyone except him.

Bowie fans might well ask: which is the "real" parrot, David Bowie or David Jones? Published in 1984 and shortlisted for that year's Booker Prize, Flaubert's Parrot coincided with a dip in Bowie's creative energies. He had just made one of his worst albums, Tonight, and seemed to be losing his way, or at least less interested in being the brilliant maverick "David Bowie" and more in being an actor and mainstream entertainer—someone closer to his ordinary, unstarry "David Jones" persona. A version of the conflict is played out for laughs in Julien Temple's long-form video Jazzin' for Blue Jean, released in cinemas that year. In it, Bowie plays both the exotic pop star Screaming Lord Byron and Vic, an ordinary nerdy bloke who lies about his connections to Screaming Lord Byron to impress a girl. "You conniving, randy, bogus-Oriental old queen!" Vic taunts Byron at one point. "Your record sleeves are better than your songs!"

David Jones the family man was self-effacing, even ascetic; especially in his last years, when, if you believe the rumors, he spent most of his time holed up in his Manhattan apartment reading, his only companions Iman, daughter Lexi, and dog Max. But you

don't have to look hard to find irony in the fact that David Jones was embracing anonymity just as his internationally famous alter ego was tending the archive that would become the V&A's world-conquering 2013 show *David Bowie Is*.

Bowie claimed not to be interested in his own mythology. But this wasn't true. In reality he was his own Geoffrey Braithwaite an obsessive reader of books about himself, even ex-wife Angie's. He had always been a hoarder. After his heart attack he started to expand his already vast collection of objects relating to his career, even buying back items like synthesizers he had given away years earlier. Why so randy for relics?

Throughout the 2000s rumors swirled that Bowie was writing his autobiography. Instead we got *David Bowie Is*, so we can't complain. At the Croisset pavilion, Geoffrey Braithwaite is humbled by the tumbler from which Flaubert supposedly took his final sip of water. At the V&A, fans queued to see a tissue blotted with Bowie's lipstick.

Read it while listening to: "Who Can I Be Now?"

If you like this, try: Bob Dylan, Chronicles: Volume One

J. B. Priestley, English Journey (1934)

Once established in Switzerland from the late 1970s onward, Bowie returned to the UK only sporadically to see friends and family, play live, and do bits of promotion. But that doesn't mean the country wasn't on his mind as riots broke out (April 10–12, 1981) in his childhood manor of Brixton and unemployment rose steadily under Margaret Thatcher's Tory government. On January 26, 1982, it was announced that, for the first time since the 1930s, over three million people in Britain were out of work.

This would have been while Bowie was writing material for what became *Let's Dance*. On that album's "Ricochet" he sings that the world is on a corner waiting for jobs while a weary, northern-accented voice (Bowie's) tells of men who wait for news while "thousands are still asleep, dreaming of tramlines, factories, pieces of machinery, mine shafts, things like that."

The very language harks back to an earlier age. Was it around this time that Bowie read the novelist, playwright, and critic J. B. Priestley's *English Journey*, self-deprecatingly subtitled "a rambling but truthful account of what one man saw and heard and felt and

thought during a journey through England during the autumn of the year 1933"?

Traversing the country by newfangled motor coach, the author of *An Inspector Calls* finds a divided nation. The south has pockets of prosperity like the port of Southampton, where Priestley begins his journey and which strikes him as not a bad town. Ditto Bristol, where Priestley visits a tobacco factory and applauds the humane way it seems to be run, so that people work efficiently and have no desire to leave.

But the industrial north, which he knew well having grown up in Bradford, has been devastated by the Great Depression. Apathy and disillusionment reign. Many people have lost any faith they once had in the government's ability to make their lives better. And this terrifies Priestley because he can see what's brewing in Germany and understands that disengagement from politics is "the soil in which autocracies flourish and liberty dies."

English Journey is also a useful nostalgia corrective. We worry today about the death of the high street and imagine that in the 1930s things were bustlingly different. Priestley, however, finds Swindon's high street a sorry affair, chiefly filled with tacky shops and sixpenny bazaars. In Newcastle-upon-Tyne what shocks him almost more than anything else is the silence that has replaced the shattering racket of men hammering away at the hulls of ships. In the old days, Priestley thinks, he might even have found the place inspiring.

Funnily enough, for all the bad news it imparts, *English Journey* is a consoling, optimistic read. This is down to Priestley's tone, which, like his way with the mostly affectionately sketched characters he

meets on his travels, is genial and uncontrived, or at least plays that way. Being a man of the people matters hugely to Priestley. He can't resist a dig at "literary" writers who dismiss him as middlebrow but remain aloof from the poverty and suffering of ordinary folk. If T. S. Eliot ever wants to write a poem about an actual physical wasteland, he jokes, he should take a trip to North Shields.

In the West Midlands town of West Bromwich, once a center for gun and nail making, Priestley hears a gang of boys throwing stones on a warehouse roof. He tries to find them to tell them to stop but they have run away. This, perhaps, is the ricochet Bowie has in mind. The devil might have broken parole, as he puts it in the song, but he's evidently having trouble finding work for idle hands. The boys might be surprised to learn that Priestley is on their side. He wouldn't blame them, he says, if they threw stones and smashed all the glass for miles around.

Read it while listening to: "Ricochet"

If you like this, try: Geoffrey Moorhouse, Britain in the Sixties:

The Other England

Keith Waterhouse, Billy Liar (1959)

Bowie paid tribute to Keith Waterhouse—his favorite writer in the mid-'60s, according to Bowie expert Nicholas Pegg—by naming an early song after Waterhouse's first novel *There Is a Happy Land*. The book sees a ten-year-old boy and his friends on a Leeds housing estate who use a secret language to disguise their conversations from grown-ups.

Billy Liar, Waterhouse's second novel, was the breakthrough, filmed to great acclaim in 1963 with Tom Courtenay and Julie Christie in lead roles. Bowie's friend George Underwood confirms that Bowie loved the book but isn't sure if he read it before or after seeing the film. Its hero is nineteen-year-old Billy Fisher, an undertaker's clerk living in the fictional town of Stradhoughton in Yorkshire who tells massive lies: for example, that his father is a retired naval captain. Fisher retreats into his private fantasy world of Ambrosia when the stress of plotting to leave his job, move to London, and become a scriptwriter gets too much. Billy wants to resign but has hidden under his bed a load of calendars he was supposed to have posted nine months earlier. The sequence where he tries to get rid of the

calendars, which have banal maxims at the bottom of every month, by flushing them down the toilet at work is Waterhouse at his best.

Less funny to the modern reader is Billy's horrible treatment of his two fiancées, Barbara and Rita. But you know, this was England in the 1950s. The misogyny doesn't detract from the gorgeous fertility of Billy's imagination or make it any less surprising that an ambitious dreamer like David Jones found so much to admire in the book.

Its sexual politics notwithstanding, *Billy Liar* transcends its northern, working-class setting to distill with giddy charm the claustrophobia that gripped Bowie growing up in suburban Bromley. Billy's frustration working at Shadrack & Duxbury would have been almost identical to Bowie's more middle-class frustration working at the Nevin D. Hirst advertising agency (see p. 235). The difference is that Billy is afraid of his ambitions. Liz, the woman who understands him best, compares him to a child at the edge of a paddling pool—not something you would ever say about Bowie.

Read it while listening to: "There Is a Happy Land" If you like this, try: Kingsley Amis, Lucky Jim

Alberto Denti di Pirajno, A Grave for a Dolphin (1956)

Curious one, this. Alberto Denti di Pirajno was an Italian doctor posted to Italy's colonies in North and East Africa between 1924, when he arrived in Libya as personal physician to the Duke of Aosta, and 1943 when as governor of Tripoli he surrendered the city to the British. A Grave for a Dolphin is the sequel to an earlier Denti memoir, A Cure for Serpents, which was a Book Society choice in 1955. While that too deals with medical misadventure in exotic places, A Grave for a Dolphin is more oblique and ruminative, more interested in local fables and legends and what they might mean. Enormously significant to Bowie personally, it was the inspiration for the famous line in "Heroes" about wishing he could swim like dolphins can swim. It is the reason the singer had a tattoo of a dolphin on the back of his calf alongside the name "Iman."

What makes the book so likable despite its colonial tang is Denti's tolerance, humility, and utter lack of condescension toward the "natives" he lives and works alongside. Although he articulates the standard white-European view of the time, that black Africans are still in a primitive stage of civilization, so rarely does this color

his interactions with them that you sense he doesn't actually believe it. On the contrary, he wants to fit in and be accepted on their terms. So he puts the work in, learning Arabic and studying folklore and anthropology, mastering local customs lest he unwittingly give offense. He discusses Muslim theology with itinerant Takrouri tribesmen who tell him that every religion has its own madmen, and suspends his doctorly skepticism after he witnesses a boy being cured of epilepsy by a medicine man.

The story that so touched Bowie and which gives the book its title is a hypnotic erotic fantasia that conflates an Ethiopian legend about a rapacious sea spirit, told to Denti by a local Muslim man, with the story of Camara, a twenty-two-year-old Italian soldier stationed on the coast of Somalia after the end of the Second World War. Camara meets and falls in love with a local girl called Shambowa, who has narrowly escaped being captured and sold into slavery by raiders. She has the gifts of being able to swim among sharks without being attacked and catch fish with her bare hands. One night, Shambowa is joined in the water by a dolphin, which she recognizes excitedly as the same dolphin she used to swim with when she was a child. This dolphin becomes the lovers' regular companion. Sometimes Shambowa catches and rides it. Camara watches in amazement as the girl grabs its back fin and, with a cry, climbs onto its hump, the action neatly symbolizing the union of their two cultures: it triggers a memory of an image Camara once saw in a museum near his home of Poseidon's son Taras, mythical founder of the town of Taranto, riding a dolphin that had rescued him from a shipwreck.

But Camara and Shambowa's idyll is all too brief. One morning

Camara wakes to find Shambowa shaking with fever, her irises darting about under flickering eyelids. All attempts to save her fail. After her death the dolphin, injured and bleeding, emerges from the water in an attempt to find its old friend, only to die itself. Camara feels it would be wrong to throw its corpse back into the sea, so the villagers dig a fresh grave for the dolphin next to Shambowa's and bury it there.

Bowie discusses A Grave for a Dolphin at length in the introduction he wrote for I Am Iman, the 2001 celebration of his wife's life and work. He even reproduces the naked photo of "Shambowa"—is it really her?—included in the original edition. Bowie says he first read the book in Berlin in 1977, finding it "magical and beautiful." A few months later, in a weird coincidence, he was sent a script based on the story but decided to pass as he felt it wouldn't translate successfully to film.

Years drifted by. Bowie met Iman and fell in love. And then one day in 1991, Iman received a script from her film agent. The role being offered her was that of a Somali girl, with Bowie penciled in as the European who falls in love with her. Iman thought it a beautiful story, but not something that would work as a movie.

It turned out the screenplay was based on A Grave for a Dolphin. "Things like this happen to us all the time," Bowie notes, adding movingly that he's glad his and Iman's story hasn't turned out like Camara and Shambowa's: "We want to swim side by side for as long as we've been given, till one of us slips under the waves for the final time."

Read it while listening to: "'Heroes'"

If you like this, try: Richard Wright, Black Power: A Record of Reactions in a Land of Pathos

Raw (1986-91)

As an innovator himself, Bowie had sensitive antennae for innovation in others, especially if they were operating in adjacent or complementary fields. One such field was comics, still being dismissed well into the 1970s as primitive and unsophisticated. What, though, if you could keep the fun of their vulgarity but add a dash of high seriousness to the mix?

After a bruising experience launching a comics magazine called *Arcade*, which folded after seven issues, cartoonist Art Spiegelman swore he would never produce another. But then his wife, Françoise Mouly, suggested they edit an anthology together. The aim of what, in 1980, became *Raw* was to take comics out of the underground, where Spiegelman felt they were becoming fossilized, and into the mainstream, where they would be set in a new context and read by people beyond the obvious constituency.

Spiegelman and Mouly assumed the first issue would be a oneoff. But its initial print run of forty-five hundred sold out in no time, and expectation of a follow-up was intense. In the end, *Raw* carried on until 1991, showcasing a host of alternative and emerging cartoonists such as S. Clay Wilson, Charles Burns, Ben Katchor, and Chris Ware. Arguably the most important contribution of all was Spiegelman's own. The first installment of *Maus* appeared in the second issue. A deeply personal project inspired by his father's experiences, it reconfigured the Jewish Holocaust story using cats and mice, at the same time exploring the relationship between a survivor of the Nazi camps and his artist son.

Bowie's love of comics was reciprocated by comic creators, who recognized him as a kindred spirit and, in some cases, incorporated him into their work. For example, the character of Lucifer in Neil Gaiman's late 1980s/early 1990s comic series Sandman was deliberately drawn to resemble Bowie. "Neil was adamant that the Devil was David Bowie," remembered artist Kelley Jones in Joe McCabe's book Hanging Out with the Dream King: Conversations with Neil Gaiman. "He just said, 'He is. You must draw David Bowie. Find David Bowie, or I'll send you David Bowie. Because if it isn't David Bowie, you're going to have to redo it until it is David Bowie.' So I said, 'Okay, it's David Bowie.'"

Read it while listening to: "Somebody Up There Likes Me" **If you like this, try:** Chris Ware, *Jimmy Corrigan: The Smartest Kid on Earth*

Susan Jacoby, The Age of American Unreason (2008)

A fter Bowie's death, Donald Trump, not yet POTUS, expressed his sorrow in his own unique way. "I didn't know he was that sick," he told the Wall Street Journal. "He was a great guy." Bowie's admiration for Susan Jacoby's elegant polemic suggests he didn't feel there was anything especially great about the surreal ascendancy of a man rumored never to have read a book the whole way through, even the ones he supposedly wrote.

Jacoby published *The Age of American Unreason* in 2008—before Twitter and Facebook and the industrial-scale pumping-out of fake news. With rage born of frustration, Jacoby points to the 42 percent of Americans who think that all living beings have existed in their present form since the beginning of time; the 25 percent of *US high-school biology teachers* who believe humans and dinosaurs shared the earth; the two-thirds of Americans unable to name the three branches of government or a single Supreme Court justice; the religious fundamentalism that makes impossible any meaningful conversation about stem cell research and abortion rights; and the "junk science" on which anti-intellectual movements such as the

flat-earth campaign and the anti-vaccination crusade are founded. One of the biggest problems, says Jacoby, is that Americans don't read as much as they once did. They have lost the habit of thinking deeply and slowly and as a result no longer respect history, knowledge, or expertise.

While we'd probably place Jacoby and Bowie on the same side in the culture wars, there are elements of *The Age of American Unreason* that you suspect wound Bowie up. Jacoby's tone is occasionally moralizing and elitist. She calls the internet a highway to junk thought, which it sometimes is. But Bowie always saw its utopian potential, still just about visible through the murk, and was one of its earliest proselytizers. She claims that reading for pleasure is antithetical to the whole experience of reading on computers or electronic devices. But she was writing before the launch of Apple's iPad or Amazon's Kindle and would perhaps feel differently now.

Jacoby deplores the collapse of a middlebrow culture she links to self-improvement. For her, growing up in Okemos, Michigan, in the late 1950s, this culture was the catalyst for intellectual aspiration, and she thinks it could be for everyone. Yet it's people like Bowie she has in her sights as she strides through the wreckage, complaining about video images and computer games and relentless loud noise that makes thought almost impossible.

The irony is, no one loved contemplation—or reading or conversation—more than Bowie did. No one strove more earnestly to better himself. No one had as firm a sense of the connections between seemingly disparate art forms. Bowie might have challenged Jacoby to explain the difference between the unremitting

BOWIE'S BOOKSHELF 4 135

noise of, say, thrash metal and "unlistenable" high-art music such as György Ligeti's *The Devil's Staircase* or John Cage's *Music of Changes*.

Then again, future shock makes conservatives of us all. By the time Bowie died, the millennial anxiety he sensed in the air and tried to channel on albums like 1. Outside and Heathen had been nourished by globalization and economic hardship and blossomed into a vicious populist politics. Have we been here before? Sort of. But after November 8, 2016—the day Trump was elected president—it's hard to dismiss Jacoby's view that this new strain of unreason could be the most destructive yet.

Read it while listening to: "I'm Afraid of Americans"

If you like this, try: Allan Bloom, The Closing of the American

Mind

Richard Wright, Black Boy (1945)

Did Bowie have something against cats? Black Boy is the second book on his list to include a kitten-killing scene (see p. 19), though this time the instrument of execution is a noose, not a knife. Four-year-old Richard Wright and his brother kill the cat not because they're evil and they want to, but because their stern, soon-to-be-absent father has told them to. Their mother, appalled by what they have done, makes Richard dig its grave. A little earlier she beat him unconscious for accidentally setting fire to his grand-mother's house—he had just wanted to see how the curtains would look when they burned.

Wright's extraordinary memoir of his childhood in the American South of the 1920s and '30s is as brutal and unflinching as *Native Son*, the novel which preceded it in 1940 and made Wright's reputation as the foremost African American writer of his day. Characters like *Native Son*'s Bigger Thomas, a black man tried for the murder of a white woman, are doomed not by some abstract fate or faulty genetics, as in other novels of the naturalistic school to which

Wright belonged, but by systemic racism, which keeps them poor and marginalized. There are moments of beauty—Wright conjures up the smell of wildflowers, clay dust, and hickory smoke with pungent clarity—but suffusing everything, indeed everybody, is a fear of white people.

The way Wright transcended his background and limited education to become an acclaimed author testifies to his talent and resilience. But it's unlikely he'd have achieved anything by staying in Memphis, where his agnosticism and questioning nature marked him out as trouble. The second half of *Black Boy* was cut from the initial version to appease the Book of the Month Club, which had the power to make the book a bestseller; the club only wanted material about Wright's childhood. The deleted ending is about escape and Wright's compulsion to preserve the things he values most in his life by moving to Chicago. There Wright took menial jobs and read everything he could lay his hands on, becoming increasingly active in the Communist Party. As Wright explains, he had no alternative. The mere fact of living in the South limited his potential, because white people shaped and controlled everything.

As husband to a black wife and father to a black daughter, Bowie would have read this and winced, then read it again and taken heed. Throughout his career, Bowie championed black artists and criticized their sidelining by mainstream white media. In a 1983 interview on MTV, he complained about the way the channel only showed videos by black acts "at about two thirty in the morning." The VJ replied that MTV had to think about all its viewers, not

138 4 John O'Connell

just those in New York and Los Angeles, and that residents of some towns in the Midwest would be "scared to death by Prince . . . or a string of other black faces." Sometimes progress feels very, very slow.

Read it while listening to: "A Better Future"

If you like this, try: Richard Wright, Native Son

Viz (1979-present)

A lovely photo exists of Bowie on a train reading Britain's number one toilet-humor comic Viz, home to Johnny Fartpants, "Nobby's Piles," Sid the Sexist, and (my favorite) the Vibrating Bum-Faced Goats. He's laughing helplessly, as if someone is tickling him. If this surprises you, bear in mind that at Glastonbury in June 1971 Bowie amused himself by performing an alternative version of "Oh! You Pretty Things" called "I'd Like a Big Girl with a Couple of Melons."

Viz was founded in 1979 in Newcastle-upon-Tyne by DHSS clerical officer Chris Donald, his brother Simon, and their friend Jim Brownlow. Its blend of proto-Onion news satire and wickedly obscene parodies of children's comics such as The Beano (see p. 51) found a ready audience, especially among students. Given how much he liked Peter Cook and Dudley Moore's "Derek and Clive" routines, Bowie's enthusiasm for Viz makes total sense. In 1990 he presided over the "pop page"—a nod to the magazine's origins as a fanzine—where bands were offered the chance to be included in Bowie's Top Ten in exchange for a cash bribe: "It's good to see that

140 4 John O'Connell

bands can score a hit for the very reasonable sum of £5," he wrote. "You can't buy much for a fiver these days. A couple of copies of my new single perhaps. But you'd only want one really. Unless you were buying one for a friend."

Read it while listening to: "Over the Wall We Go (All Coppers Are Nanas)," a novelty song written by Bowie in 1966 for Oscar, aka the actor Paul Nicholas

If you like this, try: The Framley Examiner

Ann Petry, The Street (1946)

Gail Ann Dorsey, the African American bassist in Bowie's backing band, remembers the singer recommending *The Street* to her. It's a milestone novel—the first by an African American woman to sell over a million copies—and was successful for the same reason Bowie felt compelled to champion it: there's an extraordinary power in the way it combines careful, sensitive characterization with journalistic rigor to depict the plight of a young single mother in 1940s Harlem. Petry's stated aim was for the book to create an explosion inside the reader's head.

We're rooting for Lutie Johnson and her eight-year-old son, Bub, as they survey the grim tenement on 116th Street that's to be their new home. It is a world away from the ads on the subway showing white people in fancy kitchens—the kitchens they employ black people to clean. We flinch as Lutie slaps Bub across the face when she returns from work to find him setting up a stall as a shoeshine boy rather than playing with his friends. She is not, she says, going to allow him to do the things white folks expect all eight-year-old

black boys to do. Her mission will be to protect him from the poverty and violence that surround them.

Lutie is uncommonly resilient, but her impoverished life exhausts and diminishes her, whether she's trying to dodge the local madam, Mrs. Hedges, or avoid accidentally buying old beef that's been sprayed with embalming fluid to keep it looking fresh. And whatever she does, she can't win. In Harlem, Lutie lives in constant fear of rape, but when she's employed by a rich white family as a maid, the white women all have the idea that black women are prostitutes.

Part of the novel's power derives from Petry's outsider status as a middle-class black woman. She was born in Connecticut in 1908, the daughter of a pharmacist and a podiatrist in the largely white town of Old Saybrook. She trained as a pharmacist and worked in her family's stores until 1938, when she married and moved to New York with her husband. It was through working as a reporter at the *People's Voice* in Harlem that she first came into contact with women like Lutie. Petry was no stranger to racism but had never encountered it in such a stark, concentrated form. In 1944 she enrolled at Columbia University to study creative writing, winning a Houghton Mifflin Fellowship worth \$2,400, which allowed her to write *The Street*. Like the writer with whom she's often bracketed, Richard Wright (see p. 136), she aimed to create a protest literature that worked not through sloganeering but by drawing readers into an intimate compact, one they wouldn't be able to resist.

Read it while listening to: "Day-In Day-Out"

If you like this, try: Ann Petry, The Narrows

Giuseppe Tomasi di Lampedusa, The Leopard (1958)

As their careers wind down, the 1960s generation of rock stars—once golden gods, their every transgression licensed—must feel a bit like Don Fabrizio Corbera, the prince of Salina in Giuseppe Tomasi di Lampedusa's bewitching novel. The Leopard is set in Sicily in the charged, politically fractious years between 1860 and 1910. Don Fabrizio stands for the old Sicilian aristocracy, which, as The Leopard opens, is under threat from the Risorgimento, the campaign for Italian unity headed by nationalist general Giuseppe Garibaldi. An amateur astronomer with an almost Buddhist sense of cosmic irony, he recognizes that the old order changeth and that his class, which has ruled complacently for centuries, is doomed to irrelevance. The gilt and flash remain, for now. But, walking in his garden, Don Fabrizio notices that the smell of blooming flowers is horribly similar to the scent of decay.

Did Bowie feel this way? The shadow of irrelevance that fell across him in midlife had moved away by the 2000s. But he knew

it could return at any point; also that death was nipping at his heels. *Heathen*, the 2002 album that marked the first phase of Bowie's renaissance, opens with "Sunday," a song whose resigned, undeceived lyrics echo the advice given to Don Fabrizio by his nephew and ward Tancredi, who has joined the pro-unification movement in a spirit of realpolitik, thinking his actions will give Sicily's ruling class a fighting chance of survival: if things are going to stay as they are, then they will have to change.

Spiritually and morally, everything in life is a compromise. None of us can know what our legacy will be. The other messages Bowie might have taken from *The Leopard* are that a) artists frequently do their best work toward the end of their lives, and b) this work isn't necessarily recognized as their best until years later. A man of private means who based Don Fabrizio on his own great-grandfather, Lampedusa spent most of his time reading and meditating in cake shops and only started writing *The Leopard* in 1954, when he was fifty-seven.

Ironically, given that Lampedusa died before it was published, *The Leopard* is one of the great novels about death—and has one of the best death *scenes*. The seventy-three-year-old prince, once so strong that in rages he bent cutlery without noticing, has been incapacitated by a series of strokes. Immobile in a hotel armchair, his frail legs blanketed, he makes up a balance sheet of his life, setting the pleasurable times against the sad or anxious ones.

Lampedusa's account of the prince's death is desolate. Even sadder, though, is the scene at the very end of the novel when his daughter Concetta, by now an elderly woman, looks outside and sees a whiskered, four-legged animal leaping from a window. For a second

BOWIE'S BOOKSHELF 4 145

she thinks it's a leopard, the symbol of her family. In fact it's the stuffed remains of her father's beloved Great Dane Bendicò being thrown into the trash.

Read it while listening to: "Sunday"

If you like this, try: Carlo Levi, Christ Stopped at Eboli

Don DeLillo, White Noise (1985)

There's a moment in *White Noise* when sportswriter turned academic Murray Jay Siskind, who teaches alongside the novel's narrator Jack Gladney at a college in the Midwest, praises Gladney for his achievement in setting up a department of Hitler studies. He calls it canny, clever, and forward-thinking—exactly what he, Siskind, wants to do with Elvis Presley.

For better or worse, the book you're holding in your hands is an example of Bowie studies, of satire being neatly neutralized. In fact, this book *could have been written* (and probably much better) by Siskind, *White Noise*'s master theoretician. He captures the essence of modern reality when he takes Jack to see "The Most Photographed Barn in America," a shack surrounded by tourists taking photographs of it because of the claim that it is "the most photographed."

The winner of the National Book Award for Fiction in 1985, White Noise was the Bronx-born Don DeLillo's breakthrough book. Suddenly he was regarded as a seer as much as a novelist, a high priest of postmodernism—the American equivalent of European titans such as Umberto Eco and Jean Baudrillard. Like The Insult (see p. 173), it has a blank, medicated, entropic feel. It conducts dark energy from the culture, interpreting it like data to gauge, as accurately as possible, its characters' levels of existential distress. That White Noise existed before social media is amazing. That it's so funny—laugh-out-loud funny at times—is astonishing.

Of the book's many gifts to us, the most valuable is its popularizing of the term "airborne toxic event," referring to a noxious black cloud that forms over the town after a chemical spill. Jack's family evacuate their home, only to be caught up in a simulated evacuation, a rehearsal for the "real" one they're currently experiencing. Is a simulacrum better, more useful, more "real," than the real thing?

Death stalks White Noise like a panther. Gladney's wife Babette takes an experimental drug called Dylar to counteract her fear of dying. When a student in Jack's Advanced Nazism course inquires about the plot to kill Hitler, Jack replies that it's in the nature of plots to move deathward. By the time Bowie made Blackstar, which he must have suspected would find favor as his "death album," working had become his Dylar. Dying is an art in Tibet, Murray tells Jack. Bowie showed that it could be one in the West, too.

Read it while listening to: "Something in the Air"

If you like this, try: Don DeLillo, Underworld

Douglas Harding, On Having No Head (1961)

One day in the early 1940s an English architect called Douglas Harding was hiking in the Himalayas when a shocking realization seized him—that he had no head. He's not trying to be funny, he insists in *On Having No Head*, the slim volume he subsequently wrote for the Buddhist Society. Having no head is a serious business.

It sounds like stoner nonsense but Harding's point was simple. We think of the head as the center of the self, the hard drive on which consciousness is stored, yet we can't see this head except within the artificial frame of a photograph or reflected image. If we cannot see ourselves the way others see us, how do we know who we are? (Bowie ponders this "test" awhile in "Changes," only to conclude that he's moving through life too fast to take it.) Harding was so shocked by this question that he found himself unable to think. Words failed him. All sense of time past and time future fell away. He forgot his name, gender, even what type of animal he was. All the traditional markers of identity, status, and personhood dispersed like dandelion seeds.

In Buddhist terms, the state Harding is describing is nondualism, a mature state of consciousness in which the self is transcended, usually through intense meditation. Both Tibetan and Zen Buddhism were embraced by the late-'60s counterculture as they had been earlier by Beat writers and popularizers such as Alan "The Way of Zen" Watts, for their perceived air of utopian anti-materialism and because their doctrine of ego-dissolution chimed with people who had felt their selves disintegrating after taking LSD. The lyrics for the Beatles' "Tomorrow Never Knows" draw heavily on the Tibetan Book of the Dead, as translated by acid gurus Timothy Leary, Ralph Metzer, and Richard Alpert in their book The Psychedelic Experience.

Bowie's interest in Tibetan Buddhism was inspired when as a thirteen-year-old he read The Rampa Story by Tuesday Lobsang Rampa—actually Cyril Hoskin, a former surgical fitter from Devon who did a brisk trade in occult-themed pseudo-memoirs and claimed his body hosted the transmigrated soul of a Buddhist monk. The Rampa Story and Austrian mountaineer Heinrich Harrer's Seven Years in Tibet are obvious influences on early Tibet-themed Bowie songs like "Silly Boy Blue" from his eponymous first album and Space Oddity's "Wild Eyed Boy from Freecloud." In September 1967, Bowie spent time in Scotland at the Buddhist retreat in Eskdalemuir. In May 1968, at London's Roundhouse, where he was supporting his friend Marc Bolan's band Tyrannosaurus Rex (which later became T. Rex), Bowie performed a mime based on China's invasion of Tibet. Around this time, he studied with a Buddhist guru and was, he later admitted, within a month of having his head shaved, taking his vows, and becoming a monk.

Bowie was always a dabbler where religion was concerned, but

150 4 John O'Connell

Buddhism remained important. "So much of what first appealed to me about Buddhism has stayed with me," he told the *Daily Telegraph* in 1996. "The idea of transience, and that there is nothing to hold onto pragmatically, that we do at some point or another have to let go of that which we consider most dear to us, because it's a very short life." After Bowie's death, his body was cremated in a Buddhist ceremony in Bali.

Read it while listening to: "Changes"

If you like this, try: Hermann Hesse, Siddhartha

Anatole Broyard, Kafka Was the Rage (1993)

n 1946 an American veteran of the war in Japan called Anatole Broyard arrived in New York's hipster capital, Greenwich Village, his goal the getting of an education courtesy of the US government, which was paying for it under the terms of the G.I. Bill, and embracing the alluring sweetness of *la vie bohème*. This memoir, written forty years later but abandoned unfinished when Broyard, by then the *New York Times*'s leading book critic, learned he was terminally ill, is the story of that awkward, hard-won transformation from soldier to scholar. It's a beautiful, touching, wryly funny book that looks back with serene clarity on a lost domain where nothing mattered more than books. Apart from sex.

Amid the mordant but never snide portraits of Village figures like Delmore Schwartz (who would later teach Lou Reed at Syracuse University), Anaïs Nin, and a visiting Caitlin and Dylan Thomas, Broyard's account of his kooky relationship with the painter "Sheri Donatti" (the name is a pseudonym for Sheri Martinelli, "Queen of the Beats," friend and/or lover to Ezra Pound, Charlie Parker, and William Gaddis) stands out. Avant-garde in her life as well as

her art, Donatti never wore underwear and, Broyard notes archly, embodied the latest trends in art, sex, and psychosis, faking a heart condition that obliged Broyard to carry her up the stairs to the top-floor apartments where her artist friends lived. Even her seduction of him was abstract: she told him she never had orgasms because she didn't want them.

After his death it emerged there had been limits to Broyard's self-disclosure. Although he passed as white for most of his adult life, he was of mixed-race ancestry and had taken advantage of Greenwich Village's anything-goes milieu to slough off the Creole identity he had borne growing up in the French Quarter of New Orleans. This transfiguration left a complicated legacy for the children he concealed it from. One of them, the writer Bliss Broyard, has explored it in detail in her own work.

But how beautifully he writes about transfigurations, especially thwarted ones. Unloading to his therapist, Broyard wonders why characters in novels are elevated by love and yet he hasn't been so far. Sex is fine, but it isn't enough. It can't account for the great mass of art that insists on love as a transcendence of the physical, or for the extremes of emotion it inspires.

In the end, this is another of Bowie's beloved books about artistic scenes—the magical gestalt energy of them; the way their actions, even trivial ones like not wearing knickers, transform the wider culture by expanding people's sense of what it could and should be.

Read it while listening to: "(You Will) Set the World on Fire"

If you like this, try: Anatole Broyard, Intoxicated by My Illness
and Other Writings on Life and Death

56

Charles White, The Life and Times of Little Richard (1984)

lamboyant, androgynous Little Richard was the most important influence on Bowie bar none. His peerless stagecraft was studied with academic intensity not just by Bowie but by Sly Stone, Mick Jagger, George Clinton, and, most obviously, Prince. One year, to celebrate their wedding anniversary, Iman bought Bowie one of Little Richard's suits.

George Underwood remembers going to see Little Richard with Bowie and being convinced they were witnessing the singer's death when he collapsed onstage, apparently from a heart attack. Then the emcee came on and asked if there was a doctor in the house, at which point Underwood and Bowie noticed that all of the musicians had started to go back to their instruments. Then Little Richard raised his head, shouted, "Awopbopaloobop alopbamboom!" and the crowd exploded.

Perhaps surprisingly, Bowie had his father to thank for introducing him to rock 'n' roll. One day Haywood Jones came home

with a bag of newfangled seven-inch singles he'd been given in his job as a publicist at the children's charity Dr. Barnardo's. Mixed in with records by Fats Domino, Chuck Berry, and Frankie Lymon and the Teenagers was "Tutti Frutti" by Little Richard. Bowie later recalled trying to play the record on the family's old-fashioned gramophone, set up for 78s, spinning the baize platter around by hand until it approximated the correct speed. It worked, just about, and when he heard "Tutti Frutti" for the first time his heart "nearly burst with excitement": "I'd never heard anything even resembling this. It filled the room with energy and color and outrageous defiance. I had heard God. Now I wanted to see him."

Born Richard Penniman in Macon, Georgia, Little Richard single-handedly transformed the American music scene in 1955 with his pile-driving piano and falsetto holler. Charles White's book, which demands to be read alongside Nik Cohn (see p. 8) and Greil Marcus (see p. 48), coincided with a lull in Little Richard's career, but its success helped to lift him out of it. White interviewed all the key people in the singer's life, presenting their quotes in long, unmediated chunks and keeping his own contributions to a deliberate minimum. The effect is quietly electrifying.

Despite being authorized, the biography travels to some dark places. It's frank about Richard's early gay experiences, the incessant name-calling ("They called me sissy, punk, freak and faggot"), the racial prejudice ("You knew your place you sorta stayed in your place"); and the hideous abuse the singer endured as a child. No sexual peccadillo is left unremarked upon. If you want to know

BOWIE'S BOOKSHELF # 155

about the singer's boyhood habit of defecating in jars and boxes that he then put into the kitchen cupboard for his mother to find, you've come to the right place.

Read it while listening to: "Suffragette City"

If you like this, try: Chuck Berry, Chuck Berry: The

Autobiography

57

Michael Chabon, Wonder Boys (1995)

Wonder Boys is that ironic coup, a gorgeously written novel about writer's block. Actually, it's more than that—it's about the rocky, meandering path that leads to the palace of creativity, and how easy it is to trip up. Or rather, Tripp up. A combination of substance abuse, pointless thrill seeking, and general inattentiveness to his talent has caused our protagonist, Pittsburgh creative-writing professor and novelist Grady Tripp, to spend seven fruitless years working on an unpublishable novel called Wonder Boys, whose manuscript now runs to 2,611 pages. To goad him out of his feckless ways and supply a kind of sentimental education, Chabon constructs an assault course for Tripp that involves his wife, Emily, walking out; his mistress, Sara, the chancellor of the college where he teaches, becoming pregnant with his child; his old friend and editor Crabtree arriving from New York with a transvestite; and his young student James Leer, an earnest, possibly gay Frank Capra obsessive, carrying around a novel of his own that might actually be quite good.

It's odd, given Bowie's prodigious drug intake over the years,

that he never found himself in Tripp's position. His fearsome work ethic meant the gaps between his albums were, until his 2004 heart attack, impressively small. Drugs never stalled him the way Tripp's marijuana habit does him, which may just be the difference between marijuana and cocaine; yet there's something of Bowie in Tripp's love of excess and adventure, just as there's also something of him in Leer, Tripp's unformed protégé. Leer's real talent is for bricolage—he pieces his stories together out of bits of his favorite Capra films—but he does it with such brio that the finished products are emphatically his and no one else's.

Chabon wrote Wonder Boys in seven months, having abandoned a novel called Fountain City about an architect who builds a baseball park in Florida. He had labored over the novel for five years before realizing it was bloated and awful in the manner of Tripp's genre-hopping opus. Diffusely plotted in the manner of Angela Carter's Nights at the Circus (see p. 85), Wonder Boys is best classified as "stoner picaresque." It is the shaggiest of shaggy-dog stories, not least because it genuinely does feature a dog, which James shoots and whose body Tripp hides in the trunk of his car and drives around with for the duration of the novel—along with a dead boa constrictor, a tuba, and the jacket Marilyn Monroe wore when she married Joe DiMaggio.

Wonder Boys is raucous and absurd and should be awful. Novels about writers often are. But Tripp is so hapless, he wins us over with his wit and disarming love of pulp horror and fantasy. At the end of the day—and Bowie would, as a former addict, have appreciated this too—it's a story of recovery where that recovery is genuinely a happy event. As we take our leave of him, Tripp is clean and sober,

158 4 John O'Connell

freshly installed at a new college, passing on his dubious wisdom to a new generation of students.

Read it while listening to: "Survive"

If you like this, try: Michael Chabon, The Amazing Adventures of
Kavalier & Clay

Arthur Koestler, Darkness at Noon (1940)

Bowie songs, from the early "We Are Hungry Men" to "1984," "The Next Day," and "Scream like a Baby." This last song, from 1980's Scary Monsters (and Super Creeps), is narrated by a gay pacifist who, with his friend Sam, has been blindfolded, shackled, and taken away to be pumped full of drugs until he learns to integrate with society on the government's terms.

There are shades here of A Clockwork Orange and Nineteen Eighty-Four, but also of Darkness at Noon, Koestler's chilling critique of totalitarianism set in a version of Stalinist Russia around the time of the Moscow show trials, when many prominent Old Bolsheviks were arrested on ludicrous charges, found guilty of treason, and either imprisoned or executed.

Born in Budapest in 1905, Koestler based the novel on his own experience of being imprisoned first by Franco during the Spanish Civil War; then in France in an internment camp; then in Pentonville as an illegal immigrant once he had escaped to England. The manuscript, which Koestler wrote in German while living in France, had

to be smuggled across the Channel by his partner, sculptress Daphne Hardy. The novel's success meant he no longer had to resort to the sort of desperate moneymaking strategies he had employed earlier, such as writing a sex encyclopedia under the pseudonym Dr. Costler.

From the start, the tone of the novel is bleakly ironic as main protagonist Rubashov is arrested, tortured, and tried for treason by the regime he helped to create—"the Party," as everyone calls it, headed by "Number One" (Stalin), whose color picture hung over every bed and sideboard in the land. He is the prototype for Big Brother, another of the spirits of greed and lords of theft Bowie refers to in "If You Can See Me." (*Crusade*, *tyrant*, and *domination* were the three words Bowie chose to describe that song.)

Koestler keeps us close to Rubashov. We experience his imprisonment as he does, his disappointment as he is denied food, his fearful excitement as he communicates with his neighbor by tapping on the wall, his memories of his former career as a member of the party elite. In the end, Rubashov confesses because he genuinely believes himself to be a traitor and is shot in the back of the neck.

Where *Darkness at Noon* differs from *Nineteen Eighty-Four* is that it's more of a novel of ideas. As Orwell himself observed, it's about the intellectual struggle between three men—Rubashov and the two officers dealing with his case: Ivanov, another Old Bolshevik, who knows Rubashov is innocent but also that this is irrelevant; and the youthful, ambitious believer Gletkin, compared to a bird of prey pecking at its victim.

Read it while listening to: "Scream Like a Baby"

If you like this, try: Arthur Koestler, The Ghost in the Machine

Muriel Spark, The Prime of Miss Jean Brodie (1961)

On the surface, Muriel Spark's masterpiece is a slim, funny novel about an inspirational teacher—a familiar stock figure because most of us have known one, Bowie included. His was Owen Frampton, father of guitarist Peter, who taught art at Bromley Technical High School. Bowie had passed the 11-plus (the entry exam to academically superior "grammar" schools) in 1958 but chose Bromley Tech over Bromley Grammar School because of its strong reputation for art. Like Miss Brodie, Frampton believed that education was a "leading out" of what was already there rather than a "putting in." As Peter Frampton explained to *The Independent*: "My father was very good at finding the passion for art within his students." Like Miss Brodie, he "led out" by unconventional means: "He used to leave the art-block door open so we could bring our guitars in and play Buddy Holly songs."

The Prime of Miss Jean Brodie is partly about the power of charisma. But it's also about charisma's common by-products: sex and betrayal. A genteel Edinburgh spinster, Jean Brodie is a sort of rock star to her "set" at the conservative Marcia Blaine School. She

transfixes what she calls her "crème de la crème": Monica, Sandy, Rose, Mary, Jenny, and Eunice. Instead of following the curriculum, which she scorns, Miss Brodie spins tales of her dead soldier lover. She sings the praises of Giotto, but also of Mussolini and Hitler—part of a broader, questionable love of order and control.

Miss Brodie dedicates herself to her pupils and expects dedication from them in return. But like a certain "leper messiah" who is killed by his own fans, she is betrayed for her sexual indiscretions by Sandy, the most insightful of her set. Sandy recognizes that Miss Brodie has, as she puts it, elected herself to grace, effectively becoming the head of her own religion. Miss Brodie preaches a radical individualism and singles out each girl for particular achievements—Monica is

famous for mathematics, Rose for sex, etc. What she really wants, though, is for her set to be clones of herself, as reflected in art teacher Teddy Lloyd's portraits of her girls, which all look like portraits of Miss Brodie.

So spare and taut that it is almost a vorticist-style exercise in pure form (see p. 244), *The Prime of Miss Jean Brodie* was first published, in its entirety, in a single issue of the *New Yorker*. Its genius lies in the way it makes us care so deeply about a character

BOWIE'S BOOKSHELF # 163

who is little more than a collection of camp maxims. She is all performance; all hard, glazed surfaces—the thin white duchess.

Read it while listening to: "Ziggy Stardust"

If you like this, try: Muriel Spark, The Girls of Slender Means

60

John Braine, Room at the Top (1957)

ohn Braine was a heavy smoker who had a sticker made to put on his cigarette packets that read, "CIGARETTES ARE GOOD FOR YOU—SMOKE MORE, LIVE LONGER." The former librarian's bestselling debut *Room at the Top*, one of the original Angry Young Man novels, was a huge social phenomenon and would have been consumed as such (reverently, with an expectation that it would have significance for his own life) by the young Bowie.

The film version triumphed at the box office, but there was only so much you could show on-screen in 1959. Books were different. Considering it was published before the lifting of the Chatterley ban, the novel *Room at the Top* is surprisingly racy. Like *Lady Chatterley's Lover*, it would have been passed clandestinely around the playground.

Braine was born in Bradford in 1922, moving to the nearby village of Thackley when his father got a job at a sewage works. Like *Billy Liar*, *Room at the Top* tapped into the growing working-class desire for self-improvement either by ascending into the middle or professional classes (Billy Fisher's goal in *Billy Liar*) or by making

shedloads of money (Braine's goal). Actually, Braine had a very specific ambition. "What I want to do," he announced to one journalist, "is to drive through Bradford in a Rolls-Royce with two naked women on either side of me covered in jewels."

Protagonist Joe Lampton's social climbing in *Room at the Top* has a ruthless, sociopathic quality. Moving to the fictional city of Warley to work in an accountant's office, he entraps a naive young girl, Susan, whose father is a millionaire. But their relationship doesn't go down well with the other, older woman he's been using, Alice. His elder paramour kills herself when Lampton marries Susan after getting her pregnant.

Room at the Top made Braine the wealthy man he had always dreamed of being. Bucking the trend of working-class writers leaning toward socialism, he moved from Yorkshire to Surrey's stockbroker belt, wrote angry Whither England? pieces for *The Spectator*, and hung out with right-wing authors such as Kingsley Amis.

A sequel to Room at the Top did well, but subsequent novels—including his best one, The Vodi, which drew on his experience of being bedbound with tuberculosis as a young man—failed to make an impact. "A peculiarity of them I noticed," wrote Kingsley Amis, to whom Braine would send each new book in expectation of a kind word, "was that all the characters had names that nobody ever really has—Regilla Catamountain, Menedemus Ableport—perhaps on the advice of some libel expert on the point of emigration." Bowie could better that: He once called a character Algeria Touchshriek.

Read it while listening to: "Love You Till Tuesday"

If you like this, try: John Braine, The Vodi

Elaine Pagels, The Gnostic Gospels (1979)

Bowie's hazy personal cosmology found its fullest expression on the album *Station to Station* (see p. 88), which is packed with references to obscure occult works. Another figure in the deep-pile carpet of his cocaine psychosis was gnosticism, root of many of the esoteric religions Bowie dabbled with in his quest for secret knowledge that explained the way the world worked.

Gnosticism is a catchall term for the alternative versions of Christianity that existed in the first few hundred years after Jesus's death—the ones that didn't find their way into the official "canonical" version because the church's founding fathers considered them heretical. For example, gnostics considered God to be a mother as well as a father, and Jesus's resurrection to be a myth, not a real-life event. They also believed that it wasn't humans who brought about the "fall" into sin but the earth's creator, who for gnostics is not God but a character called the Demiurge. With the help of his aides the Archons, the Demiurge keeps humans imprisoned on the material plane, unable to glimpse the truth of their predicament. A select few, however, achieve gnosis—a higher level of illumination, the

direct intuition of spiritual truth. We can guess that Bowie, manically conceited thanks to all the drugs he was taking, considered himself to be one of them.

A trove of gnostic manuscripts was found in 1945 near the Egyptian town of Nag Hammadi, and Elaine Pagels's bestselling study of them was published in 1979. Bowie had moved on to saner pastures by then, but he would still have been excited by it. With elegant precision, Pagels showed that early Christianity was far more diverse, eccentric, and complicated than people realized. The alternative Gospel of Thomas, for example, could have been written earlier than the "official" Gospels of Matthew, Mark, Luke, and John. It gives Jesus a whole new set of maxims, such as: "If you bring forth what is within you, what you bring forth will save you. If you do not bring forth what is within you, what you do not bring forth will destroy you."

Bowie seems to have viewed gnosticism as an active religion, not a dusty museum artifact. In a 1997 interview with Q he mentioned an "abiding need in me to vacillate between atheism or a kind of Gnosticism. . . . What I need is to find a balance, spiritually, with the way I live and my demise." More than any other book on the list, *The Gnostic Gospels* would have helped him to achieve that goal.

Read it while listening to: "Word on a Wing"

If you like this, try: Elaine Pagels, Revelations: Visions, Prophecy and Politics in the Book of Revelation

Truman Capote, In Cold Blood (1966)

avid Bowie has talent," Truman Capote told Andy Warhol in 1973—a generous assessment from the man who thought Mick Jagger as "sexy as a pissing frog." Bowie returns the compliment by including on his list *In Cold Blood*, Capote's gripping "nonfiction novel" (the author's phrase) from 1966 that pretty much invented the true-crime genre. The book's force and immediacy are a result of Capote using techniques from fiction to elevate mere documentary reportage into a new art form.

Six years in the writing, *In Cold Blood* tells the horrific story of a multiple murder that devastated the tiny west Kansas town of Holcomb on November 15, 1959. Prosperous farmer Herb Clutter, his wife, and two of his children were shot—Herb had his throat cut too—by Perry Smith and Dick Hickock. The murderers were two thieves just released on parole, who'd heard that Clutter kept large sums of money in a safe at his house.

The depth of Capote's research is obvious. Famously, he was helped here by his old childhood friend Harper Lee, not yet the acclaimed author of *To Kill a Mockingbird*. Lee accompanied

BOWIE'S BOOKSHELF 4 169

Capote to Holcomb, where her job was to be emollient and build trust with the local people Capote wanted to interview—farming folk reluctant to cooperate with someone they regarded as a freak from New York.

For Capote waved his freak flag high. Arch of manner and flamboyant of dress, with a squeaky high-pitched voice that soon became his signature, Capote was unapologetically gay—a rare enough sight in New York, let alone Holcomb. As Lee put it in a piece for *Glamour* written in 1966 by Gloria Steinem: "He was like someone coming off the moon—those people had never seen anyone like Truman." Truly, the man who fell to earth! But *In Cold Blood* demonstrates something Bowie knew intuitively: that being—or at least styling yourself as—an outsider pays handsome dividends.

Read it while listening to: "I Have Not Been to Oxford Town"

If you like this, try: Truman Capote, Music for Chameleons

Orlando Figes, A People's Tragedy: The Russian Revolution 1891–1924 (1996)

n his last decade, say those who knew him, Bowie read even more than usual. He loved anything to do with history—novels like Hilary Mantel's Wolf Hall and nonfiction doorstops like this one, a 924-page history of the Russian Revolution, so heavy that, like Anthony Burgess's Earthly Powers (see p. 264), it's a one-book argument for the existence of the e-reader.

Detailed and authoritative, A People's Tragedy is the logical place for a fan of Nineteen Eighty-Four (see p. 77), Darkness at Noon (see p. 159), and Journey Into the Whirlwind (see p. 208) to end up. Expanding the story beyond the 1917 revolution in each direction, Figes dates the start of the event to the great Russian famine of 1891. He considers that by 1924, when Lenin died, the main components of the Stalinist regime such as the one-party state and the cult of personality were all intact.

Bowie had firsthand experience of the USSR. He first visited in April 1973 on the way back from the Japanese leg of his Ziggy Stardust tour. With his childhood friend and backing singer Geoff MacCormack, he took the Trans-Siberian Railway from the port city of Nakhodka to Moscow, ludicrously conspicuous with his bright red hair and platform boots.

The Trans-Siberian Railway was constructed during the 1890s to facilitate Russia's trade with the Far East. During the civil war that followed the 1917 revolution, it became the focus of fighting between the Czechoslovak Legion, which supported Aleksandr Kolchak's White Russian government, and the Bolsheviks. It hadn't changed much in the intervening years. Ordinary passengers still slept on wooden benches in crowded compartments. Bowie and his entourage were in "soft class" carriages with clean bedding, though even there washing facilities were scarce. Bowie took to wandering the train in his kimono accompanied by two burly Russian women, Donya and Nelya, who had been assigned to look after him.

The gulf between his (relatively) luxurious situation and the poverty of the Siberian villages the train passed through haunted Bowie. "I don't understand how they live through the winter," he kept saying, according to *Mirabelle* magazine. Years later, after reading Figes's book, he would learn that at the height of the famine crisis of 1921–22 many Russian peasants were able to live through the winter only by eating one another: mothers desperate to feed their children would chop off the limbs of the dead and throw them in the cooking pot. People were reduced to eating their own relatives, even their young children, who often died first (and tasted the best, their flesh being particularly sweet).

In Sverdlovsk (now Yekaterinburg, its original name), where Tsar Nicholas II and his family were executed in the basement of Ipatiev House, Bowie left the train for the first time. He soon witnessed his personal photographer Leee Black Childers being manhandled by uniformed guards while trying to take pictures. Quickly, Bowie started filming the incident with his movie camera. Two more guards appeared and tried to arrest him. After two railway attendants intervened, Bowie and Childers were able to escape back to the safety of the train. Donya and Nelya blocked the doors until it had left the station.

Despite these dramas Bowie enjoyed the eight-day, 5,750-mile journey. "I could never have imagined such expanses of unspoilt, natural country without actually seeing it myself," he wrote in *Mirabelle*. Next, the party spent three days in Moscow, visiting the Kremlin and shopping in the GUM department store, where Bowie was disappointed to find the only souvenirs for sale were soap and underwear. They ordered lunch at GUM's cafeteria but Bowie found the meatballs inedible.

A second trip in April 1976, with a bigger party including Iggy Pop, was more problematic. The group was escorted off the Warsaw–Moscow train at the border by KGB guards. Bowie and Pop were strip-searched, the KGB's suspicions having been aroused by books on Goebbels and Albert Speer that Bowie had brought with him in his portable library.

Read it while listening to: "Station to Station"

If you like this, try: Orlando Figes, The Whisperers: Private Life in Stalin's Russia

64

Rupert Thomson, The Insult (1996)

Rupert Thomson's haunting fourth novel gives a convincing sense of what it might be like to live inside a dream or schizophrenic delusion.

The Insult begins straightforwardly enough, as the story of one Martin Blom, who loses his sight after he is shot in the head in a supermarket parking lot. Waking up in the hospital, Blom learns that he will be blind for the rest of his life, though prone to incredibly realistic hallucinations that may convince him he can actually see. So when Martin seems to regain his sight during the night we're initially skeptical, but we follow him anyway. He embarks on a new nocturnal life, breaking with his fiancée and parents, hooking up with a gang of oddballs in various neon-lit bars and hotels and beginning a new relationship with a woman called Nina, who goes missing after Martin—who has been pretending to be completely blind—reveals the truth of his condition to her.

But what's the truth of his condition? For all we know, Blom could be dead. Very little coheres or is logical or solid. Thomson keeps the date and location vague. We might be in the 1970s or

the 1990s. The city where the main action takes place sounds like Paris—it has districts—but the characters' names have an eastern European flavor. This uncertainty carries over into genre, especially once we reach the halfway mark and *The Insult* performs a jarring volte-face. . . .

In the mid-1990s, around the time of 1.Outside, Bowie spoke of his impatience with traditional narrative forms. The thread linking his work was, he told Musician magazine, "the realization, to me at least, that I'm most comfortable with a sense of fragmentation. . . . The idea of tidy endings or beginnings seems too absolute." As Bowie would have known, the French critic Roland Barthes in his 1970 book S/Z made a helpful and illuminating distinction between "readerly" and "writerly" texts.

Readerly texts have clear, simple plots that unfold in realistic environments peopled by realistic characters. They're easy to digest but, for Barthes, fraudulent because they don't acknowledge the role played by readers in constructing a book's reality as they read it. Writerly books such as *The Insult*, however, do acknowledge this. They hand readers a bag of puzzle pieces and say, "Go on, then. You do the work. You tell me where this is set, what genre it is, why the narrator changes halfway through, and whether the various Bowie references you've spotted (e.g., the 'ice-blue carpet' on which Martin draws a pattern with his stick) are actually there or your imagination working overtime."

Thomson was living in Rome in 1997 when he got a call from *Interview* magazine asking if he wanted to take part in a new series where famous people interviewed much less famous people. Knowing at once which role he would be occupying, Thomson asked

BOWIE'S BOOKSHELF 4 175

who would be interviewing him. "David Bowie," came the reply. The singer had enjoyed *The Insult* so much, he wanted to meet its author. "I waited for the magazine to call again, as they had promised to," Thomson remembered in a funny piece for *The Guardian*, "but the days went by, and then the weeks, and the phone didn't ring. The interview never took place. I never did meet, or even talk to, Bowie."

Read it while listening to: "What in the World"

If you like this, try: Rupert Thomson, Dreams of Leaving

Gerri Hirshey, Nowhere to Run: The Story of Soul Music (1984)

Something of a rock-star favorite—Mick Jagger told her he'd read it twice—Gerri Hirshey's Nowhere to Run covers similar ground to Peter Guralnick's Sweet Soul Music (see p. 216), which it preceded by two years. If it's less austere, that may be because Hirshey is less of a purist. Guralnick regards Motown with mandarin disdain. But Hirshey is fascinated by the way Berry Gordy's Detroit hit factory distilled blues, soul, and gospel into a massmarket product beloved by both black and white audiences.

Hirshey's nickname at Rolling Stone, where she became the

magazine's first female contributing editor, was "the nutcracker" because of her ability to cope with tricky interviewees. Here, this horse-whispering yields evocative reminiscences aplenty as an array of singers and musicians including Screamin' Jay Hawkins, Aretha Franklin, Ben E. King, Wilson Pickett, James Brown, Isaac Hayes, and a post-Off the Wall but pre-Thriller Michael Jackson open up to her, clearly delighted that she knows so much about the music and is interested in hearing what they have to say rather than foisting her own opinions upon them.

Hawkins, who would emerge from a zebra-striped coffin as part of his act, remembers the night Ben E. King and the rest of the Drifters shut the lid all the way down so that he couldn't breathe. Brown reflects that he learned much of his craft in prison, playing on pocket combs and making a bass out of a washtub. Cissy Houston takes the writer to watch her daughter sing: the teenage Whitney is, Hirshey reports, fine-boned and pretty, with lungs so powerful they could repel a tsunami. Michael Jackson gives her a tour of the funny ranch-house thing he's reconstructing in Santa Barbara—the place that will soon be famous (and then notorious) around the world as Neverland.

Many of these figures were fortyish in the early 1980s when Hirshey spoke to them, earning enough on the nostalgia circuit to get by but not really selling records anymore. Mary Wells stresses that performing live is a job she's doing to pay the bills. Others, like Diana Ross, remained superstars, not necessarily because they had the best voices but because they had *presence*. Berry Gordy may have written the lines for Ross to speak onstage, but she knew

exactly how to deliver them and, as she sang, how hard she had to work to make us love her. None of it comes easy, as she admits to Hirshey in a candid interview.

When Bowie measured himself against the soul artists he loved he inevitably found himself wanting. He worried that the funky, R&B-inflected music he'd started to make in the mid-1970s and returned to at various points in his career was kitschy and inauthentic. In a 1976 interview with *Playboy* he called *Young Americans* "the definitive plastic soul record. It's the squashed remains of ethnic music as it survives in the age of Muzak, written and sung by a white limey." Which is a bit harsh—as if, in spite of all he'd achieved, Bowie felt the highest heights would always be beyond his reach.

Read it while listening to: "Right"

If you like this, try: Charles Shaar Murray, Crosstown Traffic:

Jimi Hendrix and Post-War Pop

Arthur C. Danto, Beyond the Brillo Box: The Visual Arts in Post-Historical Perspective (1992)

Say what you like, Bowie wasn't scared of a challenge. Beyond the Brillo Box is a collection of high-fiber essays by Columbia University philosophy professor Danto that for the most part take stock of pop art and its conversion of everyday items like soup cans and Brillo boxes into art. A product of the egalitarian 1960s, pop art loosened up a stuffy scene, banishing forever the atmosphere of awed reverence in which people had been encouraged to digest art.

But it had a philosophical impact too. Warhol showed, as Duchamp had before him in 1917 with his urinal exhibited under the title *Fountain*, that you couldn't tell what art was just by looking at it. Nor could you teach art by example. In fact, says Danto,

nothing exists as art outside the context that gives it that status. One of those reasons is awareness of where an artwork "fits" historically. Because pop art exists at the point where art and reality have become indivisible, it undermines this whole approach. It has, Danto argues, reached a sort of historical end and became philosophy instead.

That still leaves the question of what art should be striving to do. Danto defends the National Endowment for the Arts' controversial sponsorship of an exhibition of explicit photos by Robert Mapplethorpe at a gallery in Washington, DC, in 1989, arguing as Bowie would surely have done that art cannot be meaningful unless it has the freedom to dissent and give offense. In another essay, considering the symbolism of messy rooms, Danto anticipates with uncanny accuracy Tracey Emin's 1998 breakthrough piece My Bed, genuinely Emin's own filthy bed surrounded by the detritus of her life—condoms, vodka bottles, dirty knickers. Bowie would have loved this coincidence, as he and Emin were friends, the singer admiring in The Independent the way Emin's work was "a celebration of personality" which deliberately lacked "what some critics would call deeper context."

Read it while listening to: "Andy Warhol"

If you like this, try: Cynthia Freeland, But Is It Art? An
Introduction to Art Theory

67

Frank Norris, McTeague (1899)

Bowie's stained, misshapen "English teeth" were one of his signature features. But in the late 1990s he had them pulled out and replaced with implants to create a shiny white Hollywood smile. Hopefully the dentist who worked on him was more skilled than McTeague, the lumpen, brutish antihero of Frank Norris's novel of San Francisco life at the turn of the century.

McTeague—we never learn his first name—is a third-rate dentist who learned what little craft he knows from a traveling dentist, "more or less a charlatan," who visited the mine where his late father used to work. McTeague watched this dentist at work and read "many of the necessary books." Despite being "too hopelessly stupid to get much benefit from them," McTeague opens his

"dental parlors" above a post office in the working-class district of Polk Street. His brute strength proves a happy bonus: "Often he dispensed with forceps and extracted a refractory tooth with his thumb and finger."

The first of many excruciating moments occurs when his friend Marcus brings his cousin Trina to McTeague to have some damaged teeth reconstructed. After drugging her unconscious with ether, McTeague wonders whether to give in to the "sudden panther leap of the animal" inside him and rape her. In the end, he decides just to kiss her, "grossly, full on the mouth."

McTeague is vivid, compelling stuff, its naturalistic focus on life's seamier side anticipating William S. Burroughs, Hubert Selby Jr. (see p. 188), and John Rechy (see p. 110). Norris's belief that a person's fate is predetermined by factors such as race and class taints it on the level of plot as well as that of character. The novel's anti-Semitism, especially, is shocking to us today. Yet there are inspired moments of high comedy such as the sequence when McTeague, sweating with nerves because he's never been to the theater before, tries to impress his in-laws by taking them to see a show, only for Trina's young brother August to wet himself during the performance.

Read it while listening to: "A New Career in a New Town" **If you like this, try:** Theodore Dreiser, *Sister Carrie*

Mikhail Bulgakov, The Master and Margarita (1966)

he devil has all the best tunes. And in Bulgakov's much-loved satire of Stalinist Russia, he also has Bowie-like wonky eyes—one black and one green. Professor Woland, as Satan calls himself, is the suspicious "foreigner" who approaches literary magazine editor Mikhail Berlioz and poet Ivan Bezdomny at Moscow's Patriarch Ponds. Incensed when he overhears Berlioz lecturing his companion about the nonexistence of God, he tells them that he was there when Pontius Pilate washed his hands of Jesus; then, to prove his point that man has no control over his destiny, predicts that Berlioz will die after slipping on oil and being decapitated. Moments later, at a train station, this comes to pass.

Horrified, Bezdomny tries to alert people to the dangers of Woland and his sidekicks, who include Behemoth, a cigar-munching human-size black cat, and Koroviev, also known as Faggot, a repulsive valet with a feathery beard who wears a pince-nez and a jockey's cap. But Bezdomny ends up diagnosed with schizophrenia and in an asylum, where he meets the Master, who has written a novel about Pontius Pilate. . . .

There was always a part of Bowie that wanted to be P. T. Barnum, the greatest showman in the world. The Hunger City set for his 1974 Diamond Dogs tour, with its looming skyscrapers, motorized bridge, and cherry picker for carrying Bowie down from the heavens and out over the crowd, was more theatrical than anything rock had seen before. So in The Master and Margarita he would have enjoyed the sequence where Woland and his oddball gang take to the stage of Moscow's Variety Theater to perform a public demonstration of the powers of black magic. First they do card tricks-Behemoth throws cards at Woland; Faggot opens his mouth "like a baby bird" and swallows the whole pack. Then they make real money cascade from the ceiling "amid gasps and delighted laughter." The pièce de résistance comes after Bengalsky, the master of ceremonies, tries to take charge and accuses Woland of hypnotizing the crowd. A furious Koroviev instructs Behemoth to do his stuff, which turns out to mean leap at Bengalsky, dig his claws into the man's glossy hair, and twist his head off in two turns. The crowd's reaction is predictable:

Two and a half thousand people screamed as one. Fountains of blood from the severed arteries in the neck spurted up and drenched the man's shirtfront and tails. The headless body waved its legs stupidly and sat on the ground.

But there's more! After weighing up carefully what he thinks the watching crowd wants, Woland decides to pander to its latent compassion and put Bengalsky's head back where it should be—which he does, without even leaving a scar.

Bulgakov completed his magical whirligig of a novel just before

BOWIE'S BOOKSHELF # 185

his death in 1940. Manuscripts don't burn, Woland famously tells the Master, Bulgakov's way of suggesting that truth will always triumph over attempts to suppress it. But he deliberately burned an early manuscript of *The Master and Margarita*, terrified that it would be discovered by Stalin's secret police. He rewrote it from memory and was still dictating revisions to his wife on his deathbed. It wasn't published until 1966, at which point it caused a sensation and became a must-read in hip circles. It inspired Mick Jagger to write "Sympathy for the Devil" and its combination of occultism, antipsychiatry, political allegory, and slapstick comedy was plainly catnip to Bowie.

Read it while listening to: "Diamond Dogs"

If you like this, try: Mikhail Bulgakov, Heart of a Dog

69

Nella Larsen, Passing (1929)

As the husband of a Muslim woman from Somalia and the father of a mixed-race daughter, Bowie couldn't help but be highly attuned to racial identity politics. He and Iman were house hunting in Los Angeles on April 29, 1992, and were caught up in the race riots that followed the acquittal of four LAPD officers for beating up African American taxi-driver Rodney King. The song he subsequently wrote, "Black Tie, White Noise," grapples with the complexity of race relations, a subject that was clearly much on his mind at the time. As he put it to NME: "If we can start recognizing and appreciating the differences between ourselves, and not look for white sameness within everybody, then we have a much better chance of creating a real and meaningful integration."

Passing is the second of the two novels written by mixed-race, light-skinned Nella Larsen, a nurse who became one of the key writers of the Harlem Renaissance, the 1920s African American intellectual movement. The book's title stands as its subject—"passing," when a member of one racial group is accepted by another as its

BOWIE'S BOOKSHELF # 187

own; a crossing of the "color line" that was possible for Larsen in her own life.

It's the story of Irene Redfield and Clare Kendry, two mixed-race women who grew up together but drifted apart. When they reenter each other's lives after a chance encounter in a restaurant, Irene, who lives a black life in Harlem, discovers that Clare has not only been passing as a white woman but is married to a racist, John, who has been kept ignorant of his wife's true racial identity. The tragedy that ensues is almost a foregone conclusion, but Larsen skirts melodrama. She's just as interested in class, sexual tension—*Passing* has a lesbian subtext—and the psychological consequences of existing in an awkward intermediate zone where it's easier and safer not to ask too many questions.

Read it while listening to: "Telling Lies"

If you like this, try: Carla Kaplan, Miss Anne in Harlem: The

White Women of the Black Renaissance

Hubert Selby Jr., Last Exit to Brooklyn (1964)

The Smiths named an album (*The Queen Is Dead*) after a section in *Last Exit to Brooklyn*, six devastating narratives of urban menace and misfortune involving the addicts, hoodlums, and misfits who haunt the mean streets of Brooklyn in the late 1950s. Selby's novel includes characters like closeted gay machinist Harry and sex worker Tralala, who is horribly gang-raped in the novel's most controversial scene. In 1967, the year after its British publication, the book was the subject of a successful, though subsequently overturned, private prosecution for obscenity—the last of its kind.

Bowie's connection to the novel was fostered earlier than he might have realized by his influencer and, later, friend and collaborator Lou Reed, for whom it was a holy text. Reed loved its phonetic, crudely punctuated prose and the way Selby attributed dialogue using delicate tonal shifts rather than quotation marks. "I say, no Selby, no anybody—that's the way I see it," Reed told *The Telegraph*'s Mick Brown in 2013. "Because he was a straight line between two points; no fucking around over there; no polysyllabic anything—it's just, God . . . if that's not rock 'n' roll, what is?"

BOWIE'S BOOKSHELF 4 189

Reed's "I'm Waiting for the Man," basically a Selby story set to music, bowled Bowie over when he heard it for the first time in December 1966. He heard the recording on a prerelease acetate disc of *The Velvet Underground and Nico* that his then manager Kenneth Pitt brought back from New York. Bowie immediately insisted his band at the time (Buzz) learn it and was performing it onstage within a week. "Amusingly, not only was I to cover a Velvets

song before anyone else in the world," Bowie wrote in *Vanity Fair* in 2003, "I actually did it before the album came out. Now that's the essence of Mod."

Read it while listening to: "I'm Waiting for the Man" (cover of Velvet Underground song)

If you like this, try: Hubert Selby Jr., Requiem for a Dream

Frank Edwards, Strange People: Unusual Humans Who Have Baffled the World (1961)

When Bowie commissioned Belgian artist Guy Peellaert to design the cover for *Diamond Dogs* he instructed him to create a "freak show" in which Peellaert's "dog-man" depiction of Bowie could be displayed. As if to hammer the point home, the title song squeezes in a reference to director Tod Browning and his controversial 1932 film *Freaks*, which had starred circus and sideshow performers with genuine deformities and extreme medical conditions. Bowie's interest in freakishness, both physical and mental, was part of a broader interest in the paranormal that never left him.

Strange People was the follow-up to Stranger Than Science, based on a radio show Edwards hosted in the US where he'd been the go-to person for tall tales of the unexplained since the 1940s. Siamese twins and a baby covered in silky black hair feature alongside a man who starts fires with his breath and "Sleeping Lucy," a teenage girl in 1830s Vermont who could "dream" where lost objects might be found. There are giants and midgets aplenty, as well as

psychic detectives and several instances of people apparently dead being revived after burial.

Two stories stand out. The first is that of poor, deformed "John" (actually Joseph) Merrick: Strange People would have been Bowie's first encounter with the so-called Elephant Man, a character he played on Broadway in 1980 to great acclaim. The second involves a man from Anderson, Indiana, who claims to need no sleep at all. His name is (drumroll, please) David Jones and his story is relayed via a snippet from the local paper, dated December 11, 1895. Jones managed to stay awake for 131 consecutive days, eating and talking as usual. To the journalist he confesses his suspicion that the condition was triggered by overuse of tobacco in his youth. (How our chain-smoking hero must have laughed when he read this.)

"A lot of those strange freak stories appealed to me in my teens and then stayed with me," Bowie told *NME*'s Angus MacKinnon in a 1980 interview to promote *The Elephant Man*. "Everything from hairy women to people with fifteen lips. I read all that stuff avidly and, of course, I did my homework on Merrick."

In later books Edwards tackled the subject of UFOs, popularizing the world-conquering theory that the US government had hidden evidence of alien visitations. In fact, he claimed, the military had a plan in place for apprehending alien craft called "Seven Phases to Contact." In the late 1960s Bowie often went UFO spotting, both on South London rooftops and up north on Hampstead Heath with Tony Visconti and the singer-songwriter Lesley Duncan. He memorialized the habit in an early song, "Memory of a Free Festival," with its nice line about scanning the skies with rainbow eyes. He gave the subject a 1950s B-movie spin in 2013's trashy-fun "Born

in a UFO," whose narrator imagines being ravished against a tree by a futurist-styled phantom in an A-line skirt and André Perugia shoes whom he's watched emerging from a landed craft. Her clutch bag reflects sun and steel—a sly little reference to the Mishima (see p. 17) book of that name.

"I made sightings six, seven times a night for about a year when I was in the observatory," he recalled to *Creem* in 1975. "We had regular cruises that came over. We knew the 6:15 was coming in and would meet up with another one. And they would be stationary for about half an hour, and then after verifying what they'd been doing that day, they'd shoot off."

Read it while listening to: "Born in a UFO"

If you like this, try: Erich von Däniken, Chariots of the Gods?

Nathanael West, The Day of the Locust (1939)

By the end of 1977 living in Berlin had given Bowie sufficient perspective to tell *NME* journalist Charles Shaar Murray that Los Angeles, his previous place of residence, was "the most vile pisspot in the world." Murray suggested that living there was like being stuck on the set of a movie you never wanted to see. It was worse than that, said Bowie: "It's a movie that is so corrupt with a script that is so devious and insidious. It's the scariest movie ever written. You feel a total victim there, and you know someone's got the strings on you."

Possibly for this reason, most of the films Bowie acted in were not American; or if they were, they were made outside the studio system by directors such as David Lynch (*Twin Peaks: Fire Walk with Me*) and Julian Schnabel (*Basquiat*). The Man Who Fell to Earth was shot in the US, but it was a British-financed film made by an English director (Nicolas Roeg) using a British crew. So you could say Bowie got off lightly.

No novel conveys the moral emptiness of Hollywood and celebrity culture as well as *The Day of the Locust*, which may have been

brought to Bowie's attention via John Schlesinger's 1975 film version starring Donald Sutherland. Its author—born Nathan Weinstein, son of a wealthy New York property developer—made it his business to expose the sham side of the American dream after his family lost all their money in the Wall Street crash. In 1933, after a stint working as a hotel night manager, he was hired as a contract screenwriter by Columbia Studios, then run by abusive tyrant Harry Cohn. When he wasn't working on scripts for B movies, West was hanging out in cheap hotels, attending porno parties, and going to gay bars, gathering material for *The Day of the Locust*.

West's friend F. Scott Fitzgerald took on Hollywood in *The Last Tycoon* but focused on the top of the food chain—the moguls like Cohn and Irving Thalberg. West was more interested in the deplorables at the bottom—the freaks and losers trying to make it big, but also the retirees who'd come to California in search of sunshine and glamour and felt so duped by the boring reality that they "burn with resentment": "Every day of their lives they read the newspapers and went to the movies. Both fed them on lynchings, murder, sex crimes, explosions, wrecks, love nests, fires, miracles, revolutions, war. This daily diet made sophisticates of them."

The straight man in this blackest of comedies is set-painter Tod Hackett ("Tod" from the German for "death"; "Hackett" because he's a hack), an artist who studied at Yale School of Fine Arts and is planning a painting in which Los Angeles will be consumed by fire. We never know what to make of Hackett, who resembles a certain singer in being what West calls "really a very complicated young man with a whole set of personalities, one inside the other like a nest of Chinese boxes." A cultured "college man," he's ostensibly

the novel's center of consciousness but in reality is no less adrift than the human flotsam he encounters in the course of his descent into hell—characters like seventeen-year-old wannabe actress Faye, the object of Tod's creepy rape fantasies; splenetic dwarf Abe Kusich; and Homer Simpson [sic], a shy hotel clerk from Iowa with unruly hands who has come to California for a rest cure.

The Day of the Locust plays like a bleaker American version of Evelyn Waugh's Vile Bodies (see p. 239) and ends, like that novel, with a surreal flourish—a riot outside a cinema on Hollywood Boulevard which consumes Homer and deranges Tod, who after being picked up by the police and offered a lift home has to check his clamped lips to make sure it's the car he's traveling in that's making the screeching siren noise and not him.

Read it while listening to: "Cracked Actor"

If you like this, try: Evelyn Waugh, The Loved One

73

Tadanori Yokoo, Tadanori Yokoo (1997)

Bowie took Ziggy to America in the autumn of 1972, just missing the solo show by Tadanori Yokoo at New York's Museum of Modern Art. Being a plugged-in sort of person, however, he would have heard all about Yokoo's provocative collages, with their echoes of Peter Blake and late-1960s psychedelic poster art. Further, Bowie would have been aware of the warm reception the Japanese graphic designer had received from pop art's high priests Andy Warhol, Jasper Johns, and Tom Wesselmann when he first visited the city in 1967.

Bowie's interest in Japanese culture—stoked by his old mime tutor Lindsay Kemp, who used contemporary Japanese music by composer Toru Takemitsu in his dance classes—had exploded into Japanophilia by the time he toured the country in spring 1973, as if he'd suddenly noticed Japan's vast potential as a metaphor for alienness. "I think it's the only place, besides England, where I could live," he told *Melody Maker* that year. Japanese culture acquired a new visibility in Britain during the early 1970s, so while Bowie's assimilation of it was genuinely innovative it occurred against a backdrop of, to cite a few examples, the V&A's exhibitions on Japanese prints (*The Floating World*, 1973) and Onisaburo (*The Art of Onisaburo*, 1974) and the show *Kabuki*, which ran at Sadler's Wells in June 1972.

Bowie immersed himself in the Japanese aesthetic. He incorporated elements of Kabuki theater into his live shows; while in Japan Bowie took lessons in Kabuki makeup with Tamasaburo Bando, one of the most renowned onnagata (actors who specialize in female roles). He was being dressed by Yohji Yamamoto and photographed by Masayoshi Sukita (who would later shoot the famous "Heroes" cover image). He was digging the movies of Akira Kurosawa and Nagisa Oshima (with whom he would work in 1982 on Merry Christmas Mr. Lawrence), and falling in love with the novels of Yokoo's great friend Yukio Mishima (see p. 17).

For Mishima, Tadanori Yokoo's art represented everything intolerable that Japanese people kept locked within themselves. He meant the tension between traditional Japanese ritual—expressed through Yokoo's use of the ancient woodblock printing technique *ukiyo-e*—and the consumerism of pop art. Sex, death, and violence, too, are preoccupations. A famous self-titled early work features the sixteen-ray rising-sun symbol, a photo of Yokoo as a baby, and a cartoon image of a corpse hanging from a noose above the phrase

198 4 John O'Connell

"Having reached a climax at the age of 29, I was dead." The older generation was appalled. But Yokoo was part of the first wave of Japanese youth to rebel against their parents. By 1970, when his solo exhibition at the Matsuya Ginza department store in Tokyo received seventy thousand visitors in six days, he was already an international star.

Read it while listening to: "Crystal Japan"

If you like this, try: Angela Carter, Fireworks: Nine Profane
Pieces

Jon Savage, Teenage: The Creation of Youth Culture (2007)

Bowie's favorite TV show toward the end of his life was *Peaky Blinders*, based on the antics of the real-life gang of that name who, from the 1890s until around 1910, brought terror to the streets of Birmingham's Cheapside district. Where did they come from? As Jon Savage shows in his weighty prehistory of teenagerdom, from 1870 onward urbanization fractured families, leaving cities overrun by aimless latchkey kids—human debris ripe for grooming.

Bowie's interest in violent, disenfranchised youth found late expression in "Dirty Boys" on *The Next Day*, almost certainly written after he'd read *Teenage*. The book's tales of brutal urchinry would have reminded Bowie of the ones his Dr. Barnardo's publicist father Haywood used to bring home from work. To these boys, clothes were all-important. The feather hat the Fagin-like narrator of "Dirty Boys" buys his young protégé before stealing a cricket bat to smash some windows en route to Finchley Fair marks him out as a dandy, like the piratical Halloween Jack of "Diamond Dogs."

The Blinders have a strut-on role in Teenage, which reaches all

the way back to Goethe, Rousseau, and the solipsistic diaries of latenineteenth-century Russian emigré Marie Bashkirtseff to explode the myth that the teenager was a 1950s invention. In 1904 the psychologist G. Stanley Hall became the first person to define the years between fourteen and twenty-four as a distinct phase marked by specific stresses. But he considered adolescence an American phenomenon, a by-product of the freedom and possibility the young country represented. Could it ever find purchase elsewhere?

It's worth reiterating that Bowie's youth was relatively comfortable by the drab standards of Britain in the 1950s. By all accounts he was indulged by his father, who bought him records and musical instruments and took him to fundraising concerts where he met stars of the day like Alma Cogan and Tommy Steele. It's almost too good to be true that his favorite record as a young teenager was "I'm Not a Juvenile Delinquent" by Frankie Lymon and the Teenagers. In fact, the adolescent David Jones was an enthusiastic Cub Scout who learned to play the ukulele beside the campfire, happily oblivious to scouting's history as a tool of social control comparable to British public schools' ethos of "muscular Christianity" and—an example Savage considers at length—the Hitler Youth.

It was America and his half brother Terry's love for all that it represented—jazz, the Beats, Hollywood—that changed everything for Bowie, filled him with radical fire and the boldness to challenge ready-made perspectives. As Savage shows, America had a head start when it came to commodifying youth culture. Way before Beatlemania, American girls went mad for Rudolph Valentino and Frank Sinatra.

Bowie mined the iconography of pre-1950s youth movements to

create his own visual style, latching with particular tenacity onto delicate Stephen Tennant, the most beautiful of the interwar Bright Young People. Tennant's glossy, androgynous look was channeled by Bowie on the cover of *Young Americans* several years before New Romantics like Steve Strange and David Sylvian borrowed it for themselves. By the time Bowie resurrected it for *Let's Dance* in 1983 it was, to be honest, a little passé.

As Savage says, the Bright Young People were, for all their elitist obnoxiousness, the first British youth culture to be defined in aspirational terms. For this innest of in-crowds, the glitter and sparkle of youth was a higher state of beauty, a kind of contagious ecstasy that over time became the preserve of pop stars.

But even pop stars grow old. Well into his fifties, Bowie was a Peter Pan figure looking for new tribes to join, though he was self-aware enough to know when the game was up. When he returned from exile in 2013, one of the biggest shocks was his decision finally to show what Charles Shaar Murray called his "old man's face" to the world.

Read it while listening to: "Dirty Boys"

If you like this, try: Jon Savage, England's Dreaming: Anarchy,
Sex Pistols, Punk Rock, and Beyond

Wallace Thurman, Infants of the Spring (1932)

Ourious, perhaps, about how he might fare in a fictional account of his own life, Bowie was drawn to satirical novels that critique scenes from within—Vile Bodies (see p. 239) being the most obvious example on his list. Infants of the Spring is a scabrous, deeply Waughian roman à clef set amid the Harlem Renaissance, or "New Negro" movement, of the 1920s which held, in a rather fractious embrace, writers such as Nella Larsen (see p. 186), Langston Hughes, and Zora Neale Hurston and artists including Aaron Douglas and the sculptor Augusta Savage. Infants of the Spring has a group of them living together in a Harlem brownstone they've christened "Niggerati Manor."

Thurman is best known for his novel about color prejudice within the African American community *The Blacker the Berry*, the inspiration for the Kendrick Lamar song of that title on 2015's *To Pimp a Butterfly*, an album Bowie admired. A showman and opportunist whose boundless energy amazed his peers, Thurman also wrote plays and cofounded an influential black modernist magazine called *Fire!!* But to his fictional avatar "Raymond" in *Infants of the Spring*

Thurman gives his downbeat private view that the pressure black writers were under was stopping them from producing work of real substance. Thurman's character Sweetie May Carr, based on Hurston, admits that a desire to make fast money is the true motivation behind the sentimental tales of her Mississippi childhood that she churns out for white readers.

As a bisexual man—married but jailed for cottaging in 1925—Thurman also worried that, in the rush to produce black art that would do double duty as civil rights propaganda, the decadent, bohemian qualities he and his friends valued in their work were being sidelined. Does African American art always have to stand for a cause? Why, if it wants to, can't it be influenced by aesthetes like Oscar Wilde and Joris-Karl Huysmans? *Infants of the Spring* pulses with such questions. It answers them obliquely at the end when its most entertaining character, Paul Arbian (based on the openly gay black artist Richard Bruce Nugent—R, B, N), who paints multicolored penises, which have no place in the official New Negro scheme of things, commits suicide by slitting his wrists in the bath to create publicity for the novel he has just completed, *Wu Sing: The Geisha Man*.

Arbian makes sure his corpse looks exquisite in a crimson robe and batik scarf of his own design. So engrossed is he in his obsession with spectacle, however, that he leaves the manuscript on the bathroom floor, which floods, rendering the text illegible.

Bowie's interest in *Infants of the Spring* may have been a tributary of his love for the 1980s New York artist Jean-Michel Basquiat, whose work he collected. Like the black artists of the Harlem Renaissance, Basquiat struggled with issues of identity and belonging. The

204 4 John O'Connell

mostly white art world valued his work highly. But among some a suspicion persisted that Basquiat was being patronized, treated as an emblem of primitivist cool. Did Andy Warhol, who took the former graffiti tagger under his wing when Basquiat was nineteen, nurture the younger artist or leech off his talent and energy? Bowie brought an informed awareness of these questions to his role as Warhol in Julian Schnabel's 1996 film *Basquiat*, telling Charlie Rose in a TV interview to promote it that he'd identified a "wariness on Andy's part . . . a realization that this might be tomorrow's world."

Read it while listening to: "Andy Warhol"

If you like this, try: Wallace Thurman, The Blacker the Berry

76

Hart Crane, The Bridge (1930)

f European modernism was powered chiefly by despair, its American equivalent had a salty, romantic tang to it. It was open and uncynical, alive with the excitement of finding new possibilities in the machine age, in a country that was itself new. After settling in Manhattan in the early 2000s, Bowie lived the most authentic New York life he could manage. And all New Yorkers love Hart Crane's visionary poem *The Bridge*, which is American modernism *in excelsis*. Tellingly, it inspired Nat Tate—the fictional artist invented by Bowie and his friend William Boyd as a prank (see Frank O'Hara, p. 21)—to produce a "once legendary, now almost entirely forgotten" series of drawings.

The Ohio-born son of the inventor of Life Savers candy, Crane was an autodidact who never completed high school—there were immense gaps in his knowledge, noted his Harvard-educated friend Malcolm Cowley—but who possessed a ferocious drive to take on T. S. Eliot and win. *The Bridge*, which he started writing in 1923 when he was twenty-three and working as an advertising copywriter, was his attempt at what he called in a letter to the critic Gor-

ham Munson "a mystical synthesis of 'America,'" his own upbeat version of *The Waste Land*, a poem he considered overrated.

As a unifying symbol of form and function he chose the Brooklyn Bridge, one of the arteries connecting New York's outer boroughs to the city. It had been completed in 1883 but was such an incredible technical achievement that it still felt new in the 1920s. Without realizing it, Crane lived at the same address as its chief engineer, Washington Roebling—seeming proof of the way the Brooklyn Bridge's sublime mythology permeated his life. Crane's sense of its musicality, conjured in *The Bridge*'s final section, "Atlantis," in rhythms that evoke jazz, would have intrigued Bowie:

Through the bound cable strands, the arching path Upward, veering with light, the flight of strings,
—Taut miles of shuttling moonlight syncopate
The whispered rush, telepathy of wires. . . .

Thanks to his love of forced, high-flown rhetoric, Crane is hard work even by modernist standards. As with Eliot, this was deliberate, Crane believing that the voice of the present must be captured even if it seems shocking or confusing or illogical. What mattered more, he believed, was the logic of metaphor. Like Eliot, he drew on classical authors, in his case Dante Alighieri, Christopher Marlowe, François Rabelais, Herman Melville, and Walt Whitman, reading them slowly and carefully, almost (said Malcolm Cowley) as if they were textbooks on advanced engineering.

Some critics attribute the obscurity of Crane's work to his halfhidden homosexuality, coded references to which he buried in the

BOWIE'S BOOKSHELF 4 207

poem, e.g., love compared to "a burnt match skating in a urinal," a reference to cruising. His heavy drinking having been exacerbated by *The Bridge*'s mostly unenthusiastic reception, Crane committed suicide at thirty-two by throwing himself into the sea.

Read it while listening to: "Heathen (The Rays)" If you like this, try: Hart Crane, White Buildings

Eugenia Ginzburg, Journey Into the Whirlwind (1967)

is interest in totalitarianism snared by Nineteen Eighty-Four (see p. 77) and Darkness at Noon (see p. 159), Bowie seems to have read around the subject in some detail. Eugenia Ginzburg's first book is a memoir of her eighteen-year imprisonment and exile under Stalin in the 1930s and '40s. Along with Aleksandr Solzhenitsyn's The Gulag Archipelago, Journey Into the Whirlwind is one of the "intelligentsia narratives of survival," as Orlando Figes describes them in History Workshop Journal. These accounts emerged decades after the event and are our chief source of information about Soviet life at the time.

Journey Into the Whirlwind came out in Britain in 1967, the year before the historian Robert Conquest's The Great Terror: Stalin's Purge of the Thirties. Conquest's book drew on fresh archive material released by Nikita Khrushchev, premier of the Soviet Union between 1958 and 1964, to expose the horrifying extent of Stalin's crimes against humanity, not to mention the complicity of those British intellectuals who had looked the other way. Possibly this is when Bowie first encountered Journey Into the Whirlwind. If so,

then perhaps it was in the back of his mind when he wrote *Space Oddity*'s "Cygnet Committee," an opaque tale of a utopia thwarted by a man Bowie described in *Interview* magazine as "a quasicapitalist who believes that he is left-wing."

A former journalist and history professor, Ginzburg was a loyal Communist until the day she was expelled from the party and accused of terrorism for not having denounced a university colleague. Her husband observes that if they arrested her, they'd

have to arrest the whole party. But that is the point. Whether or not you had committed a crime, you were still guilty even if you didn't have a clue as to what was going on. When Ginzburg protested that she didn't know Sergei Kirov, Stalin's right-hand man, and had never lived in Leningrad, where he was assassinated, she was told that it didn't matter; he had been killed by those who shared her views and she was therefore morally and criminally culpable.

Although she was released from the notorious Kolyma gulag in 1949, Ginzburg remained in exile in the town of Magadan, where she remarried, her first husband having died during her imprisonment, and adopted a daughter. She was "rehabilitated" in 1955,

210 4 John O'Connell

eventually moving to Moscow, where she wrote Journey Into the Whirlwind and a second volume, Within the Whirlwind, published in 1982.

Also redolent of *Darkness at Noon* is the episode where Ginzburg and her cellmate Lyama communicate with other prisoners by tapping on the wall using a code Ginzburg realizes she has remembered wholesale from a memoir she once read. It's incredible, she muses, the way human memory is sharpened by loneliness and isolation. Ginzburg's gift for recall, even of the grimmest moments of her confinement and forced labor, is one of the things that makes *Journey Into the Whirlwind* so extraordinary. Never has the agony of depersonalization been more affectingly described.

Read it while listening to: "The Chant of the Ever Circling Skeletal Family"

If you like this, try: Aleksandr Solzhenitsyn, *One Day in the Life of Ivan Denisovich*

Ed Sanders, Tales of Beatnik Glory (1975)

C till active as a poet and writer, Ed Sanders is a founder member Of politico-satirical New York avant-folkists the Fugs, darlings of the counterculture on both sides of the Atlantic. Paul McCartney was an early fan, having been introduced to them in 1966 by his friend Barry Miles. Miles ran the Indica Bookshop and Gallery in St. James's, London; a countercultural hub co-owned by Pete Asher, brother of McCartney's then girlfriend, actress Jane Asher. One of the first books McCartney bought there was Peace Eye Poems by Ed Sanders. When hassled for his autograph, McCartney would sometimes sign his name "Tuli Kupferberg" after the Fugs' percussionist and cofounder. Bowie encountered the band at around the same time through his manager Kenneth Pitt, who gave him the Fugs' eponymously titled third album. Bowie described them in Vanity Fair as "one of the most lyrically explosive underground bands ever," which is about right. (He would have had in mind "Wide, Wide River" aka "River of Shit," from their 1968 album It Crawled into My Hand, Honest.) Sanders had other irons in the fire too, though, such as running the Peace Eye Bookstore on New York's Lower East Side, founding the radical journal Fuck You/A Magazine of the Arts, and inventing musical instruments such as the pulse lyre, on which he would accompany himself reading his poetry.

Originally published in two separate volumes, *Tales of Beatnik Glory* is a collection of stories and sho-sto-gho-pos ("short story ghost poems") set in the Lower East Side in the golden years—broadly, 1960 to 1970—when assorted "partisans of the beat struggle" gathered in the Peace Eye, united by their awareness that, as Sanders puts it, "there was oodles of freedom guaranteed by the United States Constitution that was not being used." The stories' sort-of hero is poet and filmmaker Sam Thomas, a fictional stand-in for Sanders. Sometimes the Lower East Side he inhabits approximates to the "real" one. At other times it's a Lower East Side of the mind where members of the Anarchist Coal Collective might visit the Luminous Animal Theater. Always, it's a madcap celebration of chaos, community, and utopian possibility in the face of "Grasping and Greed and War."

Read it while listening to: In an ideal world, the Fugs' "Dirty Old Man" as played live by Bowie with his early band the Riot Squad—though sadly no recording was ever made

If you like this, try: Ed Sanders, Fug You: An Informal History of the Peace Eye Bookstore, the Fuck You Press, The Fugs, and Counterculture in the Lower East Side

John Dos Passos, The 42nd Parallel (1930)

his book is a good place to start if you are a young Englishman wanting to understand America in the first decades of the twentieth century, which Bowie clearly did. Where did rock 'n' roll originate, after all? Little read today but extravagantly praised on publication, The 42nd Parallel used modernist techniques from the visual arts like collage, montage, and eccentric typography—John Dos Passos was a painter, too, and designed his own book jackets—in the service of a downbeat naturalism. Dos Passos's father was a corporate lawyer, the son of a Portuguese immigrant. He was living apart from his first wife when he began a relationship with a widow from Virginia that resulted in John's birth in 1896. The pair didn't marry until 1910, by which time John had been packed away to Europe for his education, enduring a lonely, itinerant childhood where books were his only consolation.

Set in the run-up to the First World War, in which Dos Passos served as an ambulance driver, *The 42nd Parallel* is the first part of his huge, grandly named U.S.A. trilogy—it was followed by 1919 (1932) and *The Big Money* (1936). Its sections of "straightforward"

narrative dwell upon twelve intertwined lives, of characters like "Mac" McCreary, a salesman-turned-printer who gets involved in left-wing politics and leaves his wife and children to become a revolutionary in Mexico, and snooty interior designer Eleanor Stoddard. But for Dos Passos, novel writing was a kind of higher journalism that should aspire to nothing less than diagnosing a nation's ills. This is why he intersperses documentary material: sixty-eight "Newsreels" consisting of newspaper headlines and stories as well as snatches of popular songs; fifty-one stream-of-consciousness "Camera Eye" sections in which he grants us somewhat oblique insights into his own life; and twenty-seven curious, slightly arch biographical sketches of famous men (Henry Ford, Woodrow Wilson) and one woman (Isadora Duncan).

Dos Passos put his all into researching the books to make them as authentic as possible. Malcolm Cowley remembers the way he traveled across America by train, visiting cotton mills in Carolina, coal fields in Kentucky—anywhere he felt there was likely to be social ferment. It's hard to believe that by the 1960s this crusader for social justice had swapped his Marxism for an extreme brand of right-wing libertarianism, writing for the *National Review* and campaigning for Barry Goldwater and Richard Nixon.

In the U.S.A. trilogy, however, the theme is very much wasted potential and the conflict between labor and capital; the way ordinary men and women are ground into dust by the effort of pursuing wealth and success. It's territory Bowie explored on "Young Americans," his poignant Springsteenesque tale of a slinky vagabond who gets a young girl pregnant, then ends up begging off a bathroom floor. The starkness of the contrast between rich and poor—Bowie's

BOWIE'S BOOKSHELF 4 215

got a suite, he's got defeat—is emotionally cauterizing until in the end there isn't one damn song that can make him break down and cry.

Read it while listening to: "Young Americans"

If you like this, try: John Dos Passos, Manhattan Transfer

Peter Guralnick, Sweet Soul Music: Rhythm and Blues and the Southern Dream of Freedom (1986)

big fan of soul since his teens, Bowie first incorporated soul elements into his own music on Diamond Dogs ("1984," "Sweet Thing"). As the US tour for that album trundled on, it grew progressively blacker, mutating into a full-on soul revue augmented by black singers such as Luther Vandross and Bowie's then girlfriend, Ava Cherry. Bowie's guitarist of choice for decades, Carlos Alomar, was astounded by Bowie's huge knowledge of African American music. One of the singer's favorite albums was James Brown's 1963 Live at the Apollo, so he was thrilled when Alomar, who played in the Apollo's house band and had toured with Brown as well as Wilson Pickett and Ben E. King, took him there after the pair met at a recording session for Lulu in April 1974. Alomar was the main wrangler for what became Young Americans, mostly recorded at Sigma Sound in Philadelphia. Bowie was one of the first white artists to use the studio.

Young Americans made Bowie a star in the US. In interviews from the period he sounds ambivalent about the record, on the one

hand dismissing it self-loathingly as "plastic soul," on the other conceding that it has an emotional honesty that isn't present in his earlier work. Up until Young Americans, Bowie told Melody Maker, he had used "science fiction patterns because I was trying to put forward concepts, ideas and theories." But Young Americans is different—"just emotional drive."

The source of this emotional drive is music historian Peter Guralnick's quarry in *Sweet Soul Music*, a gripping, deeply researched portrait of the era and milieu that gave rise to soul. This Guralnick defines very specifically as a secular iteration of gospel—mostly produced in the "southern soul triangle" of Memphis, Tennessee; Macon, Georgia; and Muscle Shoals, Alabama—which became popular from 1954 onward after the success of Ray Charles, reached its peak in the early 1960s in tandem with the civil rights movement, and was spent as a creative force by the 1970s when the innocent, chaotic enthusiasm that had powered labels like Stax ebbed away.

James Brown, Solomon Burke, Aretha Franklin, Otis Redding, Sam Cooke . . . Guralnick profiles each diligently, though he's especially drawn to Cooke, tragically cut down in his prime—"the best singer who ever lived, period," in the opinion of Jerry Wexler, the journalist turned producer who coined the term *rhythm and blues* and who, with Ahmet Ertegun and a little help from Franklin, Wilson Pickett, et al., made Atlantic one of America's most formidable record labels.

Sweet Soul Music is scholarly and illuminating, then, if rather male in its outlook, unlike Gerri Hirshey's similar but more joyous Nowhere to Run (see p. 176), which expands its remit to include Motown and therefore Diana Ross, Mary Wells, Gladys Knight,

the Marvelettes, etc. Guralnick is something of a purist, scornful of Motown for what he thinks of as its craven courting of a white audience, even as he describes the writing of *Sweet Soul Music* as a process of unlearning some of his more naive, romantic assumptions about black musicians.

Guralnick is at his best when focusing on individual songs, for example the Orioles' 1953 hit "Crying in the Chapel," which blurs the line between gospel and R&B. And there's a lovely account, courtesy of a local newspaper, of Otis Redding and guitarist Steve Cropper in the studio whipping up "(Sittin' on) The Dock of the Bay," the Beatles-inspired song that became a posthumous US number one for Redding in 1967. This would likely have delighted Bowie, who in 1974 had a UK hit with the Stax standard "Knock On Wood," originally performed by Eddie Floyd but covered to thrilling effect by Redding and Carla Thomas on their 1967 album King & Queen.

Read it while listening to: "Win"

If you like this, try: Peter Guralnick, Careless Love: The

Unmaking of Elvis Presley

81

Bruce Chatwin, The Songlines (1987)

David Bowie loved Australia, and between 1983 and 1992 he kept a waterfront apartment at Elizabeth Bay in Sydney. Typically he would stay there for a month at a time, using it as a base for excursions to the Outback or the tropical rainforests of North Queensland. Early in 1983 he filmed the videos for "Let's Dance" and "China Girl" in the country. The former was a powerful, sometimes surreal political allegory that made clear Bowie's concerns about the depredation of Aboriginal culture by white settlers. In one of the video's final scenes, Bowie stands alone with his guitar in a remote desert, a vast sun setting behind him. With his tousled blond hair, he looks remarkably like Bruce Chatwin, the handsome, erudite storyteller who reinvented English travel writing in books

such as *In Patagonia* and who was also in Australia at this time researching his breakthrough work, *The Songlines*.

Abstruse and fragmentary, *The Songlines* blurs memoir and fiction to chronicle a series of visits its author made to Australia in the early to mid-1980s to learn about nomadic Aboriginal traditions. Of particular interest to Chatwin are *tsuringa*-tracks, or "songlines," the ghostly labyrinth of invisible paths ancestral Aboriginals left across the Outback as they migrated from place to place. As they walked they literally sang the land into existence, attaching names and stories to their sacred spaces so that they could navigate hundreds of miles of featureless desert simply by singing.

Charles Bruce Chatwin was born in Sheffield in 1940, the eldest son of a solicitor. He worked for many years at the auction house Sotheby's before leaving to study for an archaeology degree he ultimately abandoned to pursue his career as a writer. Friends remember him as charming, confident, and hilarious, a great talker with a talent for intimacy. The film director James Ivory described him wonderfully as a "beautiful soft boy-child who's not quite real." But he was also a depressive loner who would disappear abruptly and without warning. Compulsively unfaithful to his wife with both men and women, he died of AIDS in 1989, having told friends that the disease consuming him was a rare Chinese fungal infection.

Chatwin's stock declined after his death as it became clear that he had exaggerated, even fabricated, some of the charged, coincidence-rich experiences he distilled in his books. This seems an unkind fate for a writer who was never much interested in "fact." For fans of *The Songlines*, rooted like all Chatwin's work in Jorge Luis Borges's dictum that "a voyage is always more or less illusory," its power to

inspire matters more than whether it has any basis in anthropological reality. Chatwin himself saw the borderline between fiction and nonfiction as arbitrary, like the one between truth and lies in his own life. His prose style, much imitated, is taut and fastidious. It conceals as much as it reveals.

Chatwin was incapable of staying in one place for long and seemed to want to prove that all humans were as restless as he was. Bowie was never nomadic exactly, but he paid lip service to the romantic idea of a correlation between rootlessness and artistic success. "I don't live anywhere," he told *NME*'s Charles Shaar Murray in 1977, coincidentally the year Chatwin's debut *In Patagonia* was published to huge acclaim. (Had he read it, or about it?) "I must have complete freedom from bases. If I ever had anything that resembled a base—like a flat on a long lease or anything—I felt so incredibly trapped." When Murray quotes Elizabeth Bowen's diagnosis of the psychology of the obsessive traveler—that when a person *feels* foreign, it's easier and more relaxing for her to be somewhere that *is* foreign—Bowie's eyes show a "flash of recognition." He would go on to celebrate the idea of the "traveling man" who is addicted to constant movement on his next album, 1979's *Lodger*.

Read it while listening to: "Move On"

If you like this, try: Bruce Chatwin, In Patagonia

Camille Paglia, Sexual Personae: Art and Decadence from Nefertiti to Emily Dickinson (1990)

A merican academic Camille Paglia's crossover smash is like a firework going off in a library. Bowie liked reading about himself, so he would have loved that he crops up in the book, compared in his "neutered" extraterrestrial guise (circa *The Man Who Fell to Earth*) to "leering elf" Aubrey Beardsley and to a mannequin android in what Paglia calls his "transvestite period"—presumably the skeletal *Young Americans* years, though this seems an odd way to describe them.

Despite the book's impatience with one of Bowie's favorite theories, that culture has collapsed into meaningless fragments, there's

lots that chimes with his worldview. For Paglia, Western art oscillates between the ordered, phallic Apollonian and the disruptive, "chthonic" (i.e., to do with the underworld) Dionysian. The gate-keepers of Western culture—academics, arts journalists, etc.—prefer not to acknowledge this Dionysian dimension because they dislike its focus on violence and sex. But this, Paglia insists, is foolishness. The amorality of the instinctual life can't be so easily disregarded, and certainly wasn't by Bowie, who positioned himself within a Dionysian tradition that encompassed the Velvet Underground, surrealism, Madame Bovary (see p. 32), and A Clockwork Orange (see p. 1).

At the time of Sexual Personae's publication, Paglia was a jobbing professor at Philadelphia College of the Performing Arts (now part of the University of the Arts). She'd spent nine years trying to find a publisher for the book, which was based on material she'd been working on since the late 1960s. In a flash she became a media sensation—a broadsheet-and-arts-TV perennial, the most famous academic in the US, if not the world. Her baiting of feminists—"If civilization had been left in female hands, we would still be living in grass huts"—only stoked the flames of her celebrity.

Such was Bowie's keenness on Paglia that in 1995 he wanted her to contribute a sample of her voice to his song "We Prick You." But, as he admitted later to *Time Out*, she never returned his calls. "She kept sending messages through her assistant saying, 'Is this really David Bowie and, if it is, is it important?' and I just gave up. I replaced her line with me."

224 # John O'Connell

As if to compensate for this sorry misunderstanding, Paglia contributed a barnstorming essay called "Theatre of Gender" to the official book of the V&A exhibition.

Read it while listening to: "We Prick You"

If you like this, try: Camille Paglia, Vamps & Tramps

Jessica Mitford, The American Way of Death (1963)

rancis Bacon told David Sylvester (see p. 113) that he felt the presence of death all the time. This was, he explained, because life excited him, and if you were excited by life, then it followed that you would also be excited by its shadow, or opposite.

Jessica—or "Decca," as she was known—was the radical, left-wing Mitford sister who at nineteen ran away to fight in the Spanish Civil War, stopping first to buy a camera, which she charged to her father's account. Afterward she moved to the US, where, in her late forties, she launched her career as an investigative journalist. The American Way of Death peers behind the curtain of propriety and is horrified by what it finds—vulnerable, grief-stricken people being fleeced. Why would you want to spend hundreds of dollars on a lap-welded Colonial Classic Beauty casket made of 18-gauge lead-coated steel? Or visit a specialist grave-wear couturier? Why would you want to see your "loved one" (to use the industry parlance) embalmed and propped up on a Beauty-Rama Adjustable Soft-Foam Bed, designed to be firm so that the corpse doesn't slip, in a "sleeping room" that's billed to the family as if it were a motel room?

Mitford pours scorn on psychological theories that highlight the importance of a "memory picture," when what that means is an open-casket horror show where the occupant has been subjected to dehumanizing embalming techniques and caked in cosmetics that make him look unrecognizable. None of this happened in Europe—not then, at any rate. What had happened to America for funerals to have changed, in the space of fifty years, from homely affairs simple to the point of starkness to grotesque carnivals of excess?

Before *The American Way of Death*, few people had the faintest idea of what went on in funeral parlors. Mitford told of the needles, pumps, bowls, and basins; the pastes, sprays, oils, and creams. Her reward was an international bestseller and a reputation as one of the most dogged reporters in the business.

Life excited David Bowie, so it follows that he would have loved Jessica Mitford's blackly comic, fastidiously researched exposé—still shocking more than fifty years after it was published.

Read it while listening to: "My Death" (cover of Jacques Brel song)

If you like this, try: Mary Roach, Stiff: The Curious Lives of Human Cadavers

Otto Friedrich, Before the Deluge: A Portrait of Berlin in the 1920s (1972)

riedrich's kaleidoscopic account of life in Berlin during its Weimar pomp would have been essential reading for Bowie and Iggy Pop before they left LA for the city in 1976. "I had approached the brink of drug-induced calamity one too many times and it was essential to take some kind of positive action," Bowie told *Uncut* magazine in 1999. "For many years Berlin had appealed to me as a sort of sanctuary-like situation."

The Weimar Republic was the result of Chancellor Friedrich Ebert's creation of a new democratic constitution for Germany in the aftermath of the First World War and the Kaiser's abdication. Guaranteeing every German the right to free expression in any manner, it gave every appearance of being a blueprint for a more open, tolerant society. But the constitution was deeply flawed. Supposed innovations such as proportional representation and the emergency powers enshrined in Article 48 failed to protect Germany from turmoil and contributed to the Nazis' eventual seizure of power on January 30, 1933.

Berlin in the 1920s was a city in flux. A series of political and economic crises, especially hyperinflation—in November 1923 the cost of a loaf of bread rose to 200,000 million marks—triggered an upsurge in crime, prostitution, and anti-Semitism. At the same time, these crises ushered in a period of intense cultural and scholarly activity that seemed to feed off the atmosphere of polymorphous sexual ferment for which Berlin's bars and cabarets became notorious.

Before the Deluge is a crash course for ravers in the films of Josef von Sternberg, the plays of Bertolt Brecht, the harsh atonal music of Arnold Schoenberg, and the scabrous caricatures of George Grosz. Probably it was where Bowie realized the importance of Berlin to Brecht, whose 1918 play Baal he would go on to appear in. It joined the dots between theater director Erwin Piscator and Bauhaus founder Walter Gropius's ideas about Total Theater—a 360-degree experience involving rotating stages and seating, movie screens, and a tunnel from which a chorus could emerge to surround the audience—and the sort of rock spectacles he yearned to put on.

Interwar Berlin was home to Sigmund Freud and Albert Einstein, and also to Vladimir Nabokov, who published his "Berlin novels," including *Laughter in the Dark*, *Despair*, and *The Gift*, under the pseudonym Sirin. It may have been Friedrich who, quoting from

BOWIE'S BOOKSHELF 4 229

The Gift as he does, unwittingly gifted Bowie the image of Nabo-kov sun-licked upon the beach at Grunewald that the singer used years later in "I'd Rather Be High." The Gift's hero Fyodor wanders among the sunbathers at this lakeside beauty spot just outside Berlin observing the swollen legs of the old men lying there; then lies down to feel the benefit of the sun licking his skin. In Bowie's song, of course, Nabokov is not an old man cloistered in a hotel in Montreux (see p. 26), but in his prime—brilliant and naked, a bronzed tribute to Berlin's capacity for fostering talent.

Read it while listening to: "Neuköln"

If you like this, try: Mel Gordon, Voluptuous Panic: The Erotic

World of Weimar Berlin

85

Private Eye (1961-present)

s a paid-up Goons fan (see Spike Milligan, p. 269), Bowie was ripe and ready for the British "satire boom" of the early 1960s. Its earliest manifestation was the revue Beyond the Fringe, first staged at the Edinburgh Festival in the summer of 1960 and mostly written by Peter Cook, who opened his nightclub the Establishment on Greek Street in London's Soho the following October. (Cook and his Beyond the Fringe colleague Dudley Moore's obscene "Derek and Clive" routines were adored by British rock royalty, Bowie included.)

The magazine *Private Eye*'s appearance at around the same time was no coincidence. There was something in the air—frustration with the fusty, inept Macmillan government and impatience with the war nostalgia on which the older generation seemed permanently drunk. Ironically, *Private Eye*'s founders—Richard Ingrams, Christopher Booker, and Willie Rushton—were not classless iconoclasts but public school–educated misanthropes whose relationship with the *Beyond the Fringe* gang was adversarial before Cook swooped in and, with his business partner, bought the magazine in the summer of 1962.

Its early issues were amateurish—sheets of yellow paper stapled together in a Kensington villa and sold in fashionable West London restaurants and cafés like the folky Troubadour. By the time Bowie was old enough to enjoy *Private Eye*—let's say 1962, when he was fifteen and it was selling forty-six thousand copies a fortnight—its main appeal would have been its rejection of conformist suburban values. As the historian Dominic Sandbrook observes, *Eye* writers found lower-middle-class attitudes deeply funny, hence the use of the suburb of Neasden as a byword for tedium and idiocy.

Bowie's family was much more interesting than this—his father had once run a nightclub in Soho, so there was evidence of a bohemian edge, however blunted it subsequently became. But that didn't mean Bromley was any better than Neasden. On the contrary, as *The Buddha of Suburbia* author Hanif Kureishi, who also lived in Bromley, wrote in *The Guardian*, it was a vortex of "interminable zombie boredom and restlessness."

Bowie's friend George Underwood thinks it "highly likely" that the singer continued to subscribe to *Private Eye* while living in Manhattan, and presumably used to enjoy its regular comic strip *Celeb*, the misadventures of aging rock star Gary Bloke.

Read it while listening to: "Buddha of Suburbia"

If you like this, try: Peter Cook, Tragically I Was an Only Twin

86

R. D. Laing, The Divided Self (1960)

"We go every fortnight and we take a hamper of sandwiches and apples, new shirts, and fresh stuff. Take his laundry. And he's always very happy to see us but he never has anything to say. Just lies there on the lawn all day, looking at the sky."

—David Bowie on visiting his half brother, Terry, in the hospital

n 1960s Britain, the standard method for treating mentally ill people was to isolate and drug them in vast asylums like south London's now demolished Cane Hill, immortalized in cartoon form on the cover of the US version of *The Man Who Sold the World*. Bowie's schizophrenic half brother, Terry, spent long periods at Cane Hill in the course of his abbreviated life.

To the Scottish psychiatrist Ronald Laing, this approach wasn't just inhumane but wrongheaded. He believed social context was all-important; that abnormal family relationships, especially, could provoke in some children "ontological insecurity," a fragile sense of self that leads eventually to psychosis. Bowie seems to have worried about the normality of his own childhood setup: "I think there's an

awful lot of emotional, spiritual mutilation goes on in my family," he told *Interview*, perhaps remembering the way Terry, ten years his senior, was browbeaten and excluded by Bowie's father (Terry's stepfather). Bowie revealed to *Crawdaddy* magazine in 1977 that Terry "cried an awful lot at an age when I had been led to believe that it was not a particularly adult thing to do." Mainstream biological psychiatry held that there was no point trying to communicate with schizophrenics. Laing showed that, on the contrary, it was vital to make efforts to understand their "word-salad" (confused speech consisting of random words) because it might have something to tell us, perhaps even the "truth" of their predicament.

As the 1960s rolled on, Laing became a leading light in the "antipsychiatry" movement, committed to altering the consensus view of mental disorder and ending the practice of compulsory hospitalization. A shamanic figure within the counterculture—a two-page interview with Laing in the July 4, 1969, issue of *International Times* gets higher billing on the cover than one with Mick Jagger—he used LSD to treat Sean Connery for stress and hung out with Paul McCartney at the World Psychedelic Center in Belgravia. In 1967 he was a speaker at the Dialectics of Liberation conference at London's Roundhouse, a gathering of the era's alleged finest minds which sought to "solve all the problems of the planet," as one journalist archly put it. Laing also attracted a glamorous, cultured crowd to happenings at Kingsley Hall, his commune-like "safe haven" in East London.

Pink Floyd's Syd Barrett, admired hugely by Bowie, triggered his latent psychosis by taking vast quantities of LSD. His manager Peter Jenner took him to Laing for treatment but the session wasn't

a success. When Bowie writes about how he'd rather hang out with "madmen" than perish with the sad men roaming free, he's echoing Laing's belief that our "normal" state is a rejection of our ecstatic potential. Laing identifies schizophrenia as a state of transcendence that ordinary squares don't understand, a tributary of the nostalgic, childhood-obsessed endless-summer dream state celebrated in acid reveries such as the Beatles' "Strawberry Fields Forever," Pink Floyd's "See Emily Play" (covered by Bowie

on *Pin Ups*) and pre-RCA Bowie efforts like "When I'm Five" and "There Is a Happy Land."

In middle age, Bowie would confirm what many had long suspected: that his restless creativity was a way of harnessing a mania that might otherwise present as madness: "One puts oneself through such psychological damage in trying to avoid the threat of insanity," he admitted to the BBC in 1993. "I felt I was the lucky one [in my family] because I was an artist and it would never happen to me because I could put all my psychological excesses into my music and then I could always be throwing it off."

Read it while listening to: "See Emily Play" (cover of Pink Floyd song)

If you like this, try: R. D. Laing, The Politics of Experience and
the Bird of Paradise

Vance Packard, The Hidden Persuaders (1957)

ondon, Soho, 1964. Crop-haired boys and whey-faced girls flock to clubs like the Scene in Ham Yard to dig the latest R&B tunes and gobble "blues"—amphetamines to keep them dancing all night. Seventeen-year-old David Jones is a key face on this burgeoning mod scene. When he isn't hustling for gigs for the so-so bands he's drifting between, the Kon-Rads and the King Bees, the future David Bowie devotes himself to a day job as natty-sounding as his Italian-cut three-button suit and inch-wide tie: junior visualizer at the Nevin D. Hirst advertising agency on Soho's New Bond Street.

Later, Bowie would say he "loathed" his brief stint at Hirst, which was small-time, its biggest account the manufacturer of a slimming biscuit called Ayds. As a crash course in the art of sell-

ing stuff, though, it was invaluable. Especially when in 1985 he accepted the role of slimy advertising executive Vendice Partners in Julien Temple's movie of Colin MacInnes's Soho-set novel Absolute Beginners (1959). Bowie biographer Paul Trynka notes the way it also gave the singer a license "to pronounce on the world of design, marketing and manipulation as a self-styled expert." In an interview with Creem magazine in 1975, Bowie revealed darkly: "I used to be a visualizer for an advertising agency, and I know exactly what—I mean the advertising agencies that sell us, they are killers, man. Those guys, they can sell anybody anything. And not just products. If you think agencies are just out to sell products, you're naive. They're powerful for other reasons. A lot of those agencies are responsible for a lot of things they shouldn't be responsible for. They're dealing with lives, those ad agencies."

The second installment of MacInnes's London trilogy, Absolute Beginners celebrates two newly minted concepts: teenagers and multiculturalism. Despite its cult ubiquity, Bowie hadn't read it, which surprised Temple. But Bowie was fascinated by the way MacInnes had intentionally given Partners the same initials as the author of a book he knew well, probably because it had been required reading at Hirst. This book, a bestselling exposé of the devious practices employed by advertisers, was Vance Packard's The Hidden Persuaders.

Packard was a sophisticated New York magazine journalist with humble roots and a hatred of the marketing industry. Raised in rural Pennsylvania during the harsh 1920s, he itched to pull back the curtain and expose the machinery that made dupes of ordinary people like his Methodist farmer parents, selling them cars, cigarettes, and washing powder using techniques that exploited their deepest fears and wildest dreams. None of this surprises us now, but in 1957 the revelation that ads weren't innocent and benign was genuinely shocking.

So-called "depth psychology" was harnessed to create distinctions between indistinguishable products. The result was brands to which consumers would form powerful emotional attachments—Marlboro, say, which had been a dainty cigarette for women before it was "rebranded" as the essence of macho America. The holy grail was understanding why people made impulse purchases. Packard turned the spotlight on figures like jaunty, bow tie-wearing Ernest Dichter, director of the Institute for Motivational Research. The song-and-dance number Bowie wrote and sings as Vendice Partners, "That's Motivation," hardly needs unpacking. . . .

Branding in pop existed long before Bowie. But no one harnessed its power so effectively. Having failed to make an impact in the 1960s in any of his generic bands or as a folk singer-songwriter, Bowie established Ziggy Stardust as what the rock writer Peter Doggett calls "a brand so powerful that it would be impossible to ignore." Rather than pursue fame, Bowie would act as if he were already famous and collapse all polarities—male and female, gay and straight, human and alien—in a bid to draw the maximum number of people unto himself.

Packard's big worry was the way psychological techniques were being used by politicians in election campaigns. By 2000, he predicted, marketers would have even more sophisticated tools at their

238 4 John O'Connell

disposal, such as "biocontrol"—the science of controlling mental processes, emotional reactions, and sense perceptions by using electrical signals. As it turns out, he wasn't far wrong.

Read it while listening to: "That's Motivation"

If you like this, try: Charles Mackay, Extraordinary Popular

Delusions and the Madness of Crowds

88

Evelyn Waugh, Vile Bodies (1930)

December 1972. David Bowie is sailing back to Britain on RHMS *Ellinis* after finishing the first leg of the US Ziggy Stardust tour. Relaxing in the cruise ship's Outrigger bar and Hawaiian-themed Waikiki dining room, he starts reading a very English novel.

Vile Bodies chronicles the decadent, strung-out lives of the moneyed interwar sophisticates known as the Bright Young People, a cult first identified by the Daily Mail in July 1924. Its members included actress Tallulah Bankhead, aristocrat Diana Cooper (née Manners—the "Lady Manners" who gossips until her lips are bleeding in The Next Day's "I'd Rather Be High"), and aesthete poet Brian Howard (a conspirator in the "Bruno Hat" hoax art exhibition of 1929, which may have given Bowie and William Boyd the idea for Nat Tate). One of its best-known paragraphs lists the extraordinary variety of parties they gave and attended: "Masked parties, Savage parties, Victorian parties, Greek parties, Wild West parties, Russian parties, Circus parties, parties where one had to dress as somebody else, almost naked parties in St. John's Wood,

parties in flats and studios and houses and ships and hotels and nightclubs. . . . " And so on.

The main characters are nominally Adam and Nina, a young couple who are engaged to be married. But they are continually pushed offstage by Wodehousian grotesques like Lottie Crump and Agatha Runcible. *Vile Bodies* has a clipped, choppy structure borrowed from cinema and T. S. Eliot. The surrealistic effect is enhanced by the extraordinary dialogue, brittle and dense with non sequiturs, the way people speak when they have taken a lot of cocaine. The characters would have sounded to Bowie like his own friends, lovers, and associates. But most of all, they would have sounded like him.

Toward the end, the tone darkens and it becomes clear that Waugh is condemning rather than celebrating this frivolous scene. The storm clouds of war roll in from the sea and Adam, freshly called up, finds himself sitting "on a splintered tree stump in the biggest battlefield in the history of the world."

Perhaps it was now that a line popped into Bowie's head, something about champagne and sunrise; then an idea for a song about a gilded generation partying in the face of imminent catastrophe, unaware that the world is about to change. A song called "Aladdin Sane."

Read it while listening to: "Aladdin Sane (1913–1938–197?)" **If you like this, try:** Evelyn Waugh, *A Handful of Dust*

Howard Zinn, A People's History of the United States (1980)

Did David Bowie have fascist sympathies? It's one of those hardy perennial questions. We know his mother, Peggy, had a brief flirtation with Oswald Mosley's British Union of Fascists in her early twenties and that a regular columnist in the movement's official newspaper *The Blackshirt* went by the name of Alexander Bowie. The Ziggy Stardust "lightning bolt" symbol is remarkably similar to the BUF's logo—but then, it also resembles the logo designed by Elvis Presley to illustrate his mantra, "taking care of business"; and in Mick Rock's *Moonage Daydream* Bowie says it was based on a "High Voltage" sign he saw on a fuse box.

In 1976 Bowie gave what looked like a Nazi salute to waiting fans at London's Victoria Station. Even worse, in an interview with *Playboy* that year he declared: "I think Britain could benefit from a fascist leader," and, "Adolf Hitler was one of the first rock stars." But he was clearly in the grip of chronic cocaine addiction. An intellectual interest in the history of Nazism, especially Hitler's dark mastery of branding and the media, is more understandable when

worn soberly. And to be fair, the thin line separating rock stars from cult leaders and demagogues was one of 1970s art-rock's defining preoccupations, from *Ziggy Stardust* to the Who's *Tommy* and Pink Floyd's *The Wall*.

It should be obvious from the way he lived his life that Bowie was a tolerant, inclusive person, enormously sensitive to the plight of society's outcasts and casualties. Anyone still harboring doubts should check out *A People's History of the United States*, which tells the story of America from the perspective of the slaves, Native Americans, women, and other marginalized figures whose voices were, until recently, rarely heard. That they are heard more frequently nowadays is partly down to its author, Howard Zinn.

Brooklyn-born Zinn was a former shipyard worker who served as a bombardier in Europe during the Second World War. He got his education courtesy of the G.I. Bill and for years taught political science at Boston University. But something about the quality of the knowledge his students brought to his classes made him uneasy. Encouraged by his wife, Zinn set out to write a different kind of history, a corrective to the orthodox version he saw being taught in schools which, he felt, struck a pose of genteel objectivity the better to distort or even conceal awkward truths, especially about race. For example, the arrival of Christopher Columbus in the New World is usually presented as a happy event. In fact, it set in motion a genocide in which the indigenous population of Hispaniola was wiped out. All American schoolchildren learn about the Boston Massacre of 1770—the killing of five colonists by British soldiers. But, Zinn asks, who learns about the massacre of the Pequot tribe in 1637 when a group of Connecticut colonists torched their village?

BOWIE'S BOOKSHELF # 243

The first edition of A People's History came out in 1980 and was an immediate hit. Zinn revised and updated it several times, most recently in 2005, before his death in 2010. It still sells roughly a hundred thousand copies every year. Zinn said he was motivated by the responsibility he felt to alert people to information they didn't have and so encourage them to rethink their assumptions about the world.

Read it while listening to: "Working Class Hero" (Tin Machine cover of John Lennon song)

If you like this, try: Howard Zinn, You Can't Be Neutral on a Moving Train: A Personal History of Our Times

90

Wyndham Lewis, Blast (1914-15)

"If Vorticists wrote rock music, it might have sounded like this."

-David Bowie on "'Tis A Pity She Was a Whore"

September 2012. David Bowie is preparing to emerge from hibernation with a new album, *The Next Day*. Its release will be a shock. The first anyone knows of it will be when the single "Where Are We Now?" is played on the BBC's *Today* program on the morning of Bowie's sixty-sixth birthday—January 8, 2013.

But that is in the future. For now, Bowie is plotting and planning. Although the concept of albums as physical products is dying—at

this point, streaming is king—he wants *The Next Day*'s cover to have the impact album covers used to have. To be a bold declaration of intent: *I'm back and I have lost none of my power*.

Bowie contacts graphic designer Jonathan Barnbrook, who worked on the covers of his previous two albums. The pair agree that *The Next Day*'s cover should be the defaced cover of an earlier Bowie record. After experimenting with *Aladdin Sane*, they settle on "Heroes", subverting Masayoshi Sukita's black-and-white photograph of Bowie posing like the German Expressionist artist Egon Schiele in *Self-portrait with Raised Arms* (1914) by obscuring it with a white square containing the title rendered in a sans-serif font created by Barnbrook called Doctrine.

It's a simple but radical gesture. Which brings us to Blast.

Blast was the official manifesto of vorticism, the first British avant-garde movement and the brainchild of the writer, painter, and critic Wyndham Lewis—he dropped his first name, Percy, as you would. Vorticism exalted in pure form, hard-edged and geometric, stripped of anything ornamental or decorative. As Lewis put it, "Vorticism is art before it has spread itself into flaccidity, into elaboration and secondary applications." It was supposed to reflect the noise and clamor of the modern world, the "machine age," as intellectuals thought of it. Broad in scope, it could in theory be applied to all the arts, writing and music as well as painting and sculpture.

There were only ever two issues of *Blast*. The first appeared on July 2, 1914, a month before the outbreak of the First World War. Its cover was dazzling magenta, with the title slashing downward in bold capital letters. The first twenty-odd pages comprise a manifesto in which Lewis and his coconspirators, including the expat

American poet Ezra Pound, list things they "bless" (castor oil, the Salvation Army) and things they "blast" (the English climate, the years 1837 to 1900). Slade School of Fine Art drawing tutor Henry Tonks is both blasted and blessed. Among the manifesto's signatories was Edward Wadsworth, who had worked with Lewis at Roger Fry's Omega Workshops design business. Bowie was an enthusiastic collector of Wadsworth's work as well as Lewis's.

Another of Bowie's favorite artists, David Bomberg (see p. 56), was allied to vorticism but mistrusted Lewis and chose not to be involved with *Blast*, although he did exhibit his paintings at the sole vorticist exhibition, held at the Doré gallery on New Bond Street in June 1915. By the time the second edition of *Blast* was published, on July 20, 1915, war had drained vorticism of impetus; though it did contain T. S. Eliot's "Preludes" and "Rhapsody on a Windy Night."

Far from being forgotten, however, vorticism lived on to become a loose theoretical framework for a lot of late-twentieth-century pop music. One could see its influence in American art-rockers Devo—whom Bowie called "the band of the future" and whose debut album he intended to coproduce. It was also apparent in Frankie Goes to Hollywood, whose lead singer, Holly Johnson, called his first solo album *Blast*, drawing sly attention to where Paul Morley, in-house copywriter at his ex-label Zang Tumb Tumb (named after a sound poem by Italian futurist Filippo Tommaso Marinetti), had found the inspiration for his promotional conceits.

For Bowie, creation went hand in hand with destruction, or at least disruption. "To cause an art movement, you have to set something up and then destroy it," he told *NME*'s Lisa Robinson in 1976. "The only thing to do is what the Dadaists, the surrealists

BOWIE'S BOOKSHELF # 247

did: complete amateurs who are pretentious as hell and just fuck it up the ass. Cause as much bad, ill feeling as possible, and then you've got a chance of having a movement."

Vorticism's driving quest, like Bowie's, was for novelty—not for novelty's sake, but to advance the conversation about what art could be at a time when most gallerygoing Britons viewed French impressionism as dangerously edgy. For Lewis and Pound, whose diktat as a poet was "Make it new," good art had an obligation to anticipate the future. That necessarily involved breaking with the past. Which brings us back to the cover of *The Next Day*.

Read it while listening to: "Tis a Pity She Was a Whore" **If you like this, try:** Filippo Tommaso Marinetti, *The Manifesto of Futurism*

91

Ian McEwan, In Between the Sheets (1978)

arly in his career, before he found mainstream success with novels like Enduring Love and Atonement, Ian McEwan was nicknamed "Ian Macabre" by some critics on account of the shocking, deviant content of the short stories that were then his stock-in-trade. Incest, bestiality, pedophilia . . . In Between the Sheets, McEwan's follow-up to his acclaimed debut collection First Love, Last Rites, has them all. In "Pornography," the owner of a Soho sex shop is castrated by the women he's been two-timing. "Reflections of a Kept Ape" finds a disarmingly eloquent primate ruminating on life with his human lover—a female author who admires his black, leathery penis. In the title story, named after a line from the Rolling Stones song "Live with Me," a father struggles to curb both his sexual feelings for his teenage daughter and his jealousy of the grotesque dwarf he believes is her girlfriend.

McEwan always claimed to be baffled by the fuss these stories generated, citing in his defense William S. Burroughs, Louis-Ferdinand Céline, and Jean Genet—writers who also dealt in

clinical detachment and vivid physical detail. Bowie knew these writers well and would have understood where McEwan was coming from, as well as the craft involved in compressed, imagistic storytelling—some of Bowie's best songs ("Space Oddity," "Young Americans," "Repetition," and early pieces like "Please Mr. Gravedigger," "The London Boys," and "Little Bombardier") have the quality of short stories.

But then Bowie was always writing little fragments of things without necessarily knowing where or as what they were going to end up. On the set of *The Man Who Fell to Earth*, he claimed to have started work on a story collection to be called *The Return of the Thin White Duke*, though nothing ever materialized apart from a few lines printed by *Playboy* in 1976. (The fragment begins: "Vince was American and came to England, then went to France and became a star of dirge.") In late 1994 he wrote a surreal murder mystery for *Q* magazine, "The Diary of Nathan Adler," which formed the basis of 1995's 1. Outside album.

Bowie's attraction to dystopian fables was driven in part by nostalgia for his childhood in postwar Brixton, hazy but potent memories of ruined houses and bomb sites covered in buddleia. One of the strongest stories in *In Between the Sheets* is the explicitly Orwellian "Two Fragments: March 199–," set in a rubbish-clogged "future" London where the Thames has practically run dry and people survive by selling junk on the streets. It's very much the decaying Hunger City of *Diamond Dogs*.

I'd be surprised if Bowie's favorite story in this collection wasn't "Dead as They Come." A loquacious businessman's account of his

250 / John O'Connell

deranged obsession with "Helen," a clothes-shop mannequin he brings home, cooks for, confides in, and has increasingly violent sex with, it unspools with the deadpan savagery of a monologue by Bowie's hero Peter Cook.

Read it while listening to: "Repetition"

If you like this, try: Ian McEwan, First Love, Last Rites

92

David Kidd, All the Emperor's Horses (1961)

n Lodger's "Move On," Bowie sings about spending the night in Old Kyoto, sleeping on the matted ground. It's possible the person he was visiting there was his friend David Kidd, an expat American who had settled in the onetime Japanese capital, renowned for its imperial palaces and Buddhist temples, and founded the Oomoto School of Traditional Japanese Arts. So knowledgeable was Kidd about Japanese art and culture that he taught the tea ceremony, calligraphy, and other traditional practices to the Japanese themselves, as well as to curious foreigners whose day must have been made by their host's regal, W. Somerset Maugham—esque bearing.

"As a tourist attraction, Mr. Kidd did not disappoint," noted the *New York Times* after his death in 1996. "To sit on a cushion before his throne, listening to his erudite patter, and seeing him sitting cross-legged on his *kang*, a divided Chinese sofa, rustling his silken gown as he gestured extravagantly with his inevitable cigarette, was to be in the presence of a presence."

How did he get there? It's a good question. Kidd's father ran a coal mine in Corbin, Kentucky—not the world's artiest profession.

Young David felt compelled to escape the moment he first heard Stravinsky's *The Rite of Spring*. In 1948, age nineteen, he arrived in Peking (now Beijing) as a University of Michigan exchange student studying Chinese. Despite being flamboyantly gay, he married Aimee Yu, the daughter of a former chief justice of the Supreme Court of China, and moved into her family's enormous palace, from which he surveyed the collapse of the old regime and the rise of Communism. His memoir *All the Emperor's Horses* was serialized in the *New Yorker* in 1955 before being published in book form first in 1961, then again in 1988 with a moving new final chapter under the title *Peking Story: The Last Days of Old China*.

Kidd was one of very few Westerners living in Peking in the years leading up to the Cultural Revolution. In his book he complains about the lack of attention his set received from historians: "I used to hope that some bright young scholar on a research grant would write about us and our Chinese friends before it was too late and we were all dead and gone, folding back into darkness the wonder that had been our lives." None ever did, so Kidd takes on the task himself, writing crisply and cleanly, though some have accused him of making up details. For example, he tells a powerful story about some incense-burning bronze braziers owned by the Yu family. These braziers had to be kept constantly burning to maintain their luster. Some in the family's ownership had never been allowed to cool in five hundred years. But one day, according to Kidd, the family's servants, who had grown "insolent and lazy" under the influence of Communism, deliberately let them go out, damaging them irreparably. Art historian James Cahill, who knew a brazier from a brassiere, has called this anecdote completely phony.

Kidd's tone flits between resignation and a curious entitled impatience, as if Old China is being dismantled with the specific goal of annoying him. Hauteur adds spice to his best vignettes, such as the one about his unstable chef Lao Pei, fired when Kidd discovers he's been killing chickens by driving long needles through their brains.

In 1950 the Communist authorities' vice tightens, especially where foreigners are concerned, and one night the Yu mansion is stormed by military police. Kidd's reaction is to camp it up: when a carbine-armed soldier follows him to the bedroom, he slips into a huge blue-brocade dressing gown that Aimee had made for him from an old imperial robe, and then prances about. (John Lanchester notes in his preface to a 2003 reissue of the book that Kidd was a great noticer of clothes, especially his own. You suspect the thing he enjoyed most about his wedding to Aimee was the sky-blue gown of fine Tibetan felt he got to wear.) The following year the couple left China for New York. Kidd briefly taught Chinese art history at the Asia Institute but fled to Japan when, on account of the two years he had spent living voluntarily in a Communist country, he came to the attention of the House Un-American Activities Committee. He and Aimee separated but remained lifelong friends.

Like Stephen Tennant (see Jon Savage, p. 199), the young Kidd wouldn't have been out of place in Duran Duran. In photos from the period, Kidd looks strikingly like Bowie on the cover of Young Americans—feyly androgynous. According to the New York Times, one of Kidd's disappointments as he aged was that Bowie had "not gotten around to portraying him in a movie of his days as a blond, wavy-haired dandy in Peking." This isn't quite true. Watch Ricochet, the 1984 documentary of the Asian leg of the Serious Moon-

254 4 John O'Connell

light tour, and it's Kidd our peroxided hero seems to be channeling as he wafts around Hong Kong, Singapore, and Bangkok, the very model of an Orientalist flaneur.

Read it while listening to: "China Girl"

If you like this, try: Henry Pu Yi, The Last Manchu: The

Autobiography of Henry Pu Yi, Last Emperor of China

Malcolm Cowley, ed., Writers at Work: The Paris Review Interviews, vol. 1 (1958)

hen it came to being interviewed, Bowie was usually well served by his interlocutors. It helped that he was charming and articulate and knew how to win over journalists. A favorite trick, honed over decades, was to allot an hour for an interview the writer had been told would last forty-five minutes. Then, when the time was "up," Bowie would turn to the PR who had arrived to whisk the journalist away and say, "You know what, we're having such a good time here. Can't we let this run on for a bit longer . . . ?" And the writer would blush with pride.

After his heart attack, Bowie fell silent, preferring to let collaborators like Tony Visconti do the talking for him. He'd done a lifetime's worth of press and wanted his work to speak for itself. Possibly, too, he realized that, even at their best, interviews with rock stars tend to devolve into either idle gossip, romanticized guff, or a kind of gladiatorial performance art, the encounter soured from the outset by the need to promote whatever the conversation has been arranged to promote.

The Paris Review's Writers at Work series, inaugurated in 1953

when the esteemed literary magazine's cofounder George Plimpton called in a favor from his old Cambridge friend E. M. Forster, has always stood for the opposite of hotel-room hackery. You can afford to be a purist when there's nothing to promote except talent.

Usually recent college graduates, *Paris Review* interviewers worked in pairs. In the early days, before tape recorders, each would transcribe the subjects' answers and compare notes at the end to ensure they hadn't missed (or made up) anything. The conversation was edited and shaped to make it flow better, then the finished typescript sent to the author for his or her approval. This should set off alarm bells, but in practice it's hard to care when, as in the case of Dorothy Parker, the zinger quotient is so high.

As sources of insight into the creative process, the Writers at Work interviews are second to none, inspiring and uplifting, but also weirdly consoling. "O, to redo the rest of that album," Bowie said of 1987's Never Let Me Down, one of his weaker efforts, after he'd rerecorded "Time Will Crawl" for a 2008 compilation. In his Paris Review interview, William Faulkner identifies this longing to fix up as an important motivation and goes so far as to say that if he could write all his work again he would, because he is convinced he would do it better. Elsewhere, it's bizarre to hear the author of an acknowledged classic (Howards End) talking about it as if it were a technical failure: E. M. Forster declares the novel's plotting contrived and overreliant on the device of letters.

Sometimes the fun comes from reading between the lines. William Styron, we learn in the paragraph that introduces his epic interview, is a trifle pale. The duo assigned the author of *Lie Down*

BOWIE'S BOOKSHELF 4 257

in Darkness—what Styron would probably like to be doing at this point—remind him, for he seems to be struggling, that he was about to tell them when he started writing. But Styron has completely forgotten why he is there. (Such are the consequences of a long lunch.)

Ironically, given the reverential air of a generation's finest minds being set on higher things, Writers at Work started as a sales gimmick, as a way of getting famous names into the magazine cheaply because there was no budget for new stories. Not that it matters. What we're left with is a timeless record of the tumult and ecstasy of artistic creation, as applicable to a rock musician trying to keep ahead of the curve as it has always been to budding authors.

Read it while listening to: "Time Will Crawl" (2018 version)

If you like this, try: Daniel Rachel, Isle of Noises: Conversations with Great British Songwriters

Christa Wolf, The Quest for Christa T. (1968)

The division of postwar Germany into East and West might feel like ancient history now, but it was a fairly recent occurrence when Bowie was sleeping off the effects of Los Angeles in his Haupt-strasse apartment in 1977. By then, citizens of the German Democratic Republic were regarded by many in the West as blankly exotic metaphors for alienation. How did they live, think, and feel? Were they happy with their lot or did they yearn for Republikflucht (flight from the Republic)? To find out, you needed to read writers like Christa Wolf, East Germany's preeminent literary novelist.

My hunch is that Bowie did this (at least) twice—in 1976 or so, when Wolf was in the news for being a cosignatory on a letter condemning the expatriation of the dissident East German singer-songwriter Wolf Biermann; then again, in the 2000s, when he was trying to make imaginative sense of his nostalgia for his Berlin days. Wolf's influence is all over Bowie's mournful comeback single "Where Are We Now?" with its talk of walking the dead, a man lost in time, and the crowds surging across the Bösebrücke at the Bornholmer

Strasse border crossing after the collapse of the Berlin Wall, an event Wolf felt deeply ambivalent about—she pleaded with East Germans to stay put and create an open, democratic society of their own.

Born into a middle-class, pro-Nazi family in 1929, Wolf grew up in Landsberg—now Gorzów Wielkopolski in Poland—and was a member of the Bund Deutscher Mädel, the female wing of the Hitler Youth. After the war, her family fled the advancing Soviet army, only to end up in Russian-controlled Mecklenburg. As the extent of the Nazis' atrocities became apparent, an anguished Wolf embraced communism with religious zeal and briefly informed on her fellow intellectuals for the Stasi, the East German secret police, unaware that she was herself under surveillance. (In fact, Wolf failed to supply the Stasi with interesting enough information and her file was closed in 1962. She wrote about the experience many years later in a self-lacerating memoir, City of Angels: or, the Overcoat of Dr. Freud.)

The Quest for Christa T. is Wolf's most famous novel. It's dense and lyrical, frequently challenging, ultimately heartbreaking. Poet Christopher Middleton's sensitive English translation was published in 1970, two years after the German edition. On a basic, human level it's about the unnamed narrator's grief for her friend Christa, who has died age thirty-five from leukemia. The narrator can't believe that someone so vital and singular—the schoolgirl she remembers blowing a pretend trumpet made from rolled-up newspaper—is dead, disappearing, buried in a cemetery beneath two buckthorn bushes. So she devotes herself to reconstructing Christa out of a mixture of her own memories and the letters, diaries, stories, and assorted other written fragments that Christa left behind.

We learn a certain amount about the woman—that she became a teacher, married a vet, dreamed of building a house by a lake; that she was awkward, angular, something of an outsider—but her story never coheres, never progresses in the way we might expect. Partly, Wolf is making a point about the unreliability of memory. But she's also posing a philosophical question: what happens to the individual, to the subjective self, in a collectivist society like the GDR—a society you believe (if you are Wolf) to be broadly a good thing? "I" is a fragile entity at the best of times.

Christa feels she doesn't fit in the GDR. It's a society for straightforward, ambitious, literal-minded people, whereas she is somehow porous, receptive to new ideas and situations. This is the condition to which Bowie always aspired, the cause of him ending up in Berlin in the first place. It's also why, despite its difficulty and complexity, *The Quest for Christa T.* was such an important book for him.

Read it while listening to: "Subterraneans"

If you like this, try: Christa Wolf, City of Angels: or, the Overcoat of Dr. Freud

Tom Stoppard, The Coast of Utopia (2002)

of the British playwrights who made their names in the 1960s, Tom Stoppard was the closest thing to a rock star, with his plump lips, heavy-lidded eyes, and what the critic Kenneth Tynan in The Observer called "costly-casual dandyism." A friend as well as a doppelgänger of Mick Jagger, Stoppard later wrote a play, Rock 'n' Roll, about the power of music to undermine tyrannies, in this case his native Czechoslovakia. Stoppard is an émigré; his family fled the Nazis just before the German occupation of Czechoslovakia in 1939.

Bowie had firsthand experience of music's power himself. On June 7, 1987, he played a concert in West Berlin that some believe paved the way for the collapse of the Berlin Wall two years later. It was the third show on the European leg of the much-mocked Glass Spider tour. The stage at Platz der Republik was adjacent to the Wall and a large crowd had gathered on the East Berlin side to hear the music. Realizing what was happening, Bowie addressed this "unofficial" crowd directly before launching into "Heroes." Rioting broke out as people chanted, "The wall must fall," and "Gorby get us out"; there were more than two hundred arrests.

"It was one of the most emotional performances I've ever done," Bowie remembered in 2003 to *Rolling Stone*. "I was in tears. There were thousands on the other side that had come close to the wall. So it was like a double concert where the wall was the division. And we could hear them cheering and singing from the other side. God, even now I get choked up. It was breaking my heart and I'd never done anything like that in my life, and I guess I never will again. It was so touching."

Two observations. One, *The Coast of Utopia* is the only playscript on Bowie's list. Two, it's an unusual choice, being neither a stone-cold classic from Stoppard's early imperial phase (e.g., *Rosencrantz and Guildenstern Are Dead*, *Jumpers*, *Travesties*) nor one of his midperiod attempts to place his trademark wit and erudition at the service of ordinary human emotions (*The Real Thing*, about the pain of infidelity). Although the Broadway version directed by Jack O'Brien won the Tony Award for Best Play in 2007, nearly five years after Trevor Nunn's original production closed in London, *The Coast of Utopia* is generally more admired than loved. A trilogy with a total running time of over nine hours, it is enormously demanding of both actors and audience. What about it bewitched Bowie so? Its sheer chutzpah, probably—and Stoppard's ability to grab hold of a difficult subject and wrestle an evening's glittering entertainment out of it.

The Coast of Utopia's main theme is the necessity of idealism.

Without it, what will become of us? How will we ever learn the best way to organize and govern ourselves? Working in a naturalistic, Chekhovian mode, Stoppard charts the lives of a group of writers and political philosophers in nineteenth-century Russia, starting in 1833 at the country estate belonging to the family of anarchist Mikhail Bakunin and ending thirty-five years later in Switzerland. Characters like Bakunin, literary critic Vissarion Belinsky, and the early socialist theorist Alexander Herzen dream of utopias and live in fear of brutal suppression. At the same time, they revel in their status as rock star–like revolutionaries.

Tsar Nicholas I was a ruthless autocrat, but Stoppard's view is that the radicals' craving for attention got the better of them. Herzen and his associates preferred to live and work under his rule than flee to Spain or France, because in Russia they had adoring young fans who hung on their every word. Of course, as the play shows, many Russian intellectuals did end up as refugees in England and other European countries. In glamorous exile, holed up in a rented villa overlooking Lake Geneva, the charismatic Herzen caps the final play in the trilogy, Salvage, with an impassioned speech warning against nihilism and the urge to destroy things and people in pursuit of a perfect society. Stoppard described this in The Guardian as "the notion that the 'leader' has the right to ask huge sacrifices of your generation for a notional future paradise—if you'd be good enough to lie down under the wheels of the juggernaut. . . ." But Marx, who might have benefited from hearing it, has already left the room.

Read it while listening to: "Weeping Wall"

If you like this, try: Tom Stoppard, The Real Thing

96

Anthony Burgess, Earthly Powers (1980)

Burgess is the only writer apart from Orwell to have two books on Bowie's list. The titles contrast nicely, showcasing different aspects of their author's talents. A Clockwork Orange (see p. 1) is short and focused—a pithy sermon on free will powered by the genius of Burgess's invented language Nadsat. Earthly Powers is a Victorian-style baggy monster, a panorama of the twentieth century and a toothsome celebration of storytelling with a stagy, extroverted quality in keeping with Burgess's sometimes grandiose intellectual exhibitionism.

The Anthony Burgess of *Earthly Powers* is not the moral polemicist of *A Clockwork Orange* but a charlatan-magician with all manner of tricks up his sleeve. For example, *Earthly Powers* purports to be about "real" historical events but is full of deliberate mistakes to remind us that memory is untrustworthy—and in any case that what we're reading is a novel, a licensed lie.

The key to Burgess is that he was a performer and a dandy. With his pomaded, nicotine-stained hair and silk handkerchiefs, he was never happier than when pontificating on television, which he did a lot. He enjoyed being abstruse and craved the respect of his peers. But he also craved connection with ordinary readers and achieved it despite his prolixity because his best work has a core of warm humanity and wisdom. I say "work." The novels were only part of the show. As if it was the easiest thing in the world, Burgess churned out music, librettos, screenplays, and hundreds of book reviews over the course of his career. And, like David Jones, he hid behind an invented persona: "Anthony Burgess" was really John Wilson, born in the Manchester suburb of Harpurhey in 1917.

One of Burgess's biggest successes, Earthly Powers was narrowly beaten to the 1980 Booker Prize by William Golding's Rites of Passage. (Burgess had been tipped off about the result and was so cross he boycotted the ceremony, giving the excuse that he didn't possess a dinner jacket.) The literary world delighted in the fact that Earthly Powers' central character, a distinguished but secondrate gay British writer called Kenneth Toomey, was based on the notoriously predatory W. Somerset Maugham, with a bit of Noël Coward, Alec Waugh, and P. G. Wodehouse thrown in for good measure. Its famous opening sentence finds the eighty-one-year-old Toomey surprised in bed with his "catamite" by an archbishop. The plot, meanwhile, pivots on an apparent miracle witnessed by Toomey: the curing of a terminally ill child in a Chicago hospital by a priest, Carlo Campanati. It's an act that will have horrendous consequences down the line as the child grows up to become a murderous Californian cult leader.

Watching as Toomey bowls through the century, taking in 1920s Paris, Nazi Germany, and Golden Age Hollywood, name-dropping as he goes, is hugely pleasurable. But the most intriguing thing about

Earthly Powers—and the reason I think it resonated for Bowie—is its chilling conviction that world affairs are subject to demonic agency. As a lifelong Catholic Burgess felt this keenly, telling Martin Amis in the Observer: "I do believe in the forces of evil—I myself was subjected to black magic in Malaya [now Malaysia, where Burgess worked in the colonial civil service]. There is, for example, no A. J. P. Taylor—ish explanation for what happened in Nazi Germany. There's a very malign reality somewhere. . . ."

Finally, for clue-hungry Bowie buffs, there's the business of the numerous allusions in *Earthly Powers* to John Ford's seventeenth-century revenge tragedy 'Tis Pity She's a Whore, pointing up Toomey's near incestuous relationship with his sculptress sister Hortense. Bowie borrowed the title (slightly amended) for one of the *Blackstar* album's more raucous moments, the story of a petty-thief prostitute who steals the narrator's purse while giving him a blow job. In Ford's play, Giovanni has a grand passion for his sister Annabella, which he discusses at the very beginning with Friar Bonaventura: "Shall, then, for that I am her brother born, / My joys be ever banished from her bed?" In *Earthly Powers*, Toomey discusses his feelings for Hortense with the sexologist Havelock Ellis—a very Anthony Burgess joke.

Read it while listening to: "'Tis a Pity She Was a Whore" (again) **If you like this, try:** William Boyd, *The New Confessions*

97

Howard Norman, The Bird Artist (1994)

As if cocaine's stimulating properties weren't enough, Bowie would drink espresso after espresso in the studio to keep himself alert and engaged. Guitarist Kevin Armstrong, an associate of long standing, remembers the way Bowie always had industrial quantities of Cuba Gold coffee delivered to wherever he was recording.

Not everyone, however, finds that condition conducive to creativity. Fabian Vas, titular narrator of Howard Norman's bleakly hilarious novel *The Bird Artist*, is up front about caffeine's detrimental effects, namely his inability to draw with a steady hand or curb his anxiety long enough to finish anything when he consumes it. This is what comes of drinking twenty to thirty cups of the stuff every day. The problem, he muses, is that so few people understand caffeine addiction or the long, cold winters that foster it.

Witless Bay, where Fabian lives, is an eccentric, insular village on the east coast of Newfoundland, blanketed by a fog of gossip and inappropriate honesty, as if there is no point in trying to hide something everyone will know soon enough. Not that Fabian is very good at hiding things, or indeed at discovering them. He's the last to know that his mother has been carrying on with lighthouse keeper Botho August while his father is away on business. Fabian tells us in the first paragraph that he murdered Botho. But then he moves on and we're left thinking: *Eh?* Something is wrong but we can't quite put our finger on what. It isn't *just* Fabian's personality, though he is narrow and obsessive, interested in little beyond drawing, in lifelike detail, the huge variety of local birds.

He often takes a circuitous route to the point. And yet he's nowhere near the "village idiot" his alcoholic girlfriend Margaret derides him as; he's more a kind of savant. His uniqueness is *The Bird Artist*'s uniqueness and helps to make it what it is, a perfect example of what we might call a snow-globe novel: the type that gives you a world in miniature but where the brittle artificiality of the setup—no one anywhere *really* talks or behaves like this—is part of the point.

Why did Bowie like it? Likely because it's dry, smart, and weirdly redolent of the cult 1990s British TV comedy *The League of Gentlemen*. There's something funny on every page, from Fabian's postal mentoring by stern fellow bird artist Isaac Sprague, who signs every letter "In hopes for improvement," to his parents' disastrous attempts to marry him off to a distant relative he has never met called Cora Holly. As a wedding gift, Fabian paints her a portrait of a garganey—a rare, surface-feeding duck.

Read it while listening to: "The Loneliest Guy"

If you like this, try: E. Annie Proulx, The Shipping News

98

Spike Milligan, Puckoon (1963)

t's a Monday evening in 1958 and eleven-year-old David Jones is waiting by the radio for *The Goon Show* to begin. Itching with impatience, he has already read the latest edition of *The Eagle* three times. Now he wants a dose of pure, subversive silliness, the sort of humor he will later, when he's a bit more grown-up, recognize as "surreal." He wants to hear more about characters like Neddie Seagoon, Eccles, Hercules Grytpype-Thynne, and especially Bluebottle, played by Peter Sellers—a schoolboy tempted by the promise of dolly mixture sweets into doing dangerous, stupid things and whose catchphrase is "You dirty, rotten swine, you! You have deaded me!"

Because he is interested already in how things are made and by whom, he knows that the main writer of *The Goon Show*—as well as one of its star performers—is Spike Milligan, who went to school just down the road in the southeast London suburb of Brockley. He would also have known the price Milligan paid for the show's success—regular stress-induced mental breakdowns. He wonders, not for the first time and *certainly* not for the last, if there is a connection between artistic genius and what people still call mad-

ness. Of all the Goons, Milligan was the most special—"always the one we would mimic as kids," as Bowie's childhood friend George Underwood told me.

It's now 1963. David is sixteen and has a mass of competing interests—girls, jazz, Little Richard, girls, forming a band. But he's kept faith with Spike Milligan down the years and reads the funnyman's first novel as soon as it's published. Happily, it's everything he wants it to be. Puckoon is a small Irish town that is cut in two when the Boundary Commission decides the new border between Northern Ireland and the Irish Free State is going to pass through it. In one of the novel's best conceits, half the pub is in one country (and has lower taxes on alcohol), while the other half is in the other. The funniest character is lazy Dan Milligan, who keeps breaking the fourth wall to complain about his lot.

Most people who knew him agree that Bowie had an endearing capacity to be very, very silly indeed. Think of *Puckoon* as the university where he studied for his silliness PhD.

Read it while listening to: "We Are Hungry Men" (with its Goonish sound effects)

If you like this, try: John Lennon, A Spaniard in the Works

99

Charlie Gillett, The Sound of the City: The Rise of Rock and Roll (1970)

Some artists strike a pose of aloofness where critics are concerned. So it's surprising how interested, as a practitioner with skin in the game, Bowie was in the opinions of music journalists. His taste in rock writing tended toward the studious, even humorless. There are no silly, gossipy books about pop on his list, the kind with one eye on the ludicrousness of it all—Simon Napier-Bell's You Don't Have to Say You Love Me, say, or Giles Smith's Lost in Music.

Instead, he seems to have included the books he learned the most from, the ones that explained and ennobled his teenage enthusiasms. Charlie Gillett was a Lancashire-born writer and DJ who, along with Nik Cohn (p. 8), took rock seriously before anyone else, to the point where in 1965 he left England for New York's Columbia University to do an MA in the subject. The work he did there fed into his first book *The Sound of the City*, published in 1970. As with Cohn's *Awopbopaloobop Alopbamboom*, it's likely Bowie read this as a manual—cannily, as it turned out: Gillett went on to have a successful sideline as a manager and talent scout, discovering and promoting a number of future stars, including Ian Dury, Elvis Costello, and Dire Straits, so his advice was solid.

Inevitably, much of the book's directory-like detail is antique and irrelevant today. But its broader insights remain fresh. Gillett is especially interesting on the way rock 'n' roll bifurcated in the late 1960s—the point where Cohn started to lose interest—into "cynical" pop on the one hand (the Monkees) and "serious" rock (the Band) on the other. It would take Bowie a while to work out which side of the fence he wanted to be on. Sometimes it seemed as if he had a whole different fence in mind. It's hard to get your head around the fact that the man who wrote "The Laughing Gnome" also made Low. And that they're both great.

It all comes back to Fitzgerald's line about personality being an unbroken series of successful gestures. We can imagine Bowie drinking in Gillett's observation that audiences in the 1940s willingly confused Sinatra's image with his private self so that his image became as important as his songs. Sinatra's crooning style, much aped by Bowie, was important because it enabled each listener to feel as if he was singing to them.

Meanwhile, Little Richard's histrionic emotionalism found its white equivalent in Johnny Ray, every one of whose damn songs

BOWIE'S BOOKSHELF 4 273

could make him break down and cry, producing sobs, sighs, and gasps so overwhelming that he would have to leave the stage to compose himself. Bowie was never so crude, but stagecraft was always at the heart of his methodology, whether that meant announcing the end of Ziggy Stardust live onstage or struggling through his final Reality Tour show at the Hurricane Festival in Scheessel, Germany, in June 2004, trying to pretend for the sake of the audience he cared about so much that he wasn't in excruciating pain.

Read it while listening to: "Rock'n' Roll Suicide"

If you like this, try: Charlie Gillett, Making Tracks: Atlantic

Records and the Growth of a Multi-Billion-Dollar Industry

100

Lawrence Weschler, Mr. Wilson's Cabinet of Wonder (1995)

nwary visitors to Culver City, California, would never guess that the nondescript storefront on Venice Boulevard bearing the legend "The Museum of Jurassic Technology" is a portal to another dimension. Step inside and you'll find exhibits devoted to: a Cameroonian "stink ant" which can die by inhaling a fungus which grows inside its brain, which devours the ant until all that remains is a spike protruding from its head; early bedwetting cures, including two dead mice lying on a piece of toast; a neurophysiologist called Geoffrey Sonnabend who, after suffering a breakdown triggered by the collapse of his investigations into the memory pathways of carp, developed a radical new theory of human memory, the Sonnabend model of obliscence, inspired by an amnesiac lieder singer; microsculptures, including one of Pope John Paul II made out of hair, so tiny that it fits into the eye of a needle; a horn that was removed from the head of a woman called Mary Davis in 1688; and more, so much more. . .

New Yorker writer Lawrence Weschler's initial reaction was that

the museum must be a big joke, an ingenious art prank or timetravel installation along the lines of Robert Wilson and Hans Peter Kuhn's HG. But something about the meticulous solemnity of the setup and the museum's eccentric proprietor, former experimental filmmaker David Wilson, suggested a more complex intention. Entranced, Weschler made repeat visits, always finding himself trapped between multiple layers of irony.

Was he really, though? For one thing-much to Weschler's surprise-not everything in the museum is "fake," or at least not in the way we normally understand the word. Although the context in which it's displayed has been augmented, Mary Davis's "horn" is real enough: it's just a cyst that would nowadays be simple to remove. In fact, the museum is a throwback to the Renaissance and the "wonder-cabinets" in which wealthy collectors stored the exotic curiosities they picked up on their travels. It exists to inspire childlike wonder at the strangeness of the world and blur the boundary between the scientific, the speculative, and the magical—a boundary we know enchanted Bowie because it's the territory inhabited by so many of the books on his list, from Hawksmoor (see p. 80) and The Origin of Consciousness in the Breakdown of the Bicameral Mind (see p. 115) to Strange People (see p. 190). As Weschler points out, quoting the economist John Maynard Keynes, Isaac Newton wasn't just the first scientist, he was the last alchemist. Magical thinking did not become scientific, rationalist thinking overnight.

After much brain-hurting rumination Weschler concludes that the Museum of Jurassic Technology (which still exists, by the way, and which benefited no end from this Pulitzer-shortlisted tribute to it) is a museum, a critique of museums, and a celebration of museums all at the same time. What matters in the end is not just whether something is "true" but whether it's sincere.

An obvious parallel suggests itself. Bowie's work might have been inauthentic—nothing wrong with that; inauthenticity has been central to pop performance since Brian Epstein forced the Beatles to wear suits instead of the leather jackets they favored at the Cavern Club—but only rarely, in moments of personal and professional crisis, was it insincere. That is the reason he and his songs endure. It's the reason so many people around the world were devastated by his death. And it's the reason we care even remotely about what his hundred favorite books were.

Read it while listening to: "I Can't Give Everything Away"

If you like this, try: Lawrence Weschler, True to Life: TwentyFive Years of Conversations with David Hockney

SELECTED BIBLIOGRAPHY

- Appleyard, Brian. The Pleasures of Peace: Art and Imagination in Postwar Britain. London: Faber, 1989.
- Beckett, Andy. When the Lights Went Out: Britain in the Seventies. London: Faber, 2009.
- Bloom, Harold. How to Read and Why. London: Fourth Estate, 2000.
- Bracewell, Michael. England Is Mine: Pop Life in Albion from Wilde to Goldie. London: Flamingo, 1997.
- Broackes, Victoria, and Geoffrey Marsh, eds. *David Bowie Is.* London: V&A Publishing, 2013.
- Buckley, David. Strange Fascination: Bowie; The Definitive Story. London: Virgin Books, 2005.
- Cann, Kevin. *Any Day Now: David Bowie; The London Years* 1947–1974. London: Channel, 2010.
- Carey, John. What Good Are the Arts? London: Faber, 2005.
- Carter, Angela. Nothing Sacred: Selected Writings. London: Virago, 1982.
- Cowley, Malcolm. A Second Flowering: Works and Days of the Lost Generation. London: Andre Deutsch, 1973.
- Davies, Owen. *Grimoires: A History of Magic Books*. Oxford: Oxford University Press, 2009.

- Devereux, Eoin, Aileen Dillane, and Martin J. Power. *David Bowie:* Critical Perspectives. Abingdon: Routledge, 2015.
- Doggett, Peter. The Man Who Sold the World: David Bowie and the 1970s. London Bodley Head, 2011.
- Dylan, Bob. Chronicles: Volume One. New York: Simon & Schuster, 2004.
- Farren, Mick. Give the Anarchist a Cigarette. London: Pimlico, 2002.
- Frith, Simon, and Howard Horne. Art into Pop. Abingdon: Routledge, 1987.
- Gay, Peter. Modernism: The Lure of Heresy from Baudelaire to Beckett and Beyond. London: Heinemann, 2007.
- Gillman, Peter, and Leni Gillman. Alias David Bowie. London: New English Library, 1987.
- Goddard, Simon. Ziggyology: A Brief History of Ziggy Stardust. London: Ebury, 2013.
- Green, Jonathon. Days in the Life: Voices from the English Underground 1961–1971. London: Minerva, 1989.
- Haffenden, John. Novelists in Interview. York: Methuen, 1985.
- Hepworth, David. 1971: Never a Dull Moment. London: Bantam, 2016.
- Hoskyns, Barney. Glam! Bowie, Bolan and the Glitter Rock Revolution. London: Faber, 1998.
- Iman. I Am Iman. London: Booth-Clibborn Editions, 2001.
- Jones, Dylan. David Bowie: A Life. London: Preface, 2017.
- Levy, Shawn. Ready, Steady, Go! Swinging London and the Invention of Cool. London: Fourth Estate, 2002.
- MacCormack, Geoff. From Station to Station: Travels with Bowie 1973–1976. Guildford: Genesis, 2007.

- MacDonald, Ian. The People's Music. London: Pimlico, 2003.
- ——. Revolution in the Head: The Beatles' Records and the Sixties. London: Fourth Estate, 1994.
- MacGregor, Neil. Germany: Memories of a Nation. London: Allen Lane, 2014.
- Miles, Barry. In the Sixties. London: Cape, 2002.
- Miles, Barry, and Chris Charlesworth. David Bowie Black Book. London: Omnibus, 1980.
- Mitchell, Leslie George. Bulwer-Lytton: The Rise and Fall of a Victorian Man of Letters. London: Continuum, 2003.
- Morley, Paul. The Age of Bowie. New York: Simon & Schuster, 2016.
- Murray, Charles Shaar. Shots from the Hip. London: Penguin, 1991.
- Murray, Charles Shaar, and Roy Carr. David Bowie: An Illustrated Record. London: Eel Pie Publishing, 1981.
- Norman, Philip. John Lennon. London: HarperCollins, 2008.
- Paytress, Mark. Bowie Style. London: Omnibus, 2000.
- Pegg, Nicholas. The Complete David Bowie. London: Titan, 2016.
- Pitt, Kenneth. Bowie: The Pitt Report. London: Omnibus, 1985.
- Reynolds, Simon. Rip It Up and Start Again: Postpunk 1978–1984. London: Faber, 2005.
- Rock, Mick, and David Bowie. Moonage Daydream: The Life and Times of Ziggy Stardust. Guildford: Genesis Publications, 2002.
- Roob, Alexander. The Hermetic Museum: Alchemy & Mysticism. Cologne: Taschen, 1997.
- Ross, Alex. The Rest Is Noise: Listening to the Twentieth Century. London: Fourth Estate, 2007.

- Sandbrook, Dominic. White Heat: A History of Britain in the Swinging Sixties. London: Abacus, 2009.
- Savage, Jon. Time Travel: From the Sex Pistols to Nirvana; Pop, Media and Sexuality 1977-96. London: Vintage, 1997.
- Stanley, Bob. Yeah Yeah: The Story of Modern Pop. London: Faber, 2014.
- Toop, David. Ocean of Sound: Aether Talk, Ambient Sound and Imaginary Worlds. London: Serpent's Tail, 1995.
- Tremlett, George. David Bowie: Living on the Brink. London: Century, 1996.
- Trynka, Paul. Starman: David Bowie. London: Sphere, 2010.
- Taylor, D. J. Bright Young People: The Rise and Fall of a Generation 1918-1940. London: Chatto & Windus, 2007.
- ----. Orwell: The Life. London: Chatto & Windus, 2003.
- Visconti, Tony. The Autobiography: Bowie, Bolan and the Brooklyn Boy. London: HarperCollins, 2007.
- Washington, Peter. Madame Blavatsky's Baboon: Theosophy and the Emergence of the Western Guru. London: Secker & Warburg, 1993.
- Young, Rob. Electric Eden: Unearthing Britain's Visionary Music. London: Faber, 2010.

I also made heavy use of the vintage interviews and articles archived at Roger Griffin's *Bowie Golden Years* site and was constantly inspired and intrigued by Chris O'Leary's superb *Pushing Ahead of the Dame* blog (now available in two-volume book form), which I can only read in short bursts because it makes me manic with excitement. There are lots of excellent books on David Bowie out there, but a special men-

BIBLIOGRAPHY 4 281

tion must go to Nicholas Pegg's regularly revised *The Complete David Bowie* for its astonishing comprehensiveness, attention to detail, and critical acuity.

Gary Lachman's story about Bowie, Colin Wilson, and the dead Nazis is from Lachman's website and can be found at https://garylachman.co.uk/2016/01/11/the-david-bowie-colin-wilson-story.

and the second of the second o

ACKNOWLEDGMENTS

First of all, thank you to Jan Martí Cervera at Blackie Books, whose idea this was, for entrusting me with the project; and to my other editors, Alexis Kirschbaum at Bloomsbury in the UK and Lara Blackman and her successor, Rebecca Strobel, at Gallery Books/Simon & Schuster in the US; also to my agent Antony Topping and everyone at Greene & Heaton. For their forensic copyediting I salute Polly Watson and John English. Thanks also to Angelique Tran Van San, Lauren Whybrow, Hetty Touquet, Sydney Morris, and Genista Tate-Alexander.

This book owes something to everyone with whom I've discussed David Bowie over the years, especially former colleagues at *Time Out*—and of course those who helped me while I was writing it, both physically and psychologically. Thank you also, then, to: Jake Arnott, Matt Baker, Richard Baker, William Boyd, David Buckley, Paul Burston, Laura Lee Davies, Peter Earl, Alice Fisher, Katy Follain, Rebecca Gray, Will Grove-White, the late Chris Hemblade, Charlotte Higgins, Antonia Hodgson, Matthew Hotopf, Paul Howarth, Nigel Kendall, John Lewis, Toby Litt, Geoff MacCormack,

284 4 Acknowledgments

Preetha McCann, Jo McGrath, Julia and David Newman, Alex O'Connell, Brian O'Connell, Nicholas Pegg, Alice Rawsthorn, Emma Staples, Xanthe Sylvester, Matt Thorne, Paul Trynka, Pete Watts, Dominic Wells and Leigh Wilson. Special extra thanks to George Underwood (www.georgeunderwood.com) for answering my questions so obligingly, and to Pete Paphides who helped in innumerable generous ways, including reading an early draft and making valuable comments and suggestions.

Finally, I want to thank my wife, Cathy Newman, for her infinite love, patience, and kindness, and our daughters Scarlett (favorite song: "Life on Mars?") and Molly (favorite song: "Magic Dance").

NB: To avoid confusion with Bowie's first solo album, 1967's *David Bowie*, I've followed the convention of referring to his second album, first released in 1969 and also called *David Bowie* in the UK, as *Space Oddity*—the name it was given in 1972 for its RCA rerelease and by which it was generally known until 2009 when the original title was reinstated.

ABOUT THE AUTHOR

John O'Connell is a former senior editor at *Time Out* and music columnist for *The Face*. He is now freelance, writing mainly for *The Times* and *The Guardian*. He interviewed David Bowie in New York in 2002. He lives in South London.

,或用的是Experies Toffice and the